new fashion figure templates

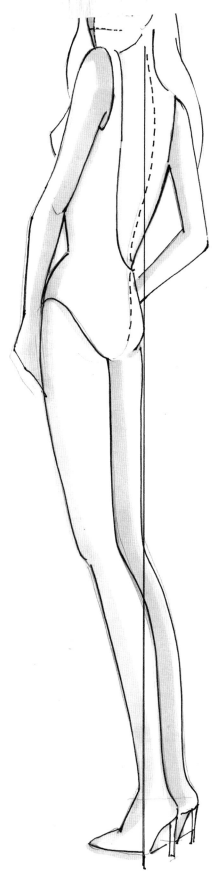

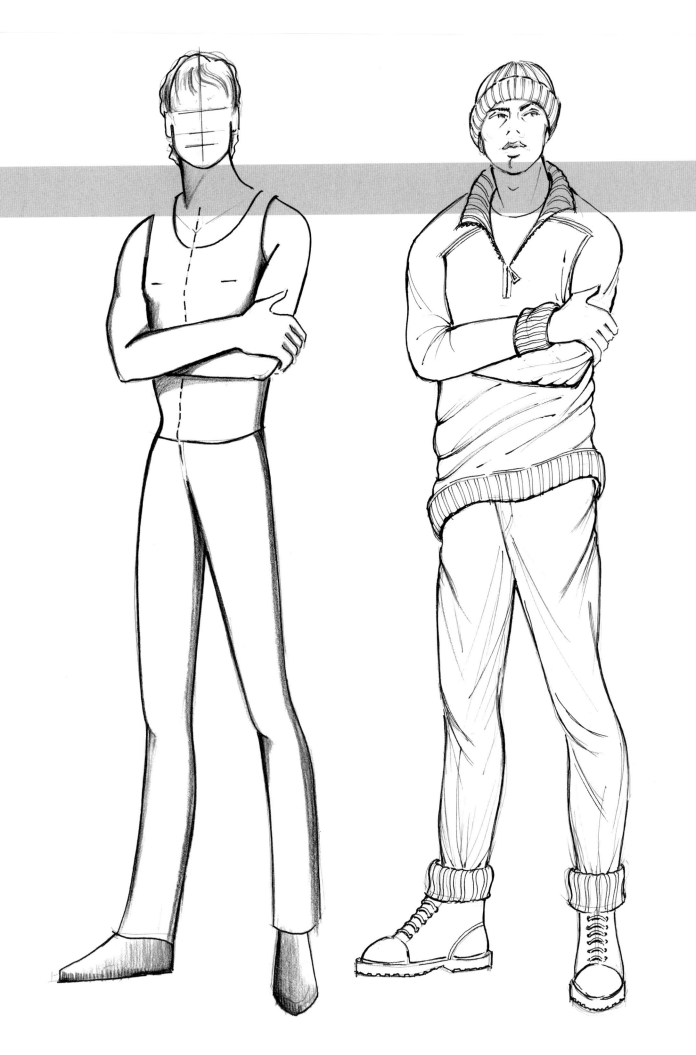

Patrick John Ireland

new fashion figure templates

BATSFORD

First published in the United Kingdom in 2007 by
Batsford
10 Southcombe Street
London W14 0RA

An imprint of Anova Books Company Ltd

ISBN-13: 9780713490336

A CIP catalogue record for this book is available from the British
Library.

15 14 13 12 11 10 09 08
10 9 8 7 6 5 4 3

Reproduction by Anorax Imaging Ltd, Leeds
Printed and bound by Craft Print International Ltd, Singapore

This book can be ordered direct from the publisher at the website:
www.anovabooks.com, or try your local bookshop

Distributed in the United States and Canada by Sterling Publishing Co.,
387 Park Avenue South, New York, NY 10016, USA

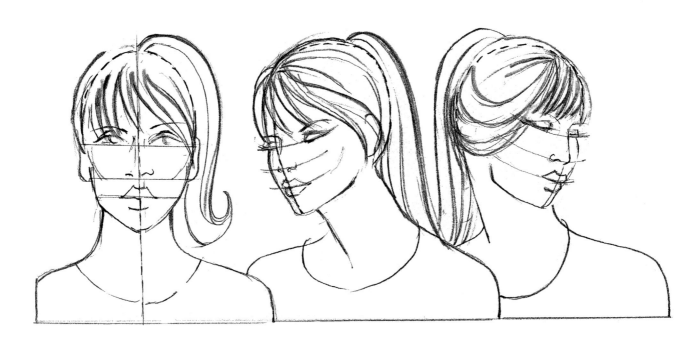

contents

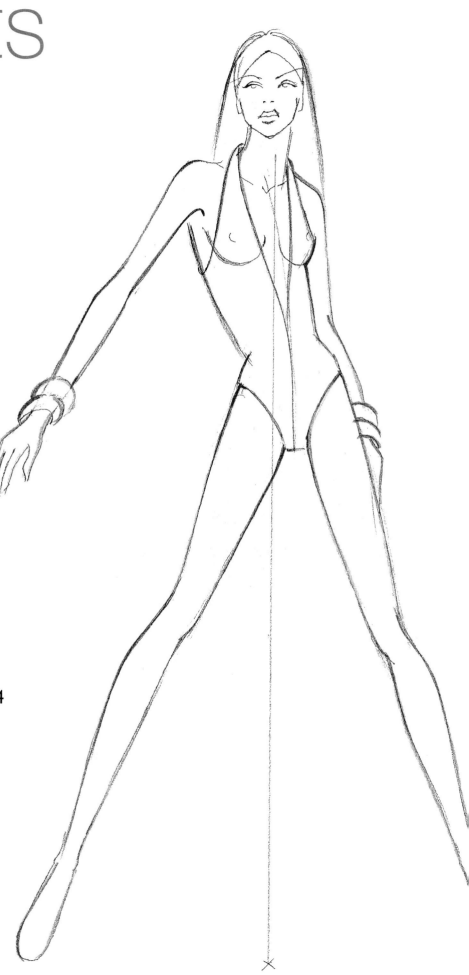

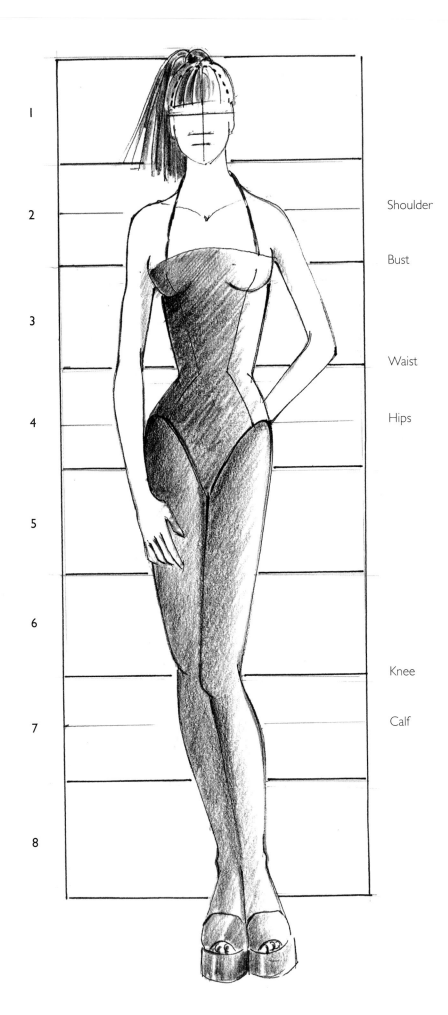

1

2 Shoulder

 Bust

3 Waist

4 Hips

5

6

 Knee

7 Calf

The average figure proportions
are 7½ head measurements. 8
Fashion figures are 8–8½ head
measurements, with the extra
length added to the legs.

introduction

The purpose of this book is not only to help fashion design students to develop sketching techniques, but also to hone their skills for creating and communicating design ideas for presentation.

Many students of design find it difficult in the early stages to sketch the human figure and the methods illustrated throughout this book will be helpful in developing these skills.

The book is arranged in sections to cover the different stages of fashion design drawing and illustrative techniques for women, men and children of different age groups.

It explains how to use figure templates and describes simple methods for developing figure poses as an aid to expressing design ideas.

The figure template enables the student to sketch and design in a free style over the impression of the figure with the use of semi-transparent layout paper, a light box or by scanning into a computer and enlarging to the size required.

The average figure proportions are illustrated, from 7½-head measurements to the more exaggerated figure, often elongated to give more elegance or to convey a stronger image.

The proportions of a more exaggerated figure may vary from 8-, 9- or 10-head measurements. The length is added to the legs from the waist or knee. All other proportions of the figure remain the same with some exceptions; when producing highly stylized fashion drawings the exaggeration may be extreme, with emphasis on large hands, feet and general proportions of the figure.

COMMUNICATION THROUGH DRAWINGS

Design development

In the earliest stages of developing a design collection, the designer's sketches should be executed quickly, allowing the ideas to flow. At this stage of the design process they need only be drawn as roughs, a method often referred to as 'brain storming'.

Developing ideas in diagrammatic form known as 'flats' can be effective, and will help when developing related ideas and building up a unified collection.

Some designers draw in a more controlled style while others prefer a freer style. It doesn't matter at this stage, as these roughs are for personal reference only. It is also helpful to transfer the flat design drawing onto the figure using the figure templates, relating the proportions and layering of the garments to the figure.

Working drawings

Final presentation illustrations often need to be supported with working drawings or 'flats'. These drawings have to be clear, accurate and drawn in a diagrammatic form. The working drawing should convey exactly how the garments are cut and clearly indicate details of collars, pockets, seam placement and trimmings, and also any proposed style features. Fabric samples are often included.

Presentation drawings

Presentation drawings are used on many different occasions, for example when showing design ideas to clients, entering fashion design competitions, setting up displays of work for exhibitions, as well as for portfolio work for interviews and assessments.

The presentation drawing should be the finished drawing in a collection of designs that projects the intended fashion image. Careful thought should be given, not only to drawing design garments, but also to whether the pose of the figure reflects the mood and occasion. Hairstyles and accessories should also be indicated in order to achieve an overall effect. Consideration should be given to the style of illustration to ensure that the work is shown off to best effect. Working drawings and fabric samples may be incorporated with the designs or illustrated on a separate sheet of paper or board.

Many different techniques may be used for the presentation of work. The mounting and layout of work especially needs to be considered. Photographs and different colour effects may be introduced to complement the illustrations. The camera, photocopier and computer can also be valuable tools for presentation techniques. Care must be taken not to let the presentation of the work overpower the design itself.

Examples of presentation work are shown in colour in the final section of the book (see pages 124–155).

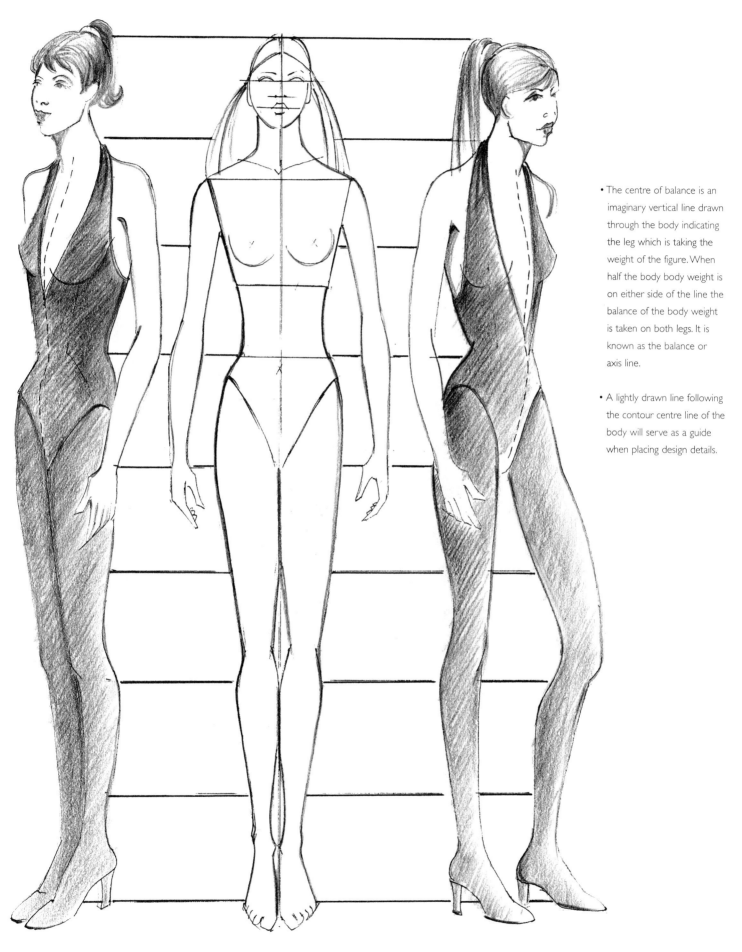

• The centre of balance is an imaginary vertical line drawn through the body indicating the leg which is taking the weight of the figure. When half the body body weight is on either side of the line the balance of the body weight is taken on both legs. It is known as the balance or axis line.

• A lightly drawn line following the contour centre line of the body will serve as a guide when placing design details.

fashion figure proportions

The human body is made up of simple solid forms. It is helpful to think in terms of basic forms and to understand the essential mass of the separate parts, placing them in their correct proportions and relationships. Think of the form of the figure as if it were made of solid separate shapes.

Drawing from life

Most fashion design courses include sessions allotted to life and fashion drawing. When a model is being drawn in a standing position, it is much harder for even an experienced model to keep the pose for a long period of time. The length of the pose will vary between five and twenty minutes. It is helpful if you can persuade a friend to model for you to give you extra time to practise drawing from life.

The form should be seen as simple blocks based on the cube, cylinder and sphere.

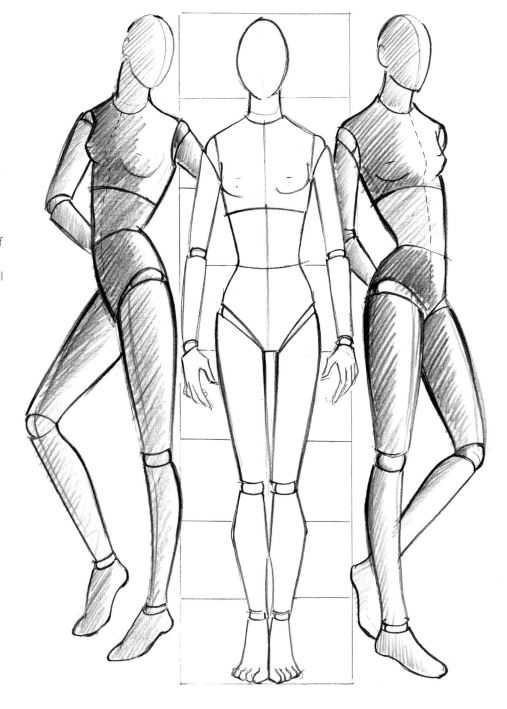

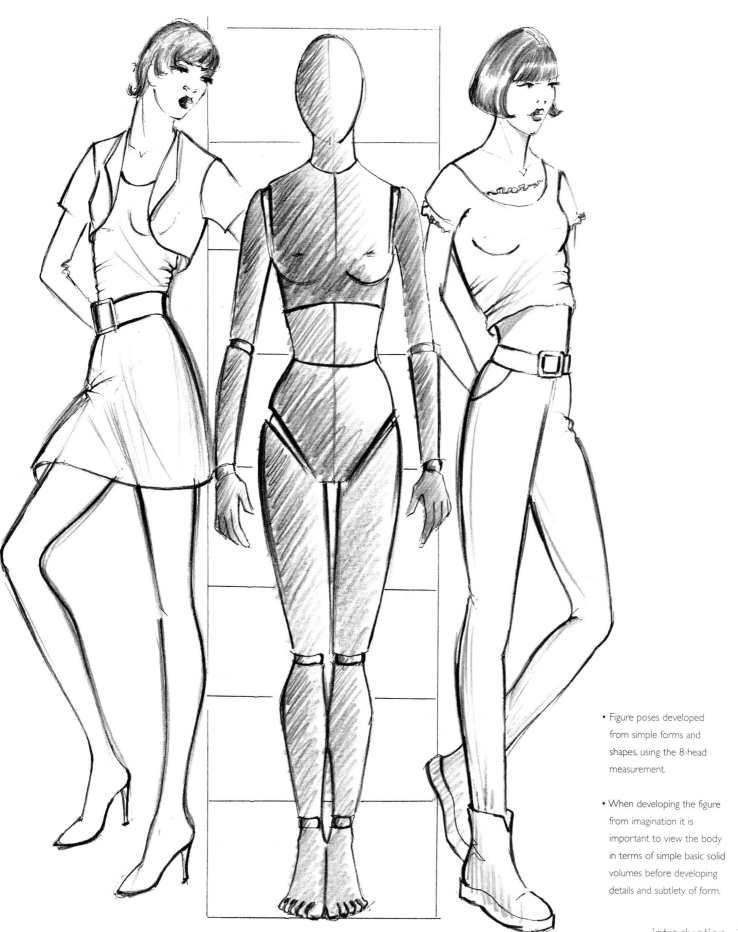

• Figure poses developed
 from simple forms and
 shapes, using the 8-head
 measurement.

• When developing the figure
 from imagination it is
 important to view the body
 in terms of simple basic solid
 volumes before developing
 details and subtlety of form.

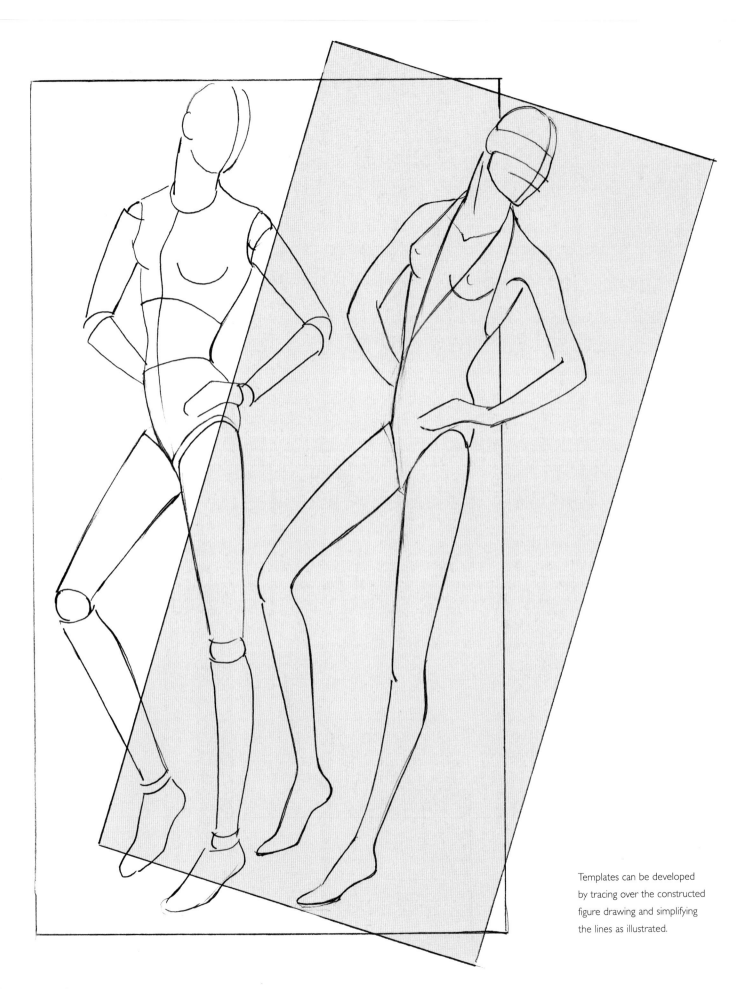

Templates can be developed
by tracing over the constructed
figure drawing and simplifying
the lines as illustrated.

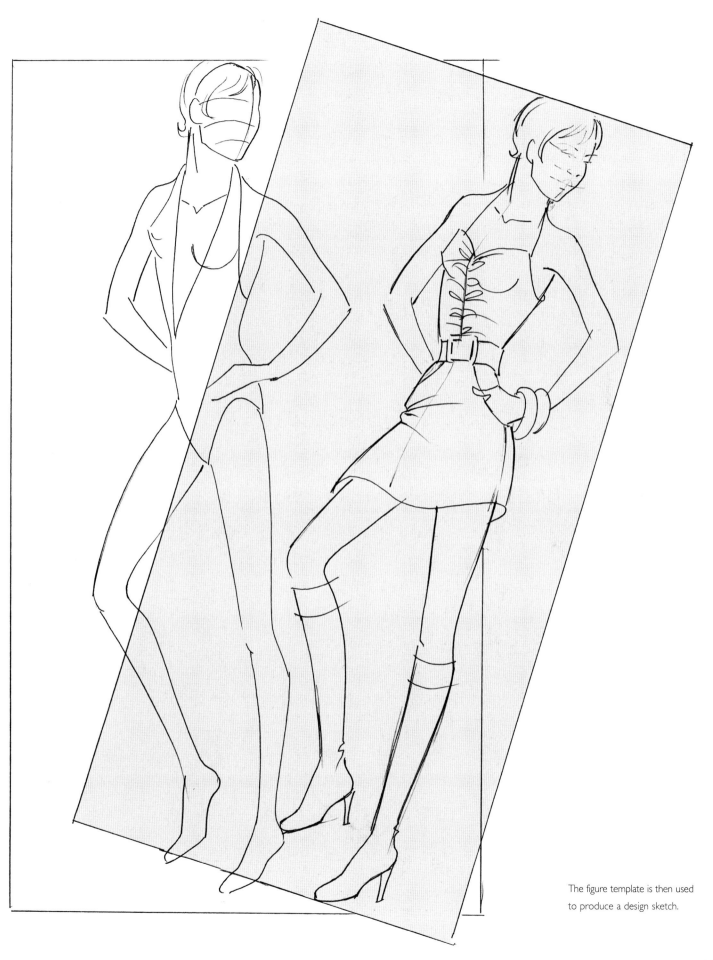

The figure template is then used
to produce a design sketch.

creating figure poses

Sketch a number of basic figures in a variety of poses. Remember to visualize the various body parts of the figure in three-dimensional basic forms, such as spheres, cylinders and cubes.

Using this method of construction it is easy to develop convincing sketches of the human figure and, later, the ability to create new templates from imagination.

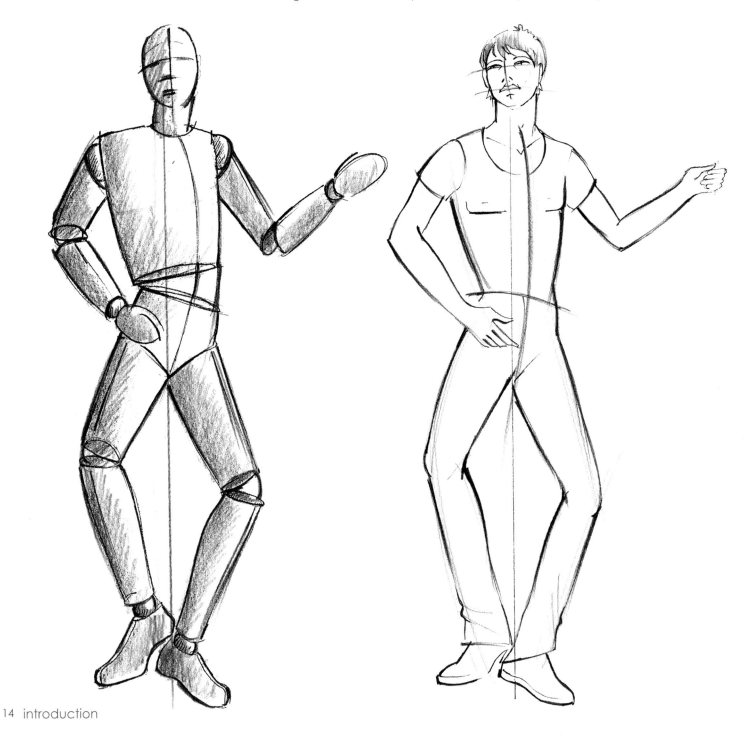

The figures illustrated have been developed using a wooden artist's dummy, or 'lay figure', for reference. The proportions and construction are correct. The figures have convincing mass and weight because each part has been drawn in three dimensions.

Very little attempt has been made to suggest anatomical detail, but any of the figures could be developed into a finished figure as illustrated.

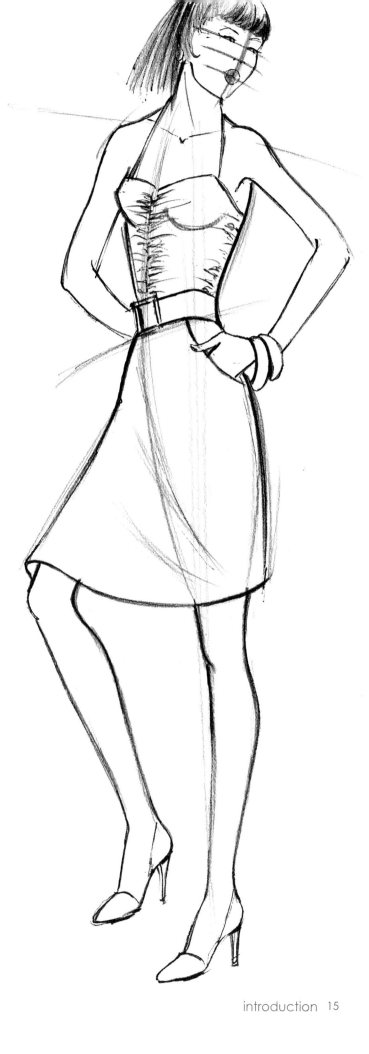

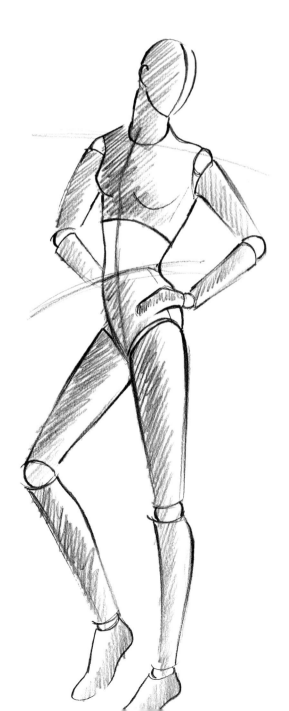

CREATING FIGURE TEMPLATES

Figures can be sketched using the following techniques:

- Line a sheet of drawing paper with 8-head measurements (as illustrated).

- Sketch freely, developing the poses using the lines as a guide for the proportions of the body. When drawing the figure, imagine the basic solid forms.

- Remember only to exaggerate the length of the figure in the length of the legs.

- Draw a light line from the pit of the neck to the floor. This shows how the length of the legs takes the weight of the figure and supports the body. This is helpful when checking if the figure is standing correctly.

- It is useful to use a 'lay figure' or wooden artist's dummy for reference when drawing and developing figures from the imagination.

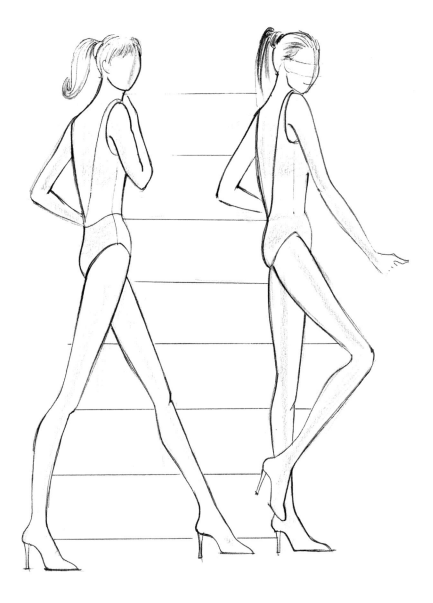

Figure poses developed into templates illustrating a selection of different angles of the figure. Front, side, back and three-quarter views are shown on the following pages, all using the 8-head measurement.

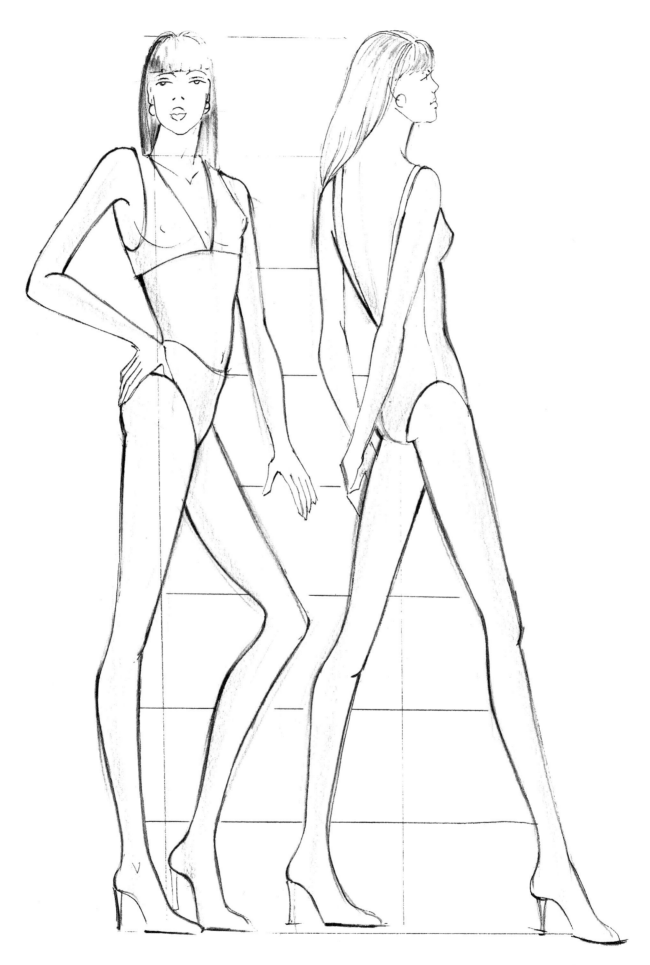

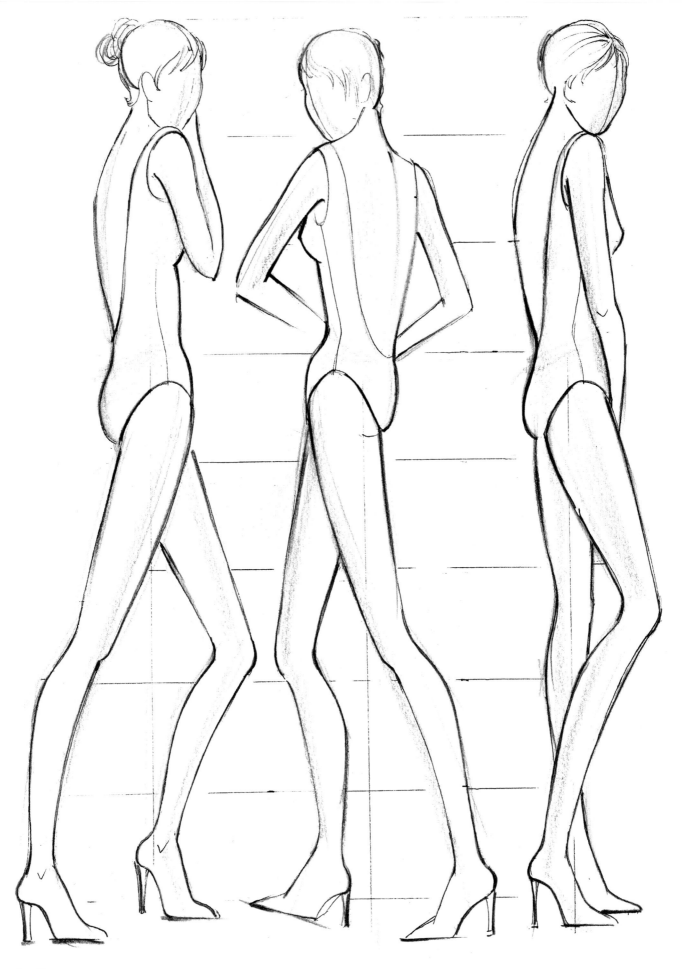

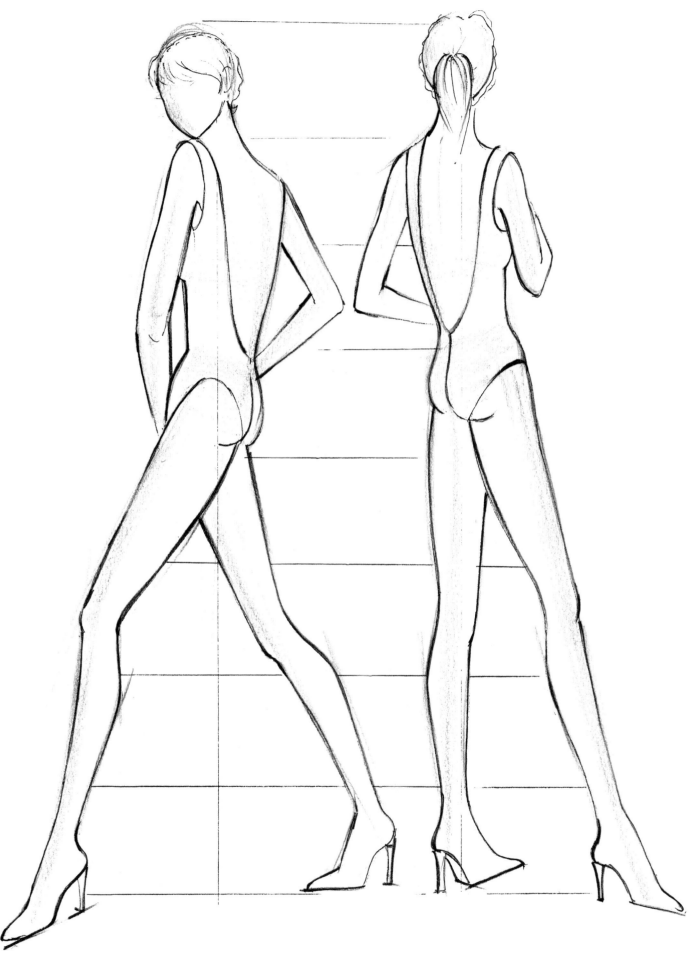

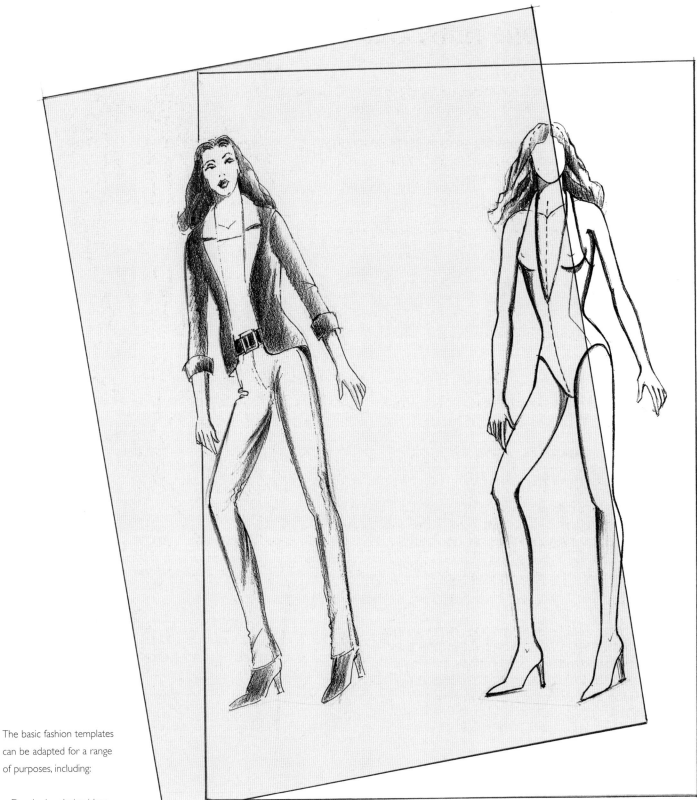

The basic fashion templates
can be adapted for a range
of purposes, including:

• Developing design ideas.
• Presentation illustrations.
• Producing working drawings.
• Developing and adapting new poses.
• Enlarging and reducing with the aid of
 the photocopier.
• Scanning templates into a computer
 over which to design.

USING THE FIGURE TEMPLATES

The figure template enables you to sketch and design quickly in a free, creative style over the impression of the figure, using semi-transparent layout paper. Using a lightbox would enable you to use varying thicknesses of paper. The figure may also be scanned into a computer and adapted to the required size. The template should not be traced, only used as a guide, sketching freely over the impression of the figure through the paper.

- The dotted line indicates the contour of the centre front of the body. This line can be very helpful as a guide when designing and balancing design details.

- The length of the face, forehead to chin, can be measured by the length of the hand.

- Height and width of the head are almost equal.

- The torso is about two heads high.

- After drawing the head position, use the axis line to balance the figure.

- Parts of the figure are slightly exaggerated to give the figure a graceful image.

- Select a pose that will complement the design and convey the image you want to project through the design sketch, such as sporty, casual, elegant, sophisticated or glamourous.

Using a template as an aid for developing design ideas and presenting work in the early stages allows you to express ideas with more speed.

Different designers develop different ways of expressing design ideas on paper. The design sketch may be in a free style or a more controlled technique. However, it is important when showing a collection of sketches to a client, lecturer or examiner, or presenting work for an interview, that the drawings convey the ideas clearly.

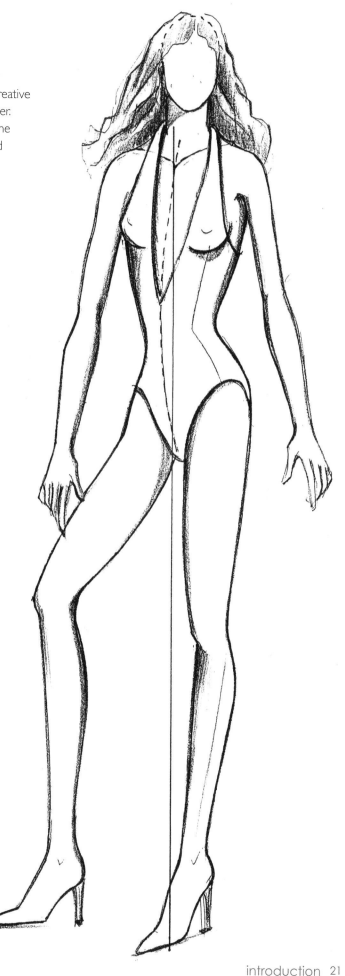

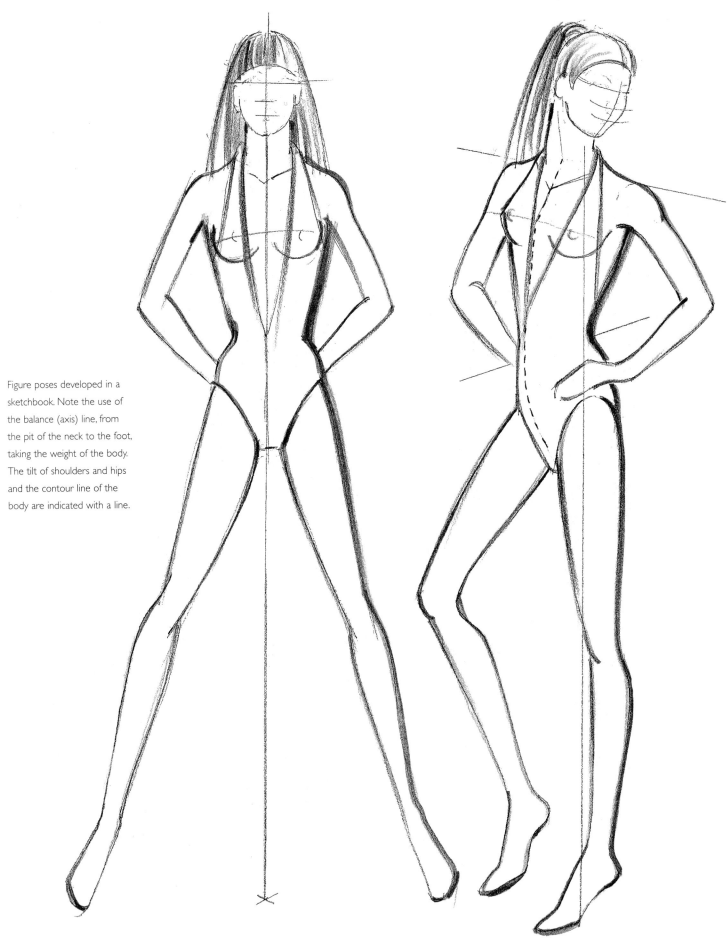

Figure poses developed in a sketchbook. Note the use of the balance (axis) line, from the pit of the neck to the foot, taking the weight of the body. The tilt of shoulders and hips and the contour line of the body are indicated with a line.

womenswear

PROPORTION

As a fashion designer it is important to gain some knowledge of the structure and proportions of the human body. It is important to always remember to relate the design to the human figure. Proportions are often elongated to create a feeling of elegance. However, the exaggeration is on the length of the legs only, the upper part of the body from the waist up is based on average proportions.

The human body measures around 7½ heads. The fashion figure increases to 8 heads, and very exaggerated, stylized poses could be 8½, 9 or 10 heads.

The centre of balance is the imaginary vertical line drawn through the body, indicating the leg that is taking the weight of the figure. Half the body weight is on either side of the line and the balance of the body weight is taken on both legs.

Design

When design sketching, it is helpful to lightly draw a line following the contour centre line of the body. This will serve as a guide when designing and placing details.

The sketch on the left and on the following pages show the tilt of the hip and the weight being carried by the supporting leg. A shoulder or hip may be dropped or raised to express more action.

When designing, it is important to be aware of the proportions of the design in relation to the figure.

The vertical or balance line is drawn from the pit of the neck to the foot taking the weight of the body. It is useful to draw this line very lightly when starting the sketch to obtain the correct balance.

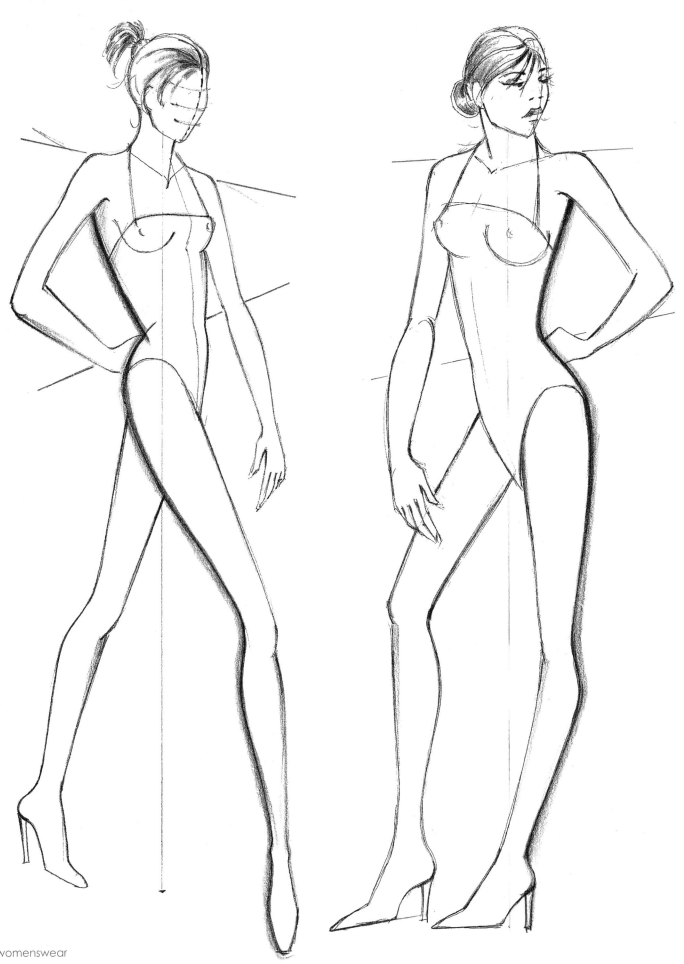

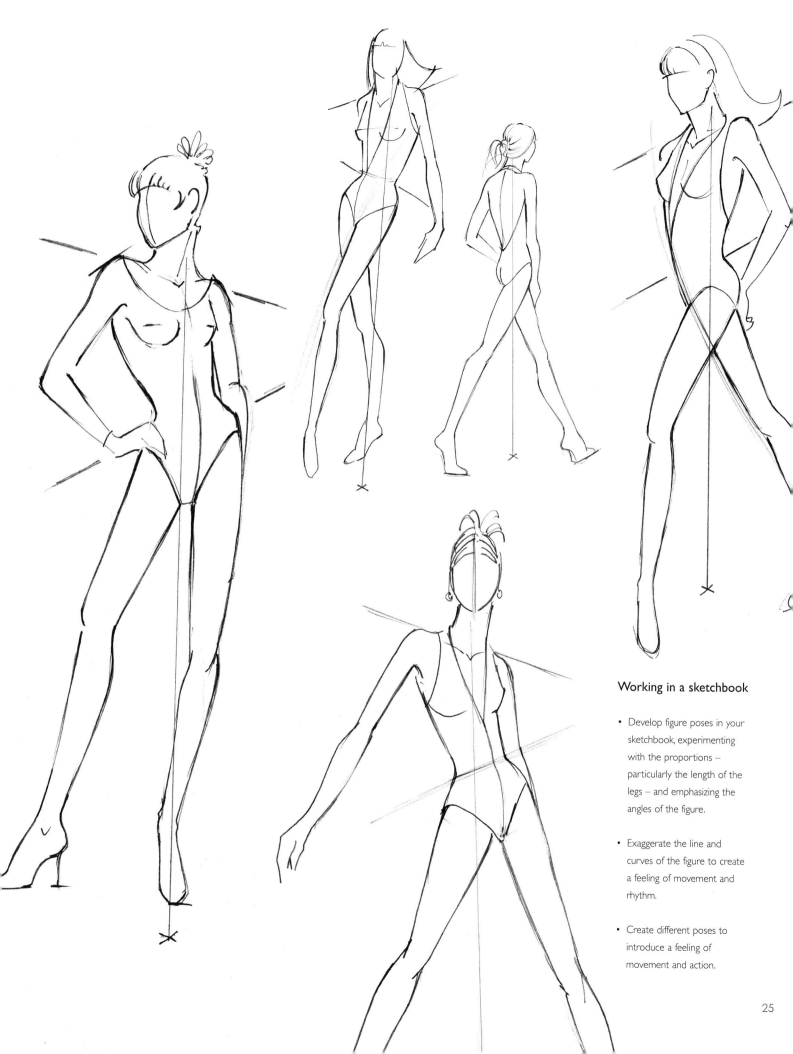

Working in a sketchbook

- Develop figure poses in your sketchbook, experimenting with the proportions – particularly the length of the legs – and emphasizing the angles of the figure.

- Exaggerate the line and curves of the figure to create a feeling of movement and rhythm.

- Create different poses to introduce a feeling of movement and action.

DEVELOPING DESIGN IDEAS

Simple, straightforward figure templates are used at this stage when developing ideas. Details of faces, hair and hands need only be suggested. The approach to the style of drawing may vary from a controlled diagrammatic technique to a more free style. Back views of the design should be included.

Many sketches are produced in the early stages of the design process – the 'brain storming' – before selecting a collection of designs. The designer works on a theme, researching ideas and selecting colours, fabric, prints and trimmings. The creation of the roughs is a very important stage in the design process.

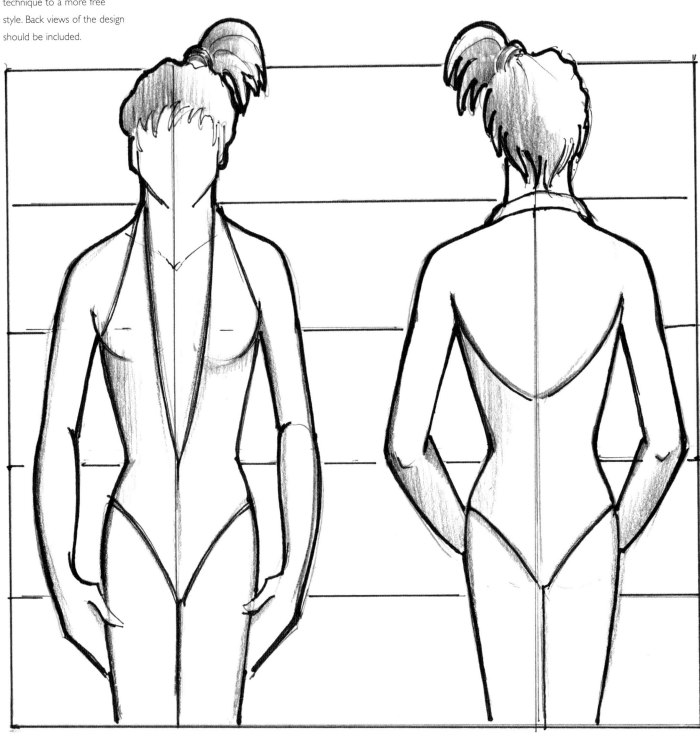

Development of design ideas working with the same figure pose. This enables the designer to work quickly, relating one idea to the next.

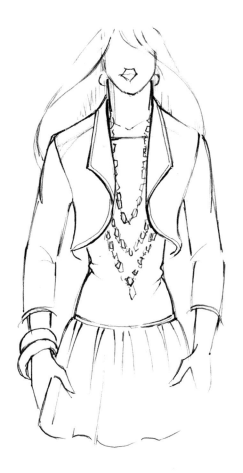

classic templates

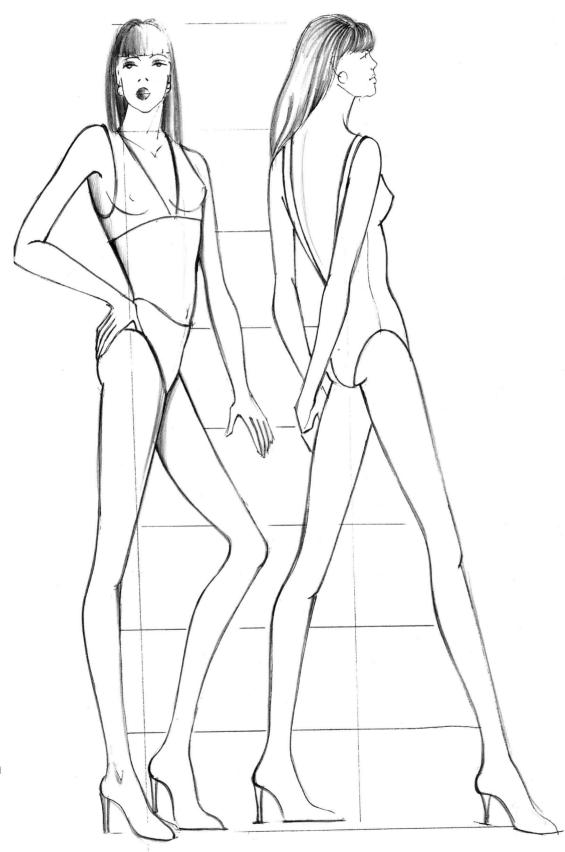

These templates use an 8-head
measurement.

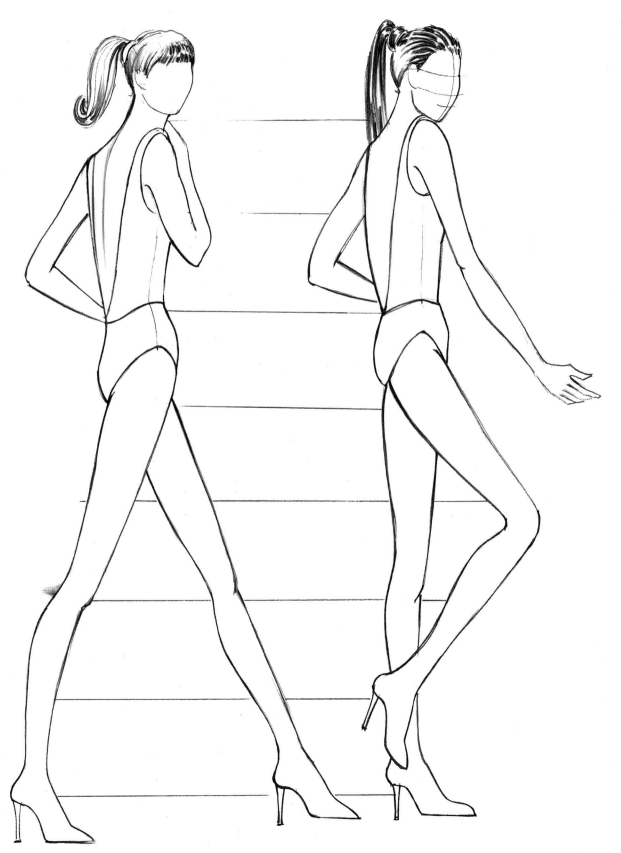

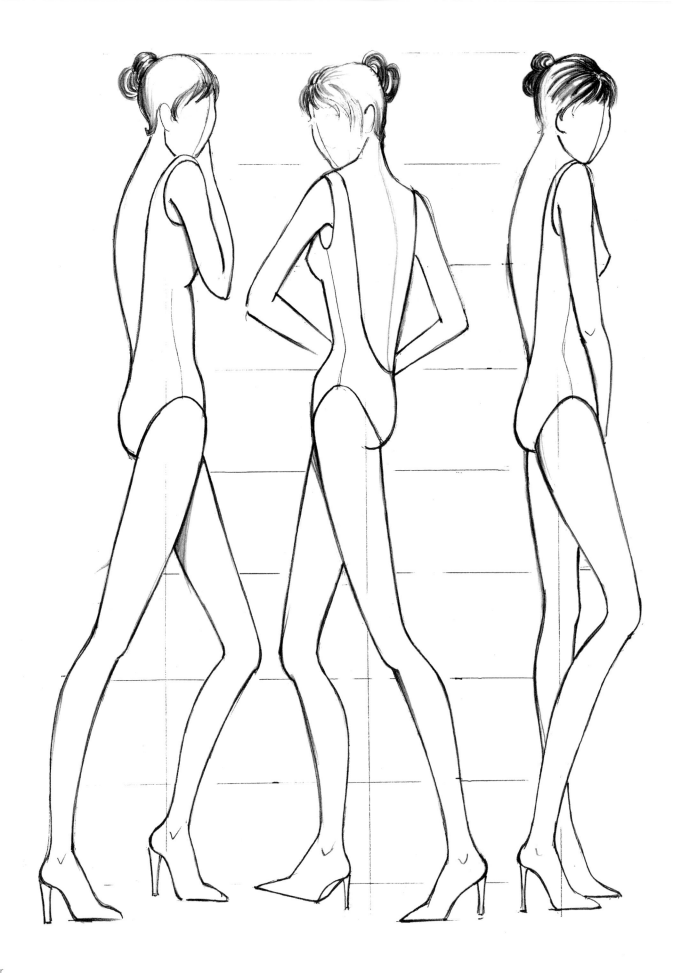

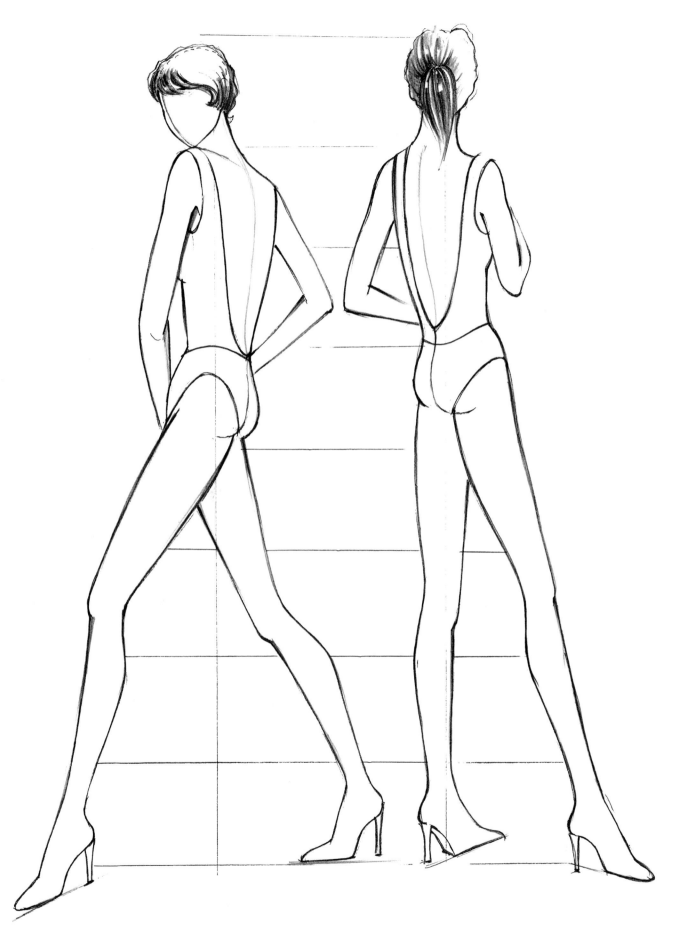

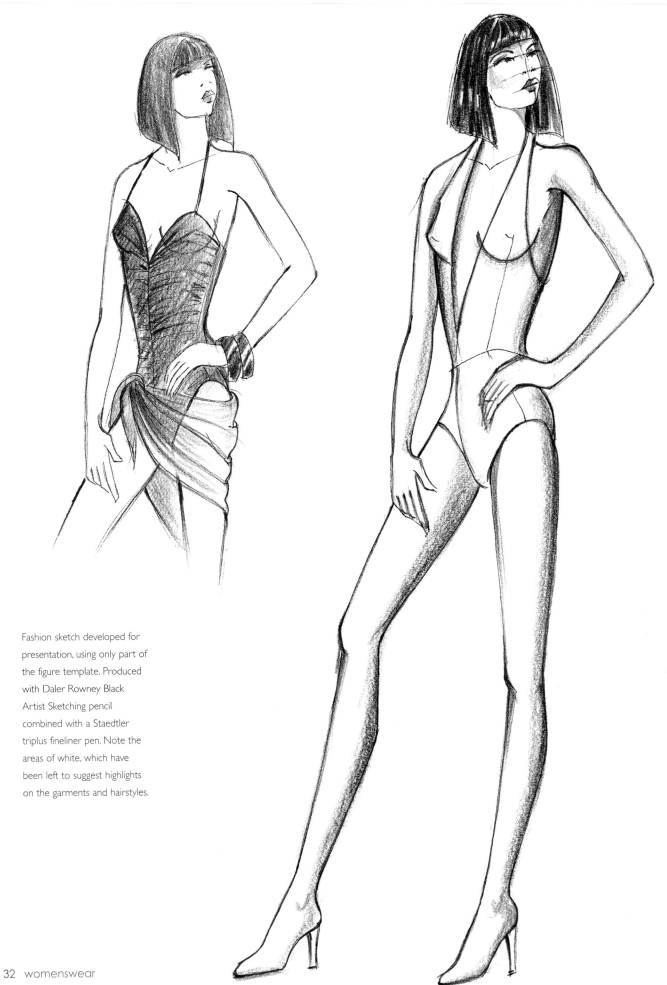

Fashion sketch developed for presentation, using only part of the figure template. Produced with Daler Rowney Black Artist Sketching pencil combined with a Staedtler triplus fineliner pen. Note the areas of white, which have been left to suggest highlights on the garments and hairstyles.

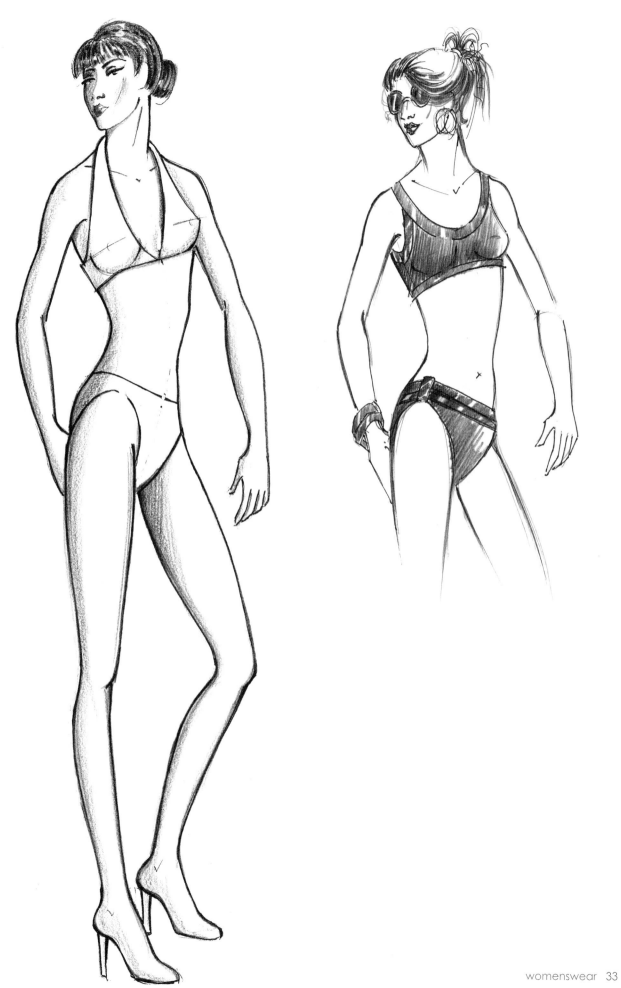

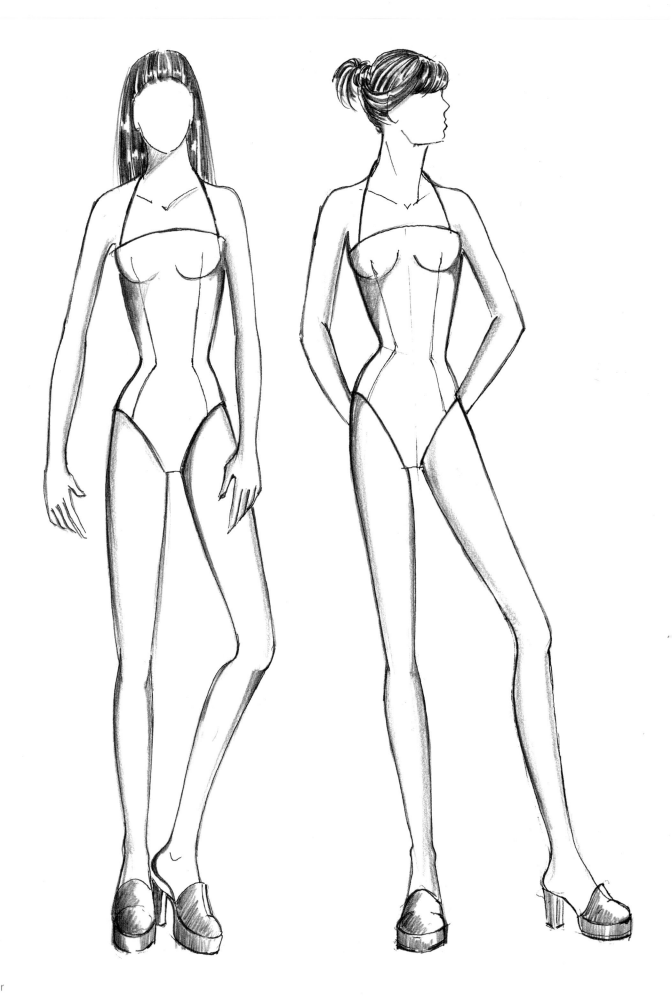

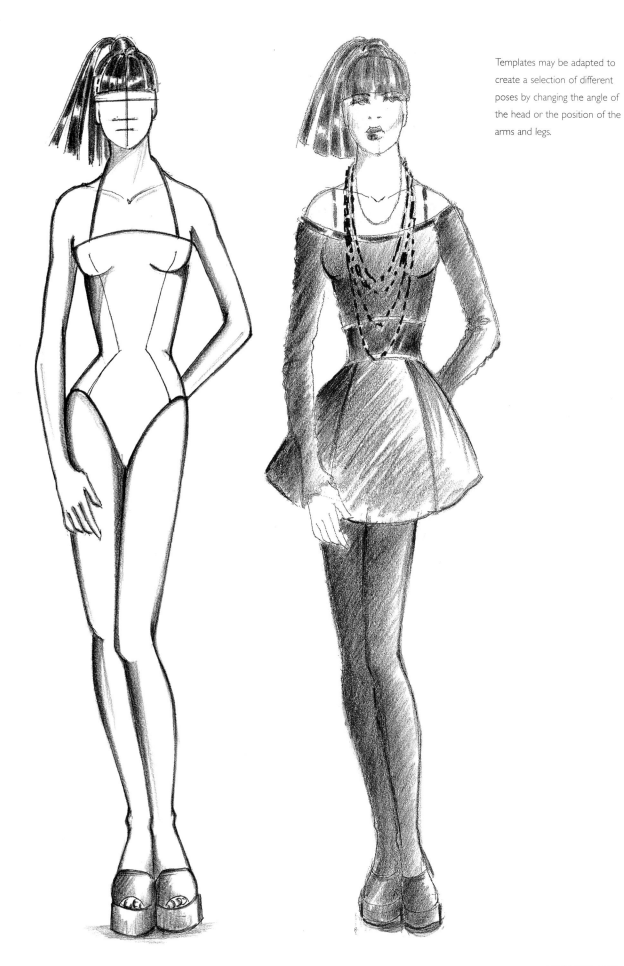

Templates may be adapted to create a selection of different poses by changing the angle of the head or the position of the arms and legs.

Sketches produced using a
Derwent Artist Ivory Black
pencil on a textured cartridge
drawing paper. Using different
pressure with the pencil
creates tonal effects.

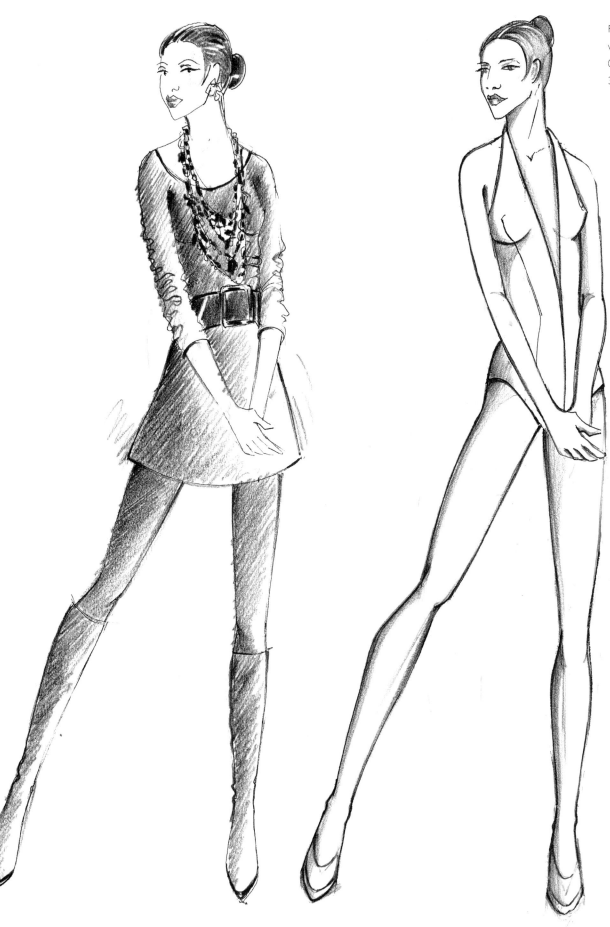

Fashion sketches produced
with a Staedtler pigment liner
0.6 pen with shading using soft
3B pencils.

movement templates

Figures in movement are difficult to capture in detail unless the action is very slow or continuously repeated. It is good practice to make quick, rough sketches from life in a sketchbook and develop them later.

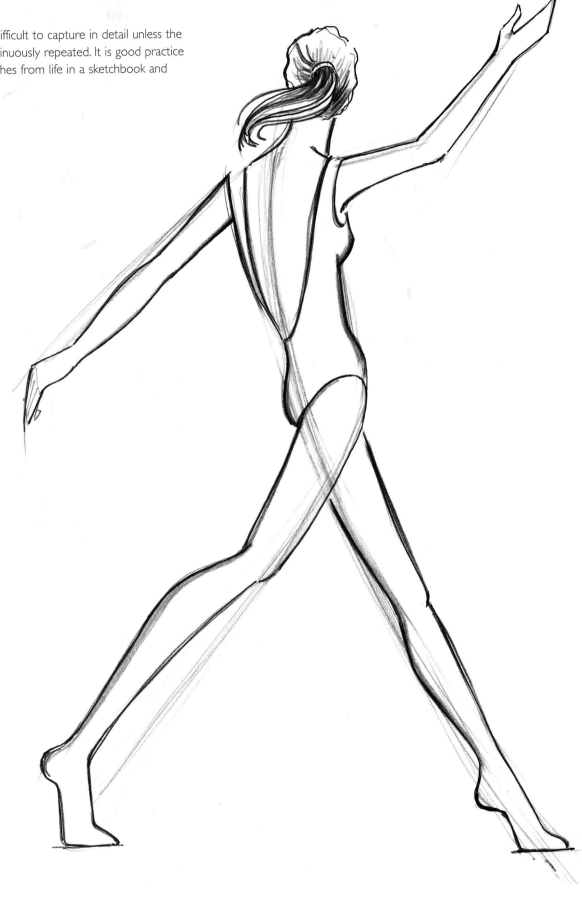

- A slow action such as walking can be studied by asking a friend to pose for you if a model is not available.

- The most convenient method is to resort to photography for establishing moving poses.

- It is useful to keep a collection of reference cuttings of action and moving poses from newspapers, sports and dance magazines.

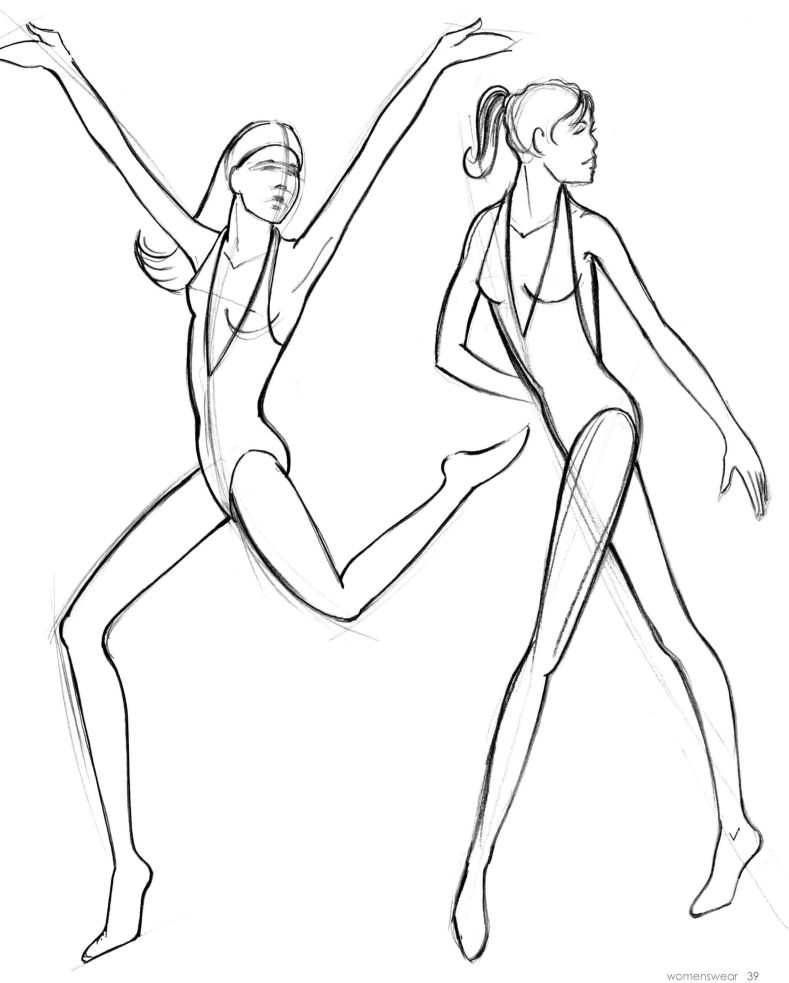

Figure template in walking movement. Note the emphasis on the accessories to complement the design sketch and add interest. Sketch produced with a fine waterproof Staedtler pigment fineliner 0.21 pen and soft 2B Graphite pencil for shading.

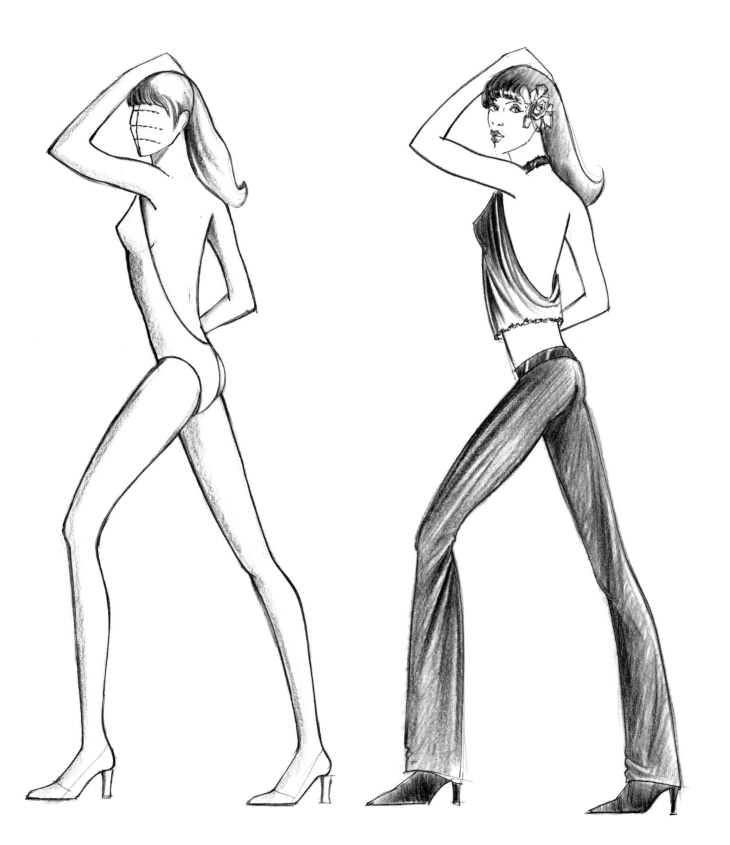

Template showing a back view
and walking movement. Note
the exaggerated proportions
on the length of legs (9-head
measurement).

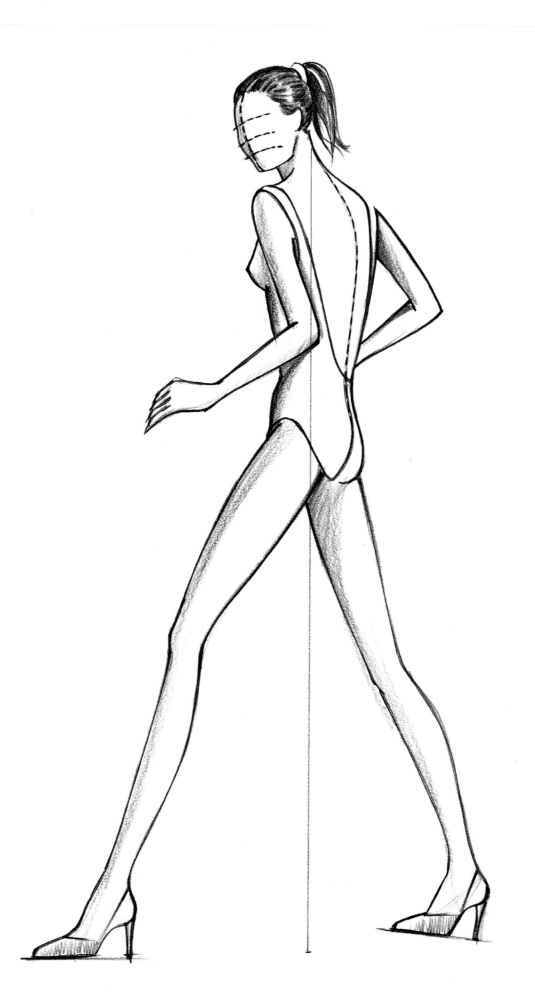

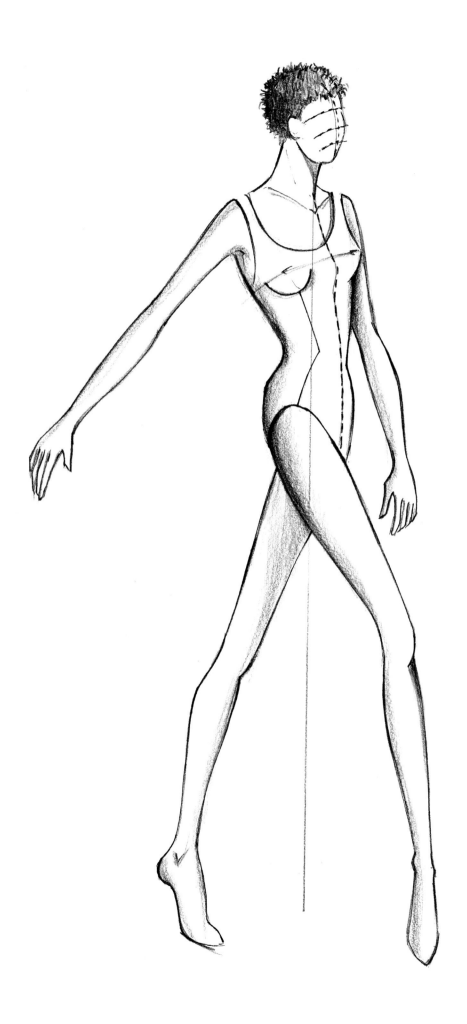

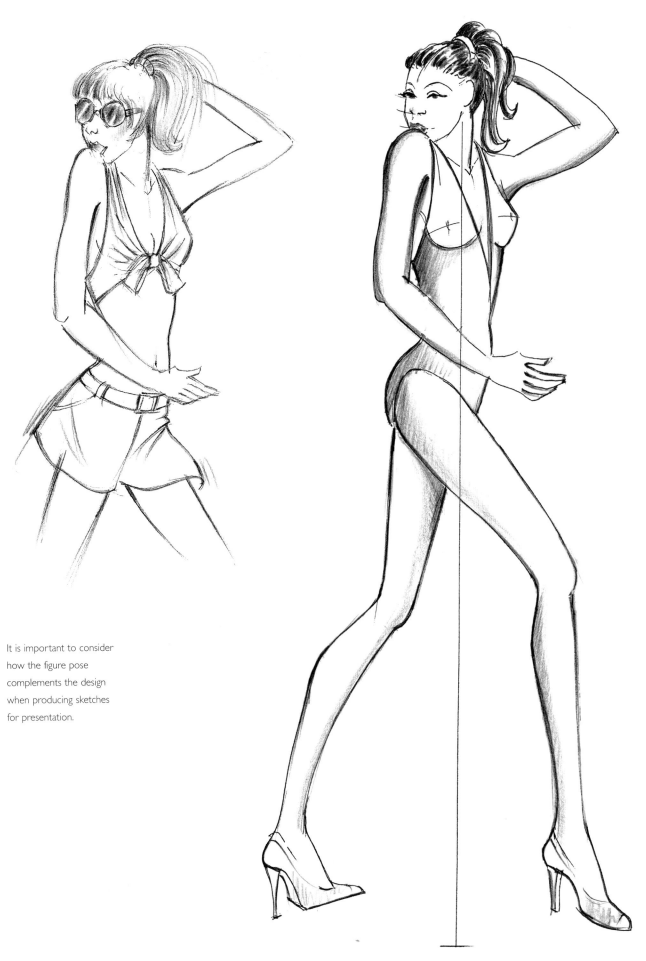

It is important to consider how the figure pose complements the design when producing sketches for presentation.

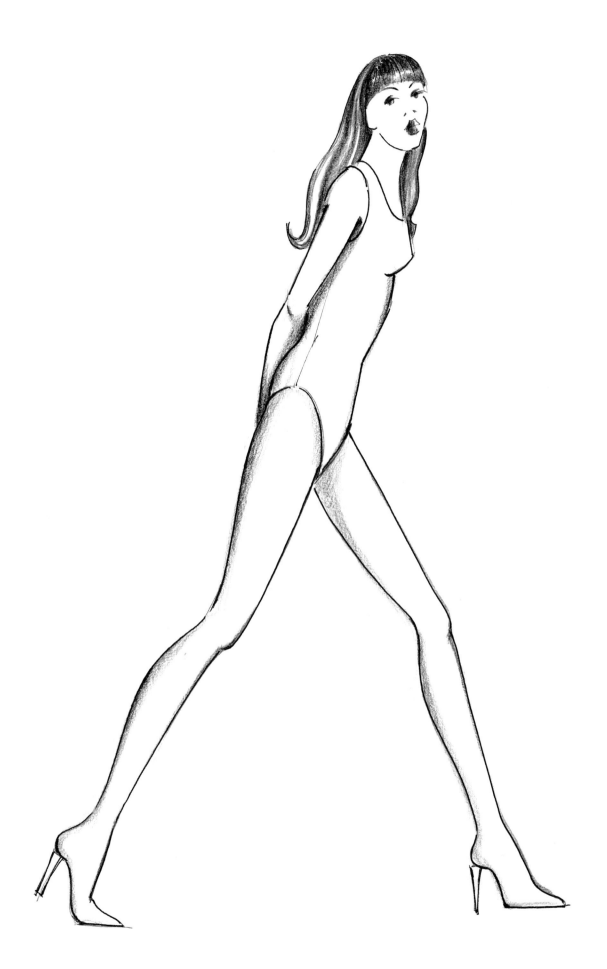

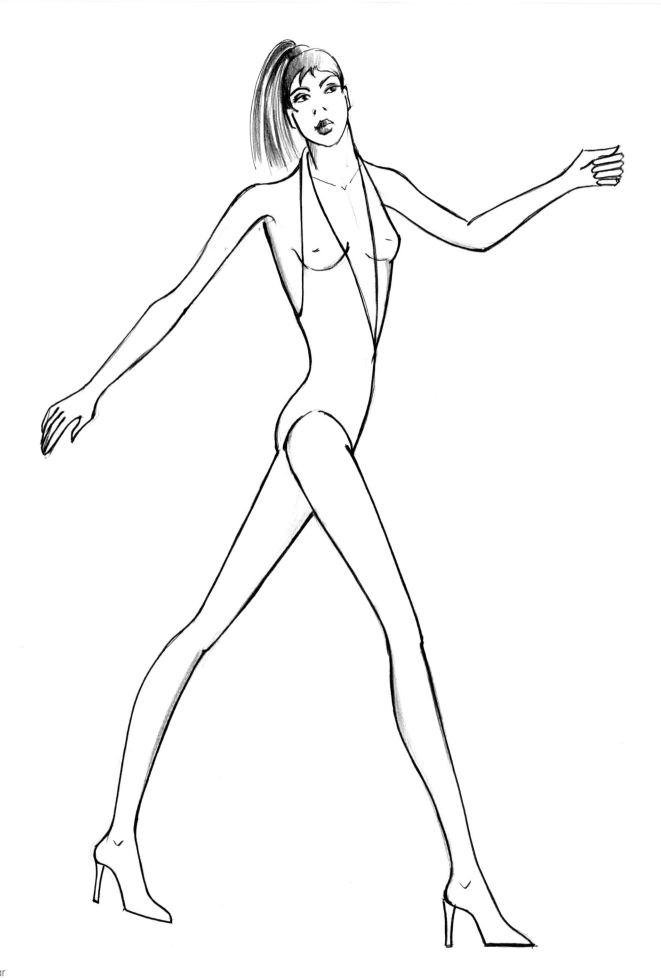

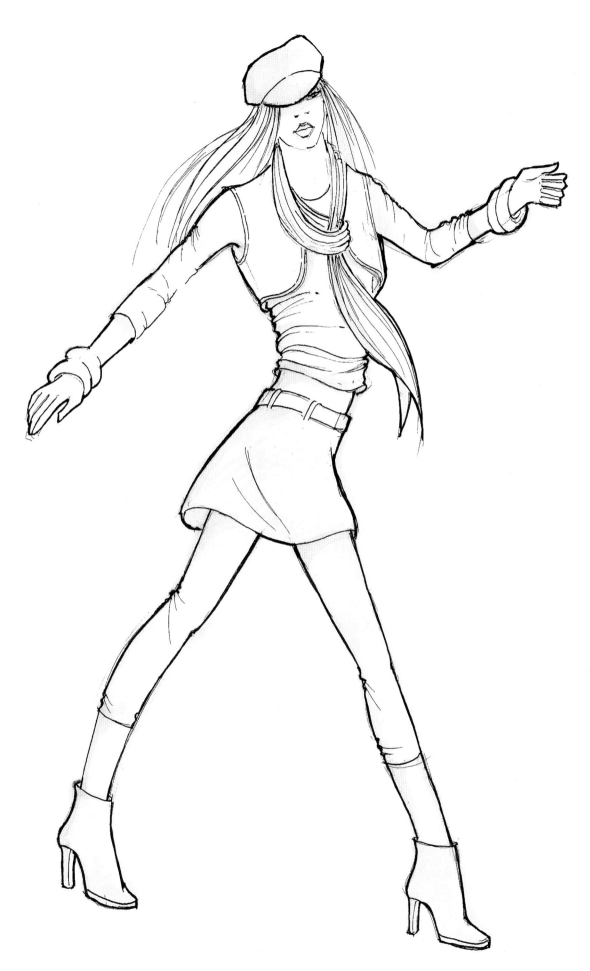

Sketch using Staedtler triplus fineliner pen, combined with a thicker pen for the outline of the sketch. Letraset Promarker cool grey is used for shading.

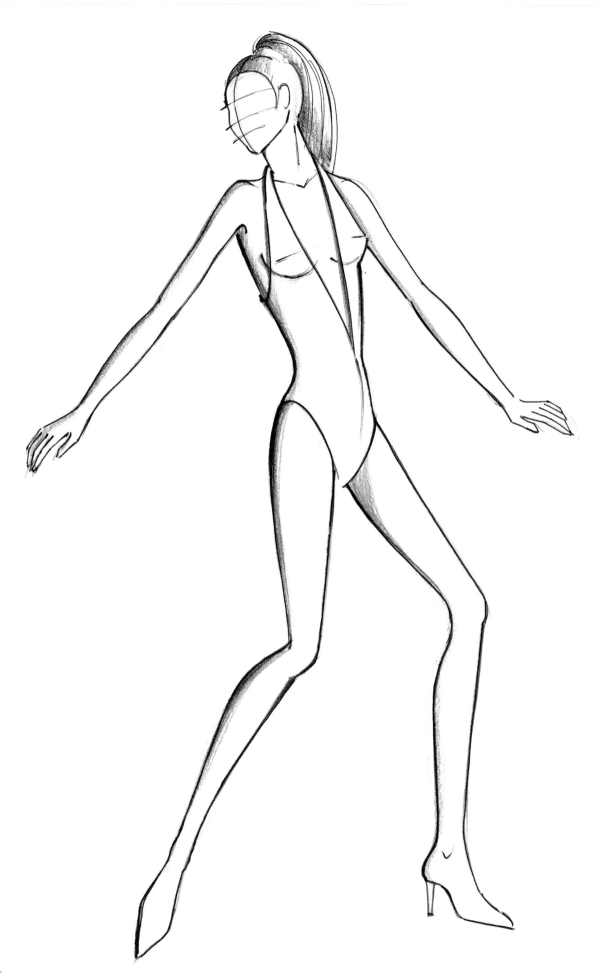

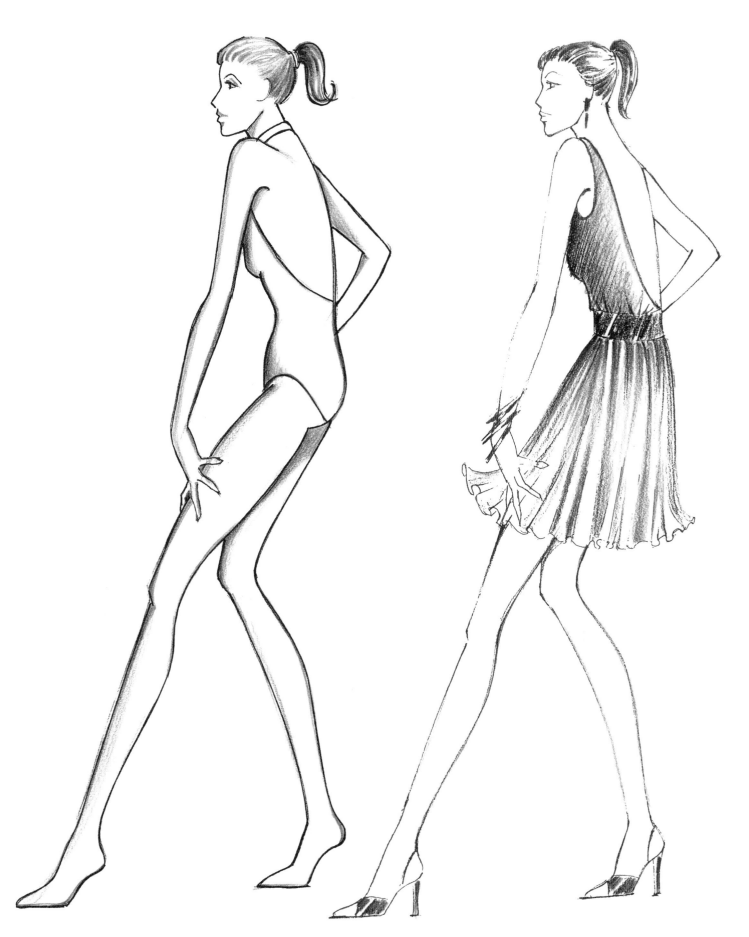

strike a pose

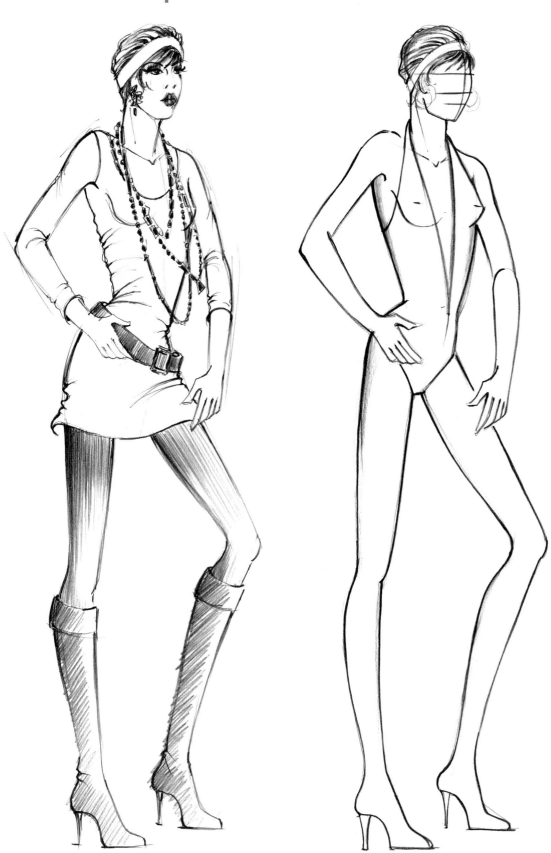

Sketch produced with a Derwent Artist Ivory Black pencil on a smooth white surface. Different pressures are used to obtain tonal effects, leaving areas of white for highlighting and suggesting the surface of the material.

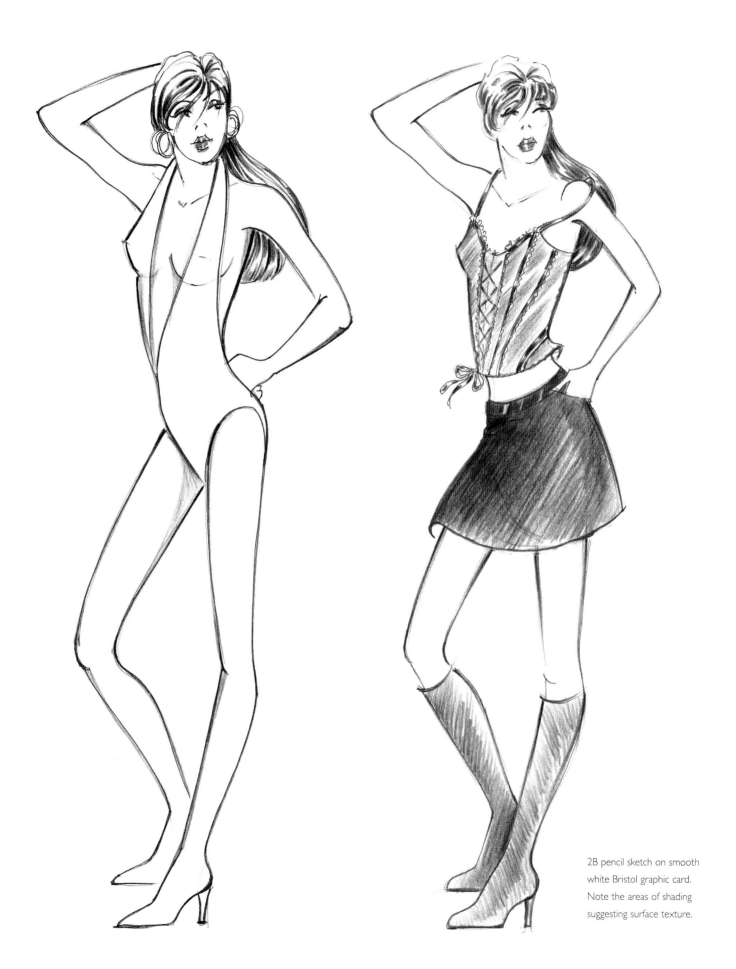

2B pencil sketch on smooth
white Bristol graphic card.
Note the areas of shading
suggesting surface texture.

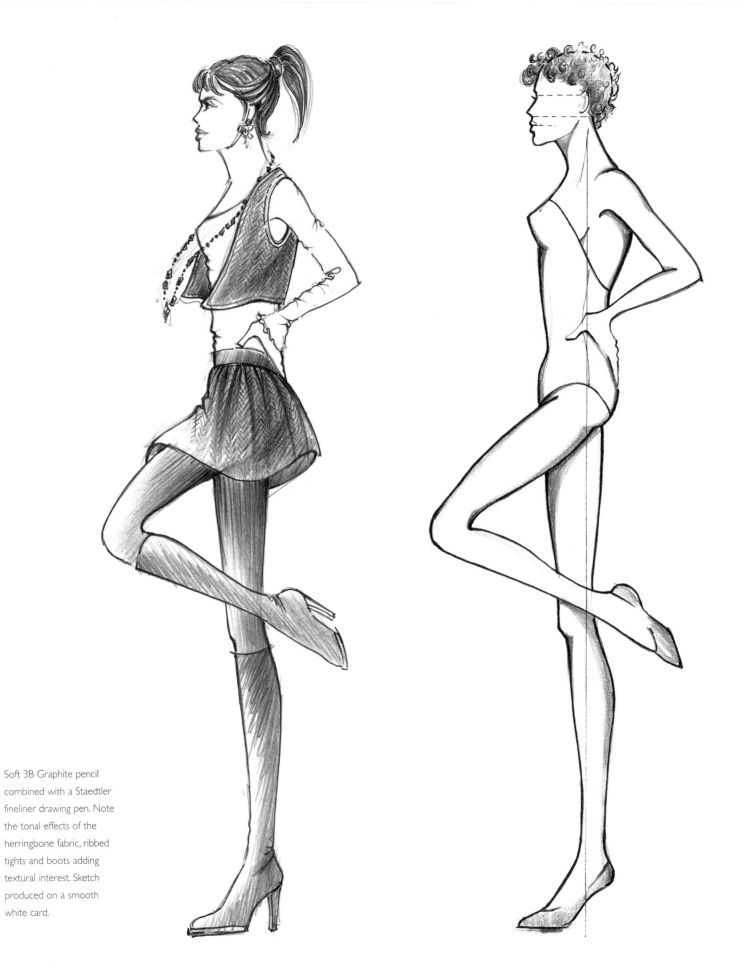

Soft 3B Graphite pencil combined with a Staedtler fineliner drawing pen. Note the tonal effects of the herringbone fabric, ribbed tights and boots adding textural interest. Sketch produced on a smooth white card.

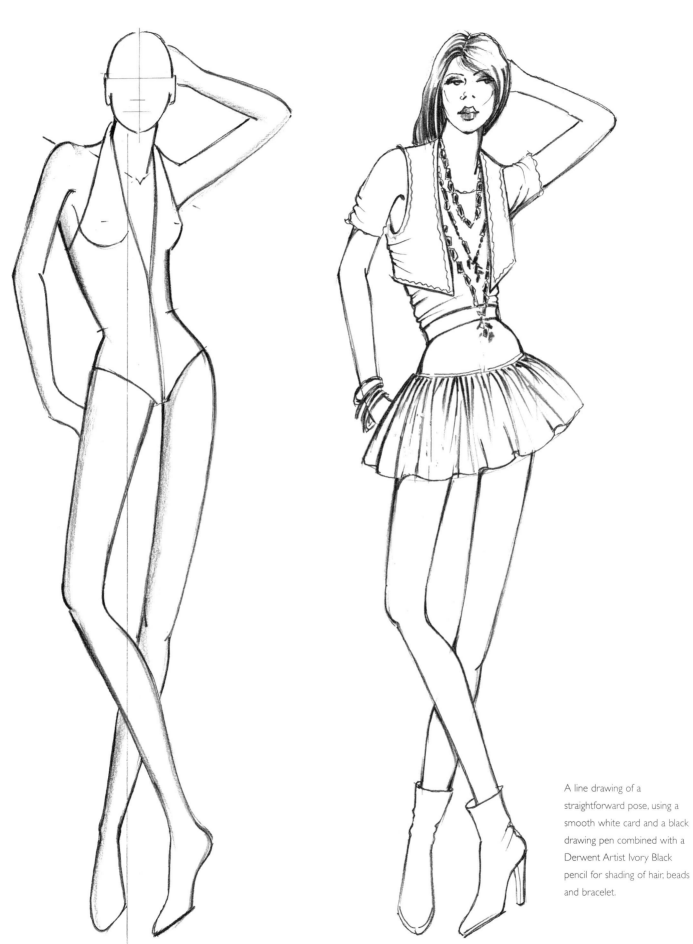

A line drawing of a straightforward pose, using a smooth white card and a black drawing pen combined with a Derwent Artist Ivory Black pencil for shading of hair, beads and bracelet.

Figure template selected for attitude of pose. A simple line drawing produced with a Staedtler triplus fineliner pen on a smooth white drawing paper.

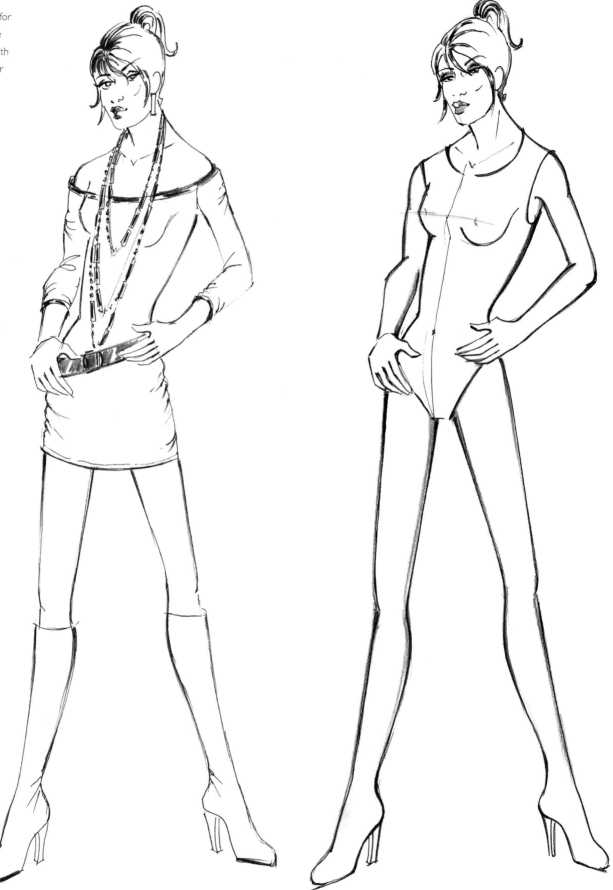

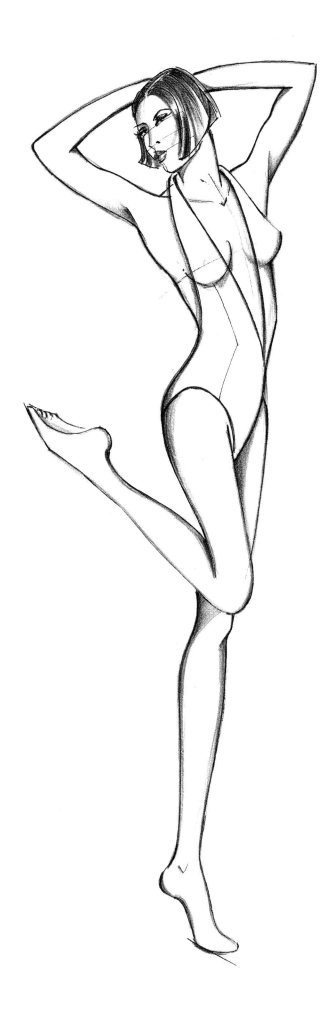
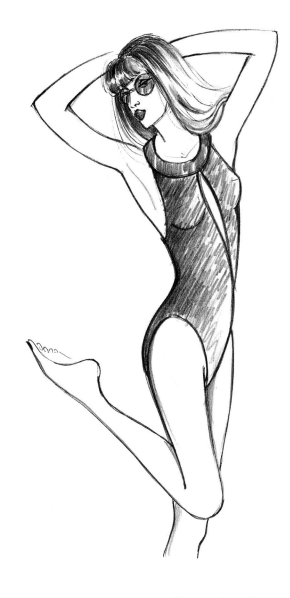

Figure template with movement reflecting a sporty mood and attitude. A soft black pencil is used with different pressure to achieve contrast of tone and pattern.

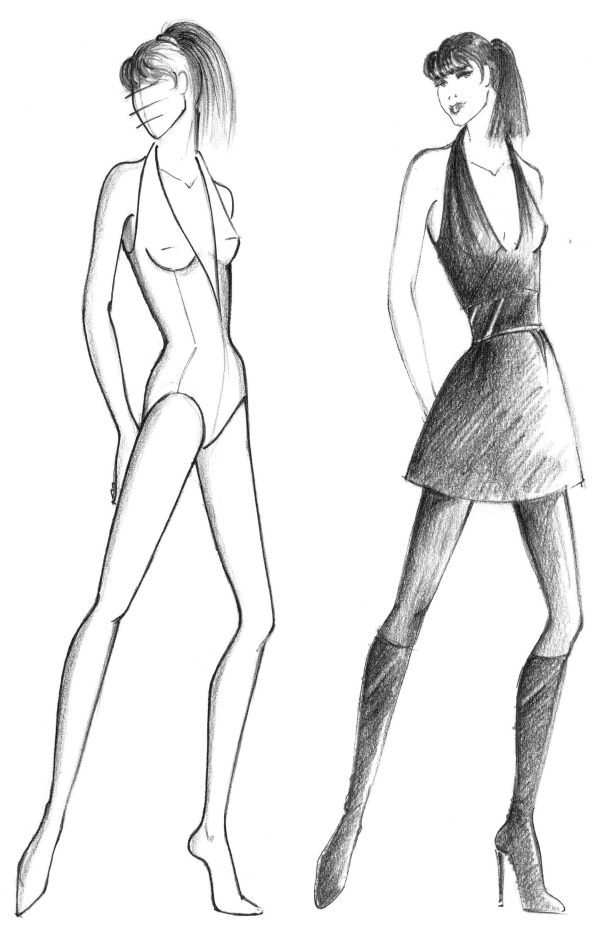

Light and shade

The figures on these two pages demonstrate how to use pencil shading to produce a contrast of light and shade in design sketches. Consider the side of the figure on which the light is falling, highlighting folds, gathers and other fashion details.

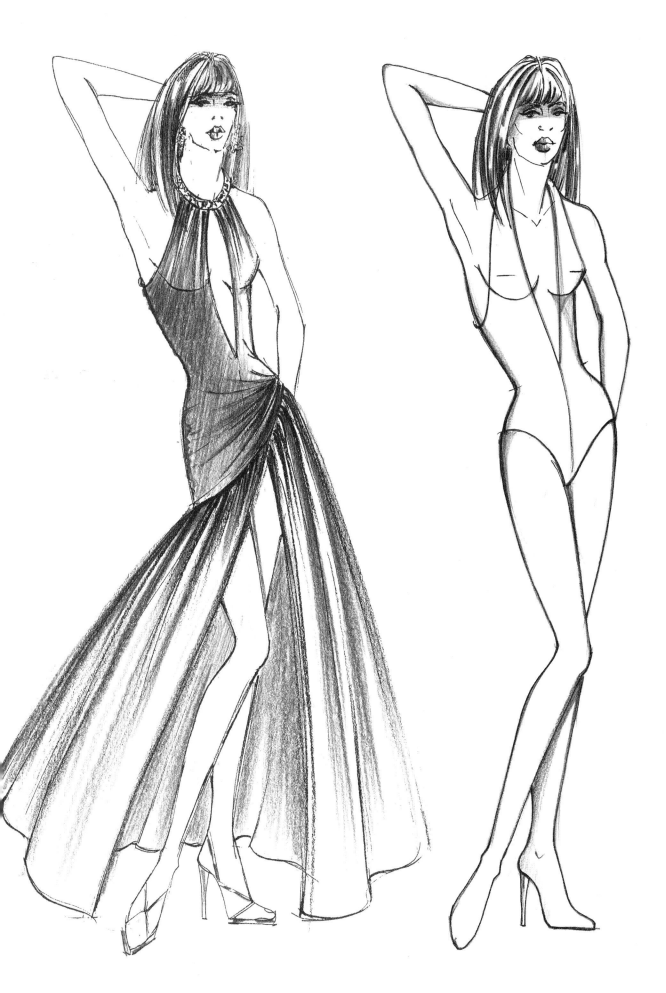

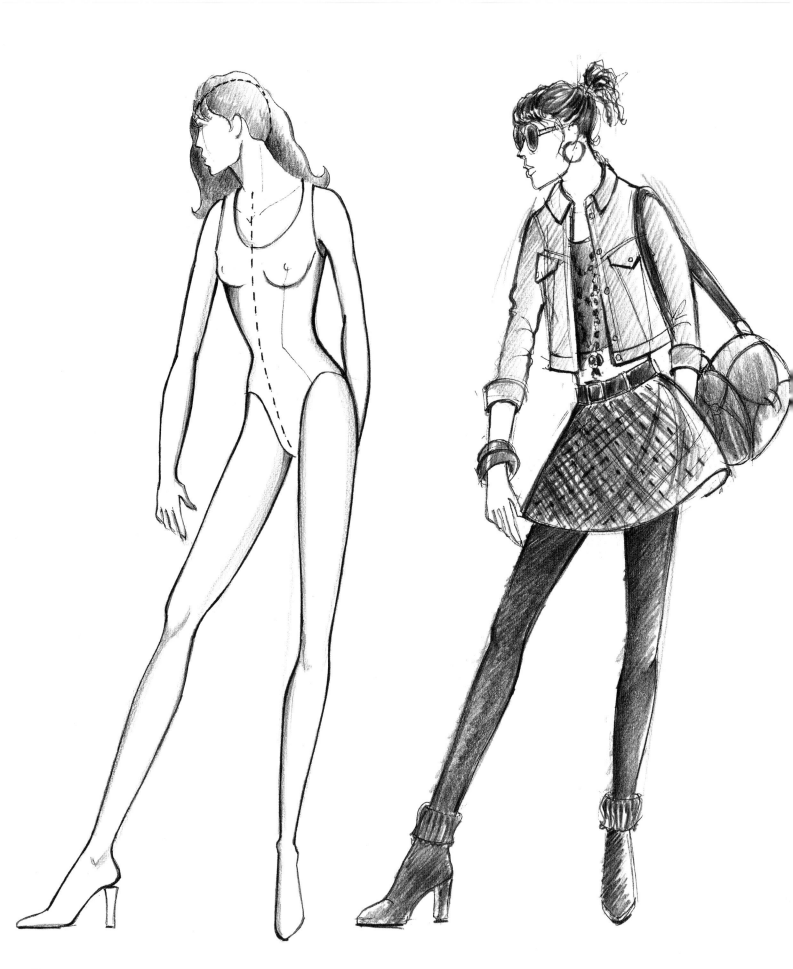

This sketch was produced
with two black drawing pens,
Staedtler Lumocolor and
triplus fineliner pen, combined
with a Letraset Promarker
cool grey pen for tonal effect.

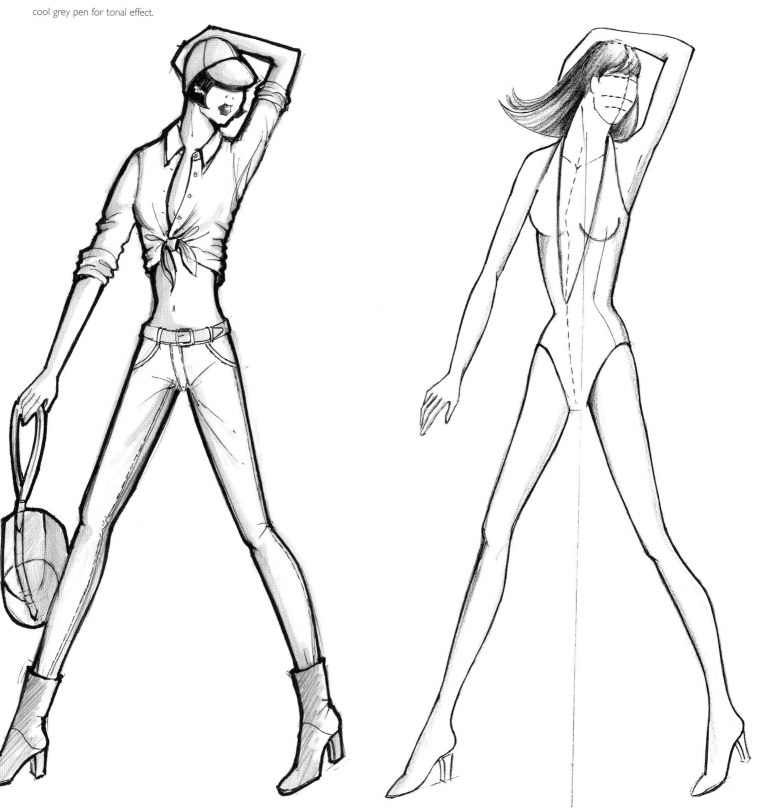

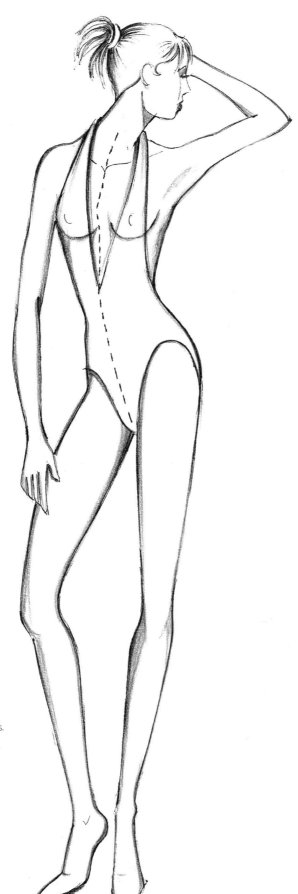

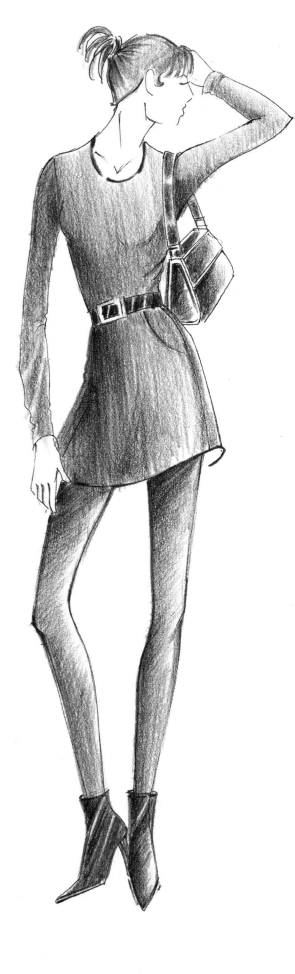

This figure template was
selected to add interest to
the simple design of the dress.
A Derwent Artist Ivory Black
pencil was used on a lightly
textured drawing paper. The
texture of the paper is used
to give the effect of shading.
Start with light pencil marks
then allow more pressure
to achieve the darker area
of shading.

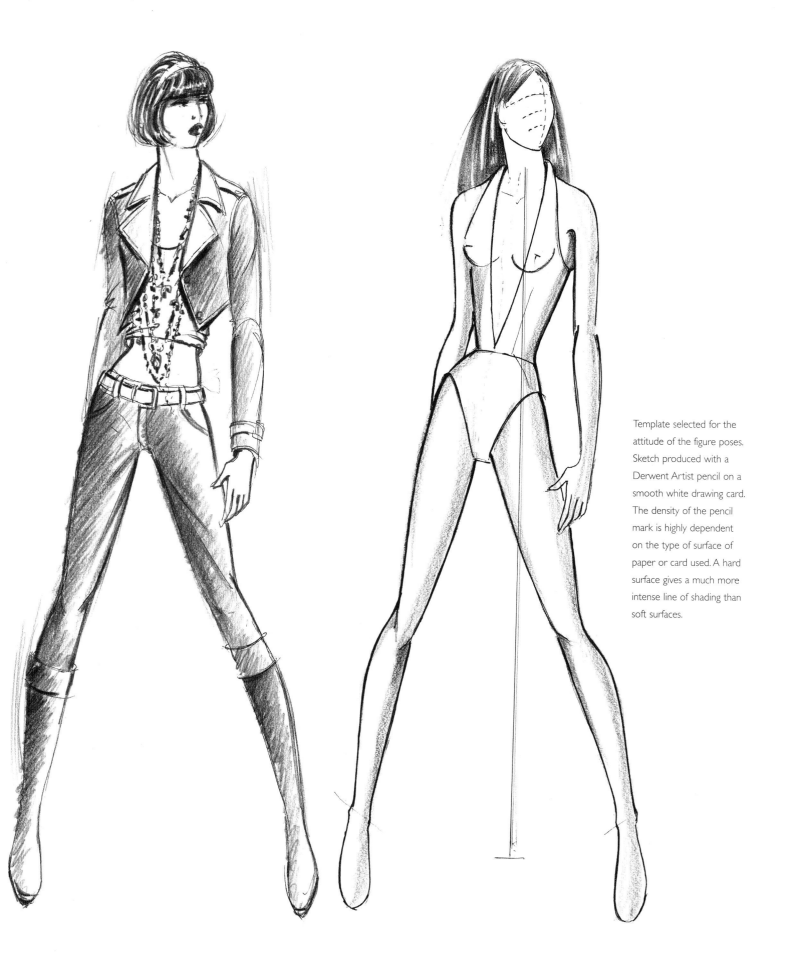

Template selected for the attitude of the figure poses. Sketch produced with a Derwent Artist pencil on a smooth white drawing card. The density of the pencil mark is highly dependent on the type of surface of paper or card used. A hard surface gives a much more intense line of shading than soft surfaces.

heads, faces and hairstyles

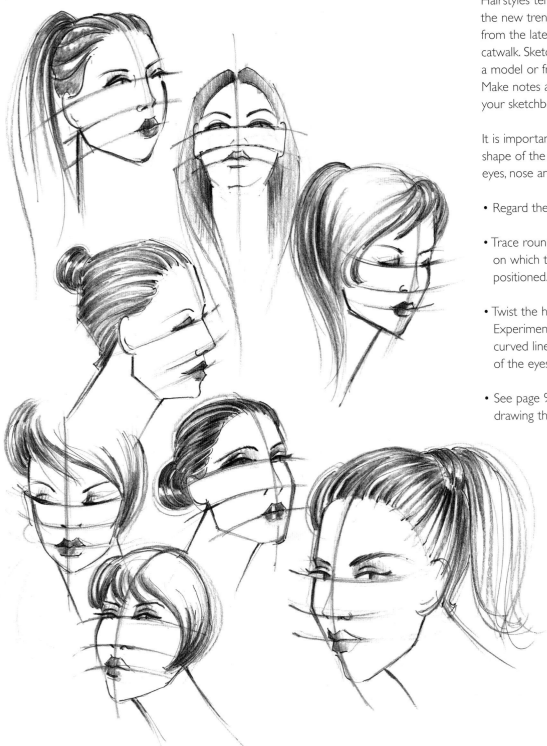

Hairstyles tend to date quickly. Observe the new trends and collect references from the latest fashion magazines and the catwalk. Sketch faces and hairstyles from a model or from magazine photographs. Make notes and observation sketches in your sketchbook for reference.

It is important to understand the basic shape of the head and the position of the eyes, nose and mouth.

• Regard the head as an egg shape.

• Trace round the head using three lines on which the eyes, nose and mouth are positioned.

• Twist the head, tilt it up and then down. Experiment with the shaping of the curved lines and observe the position of the eyes, nose and mouth.

• See page 90 for more information on drawing the head.

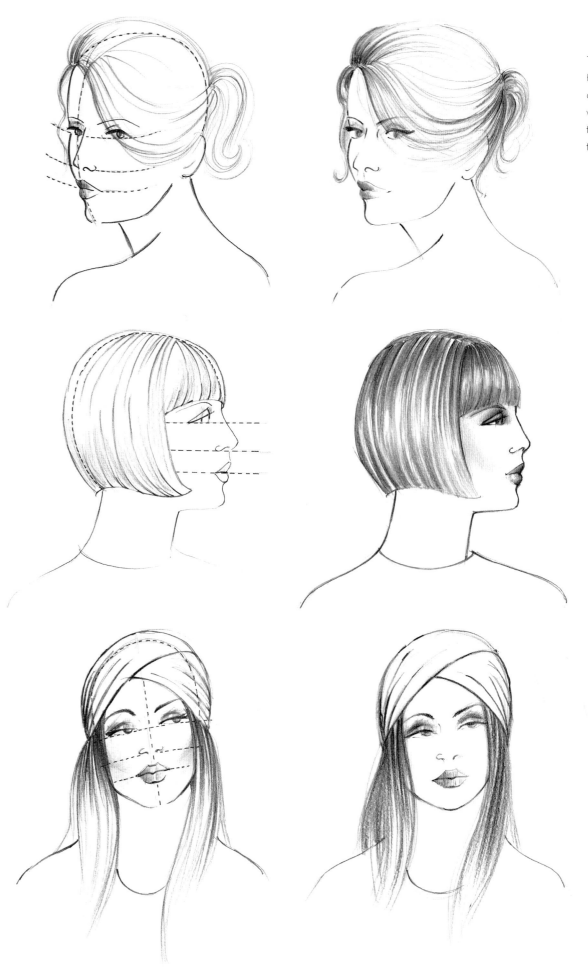

Tonal sketches of head and hairstyles sketched from different angles produced with a very soft 3B pencil for shading to HB pencil for finer detail.

Average figure proportions.
Note the positions of figure
details related to the grid.

Eyes

Nose

Mouth

Shoulders

Chest

Waist

Hips

Length of arms

Knee

Calf of leg

Ankle

menswear

PROPORTION

The height of the average male figure varies from between 7½–8 times the height of the head.

In a fashion sketch proportions are usually 8–8½ with the exaggeration on the length of the legs. Try not to over exaggerate as this may distort the proportions of the design. Extreme exaggeration is only used when promoting a strong image for presentation purposes.

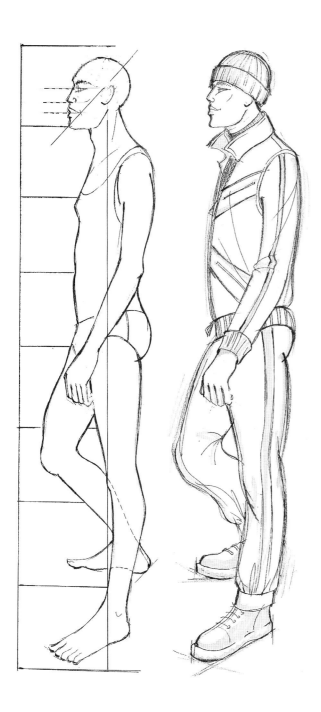

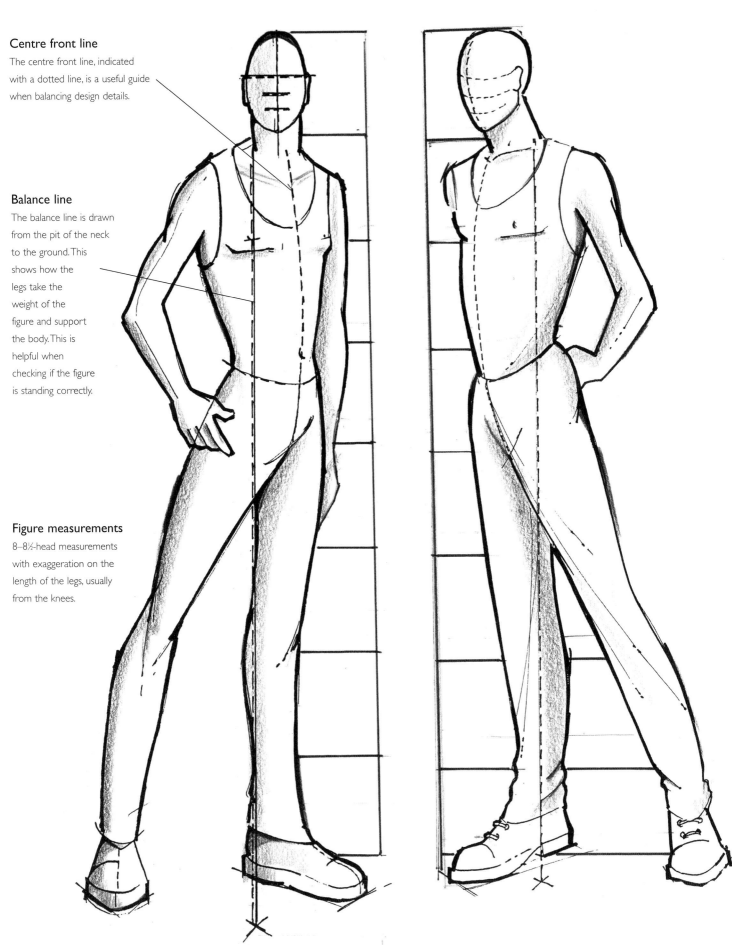

Centre front line
The centre front line, indicated with a dotted line, is a useful guide when balancing design details.

Balance line
The balance line is drawn from the pit of the neck to the ground. This shows how the legs take the weight of the figure and support the body. This is helpful when checking if the figure is standing correctly.

Figure measurements
8–8½-head measurements with exaggeration on the length of the legs, usually from the knees.

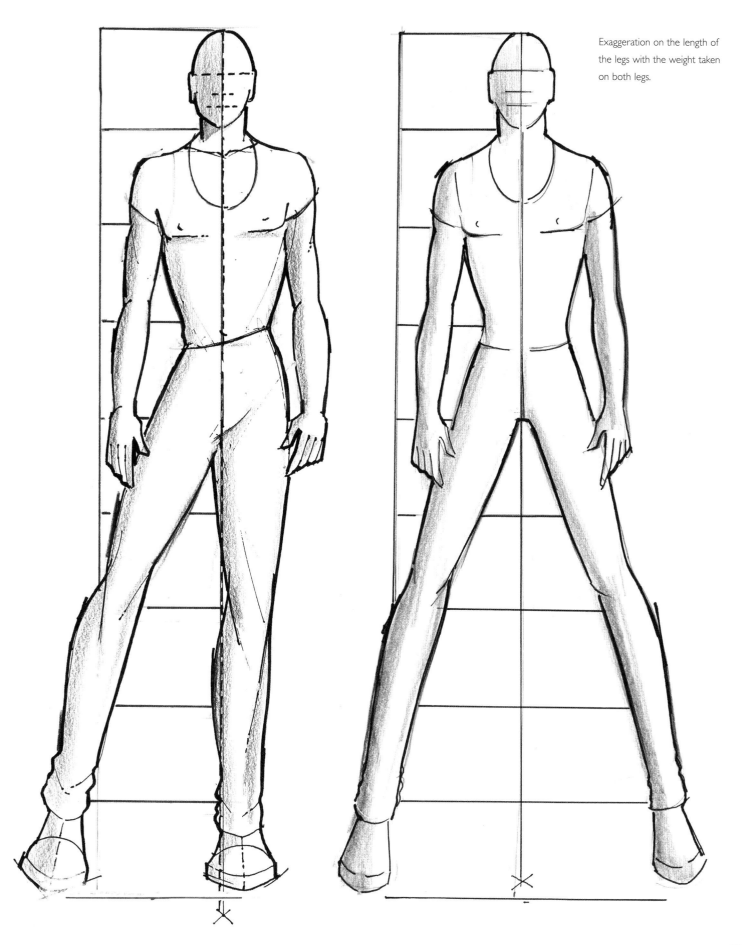

Exaggeration on the length of the legs with the weight taken on both legs.

GARMENT DETAIL

Sketches can be produced in a sketchbook for further reference.

• Remember to consider the characteristics of the fabric when sketching. A few simple lines can express the effect of soft folds or movement without going into great detail.

• These line drawings were sketched with a 2B pencil and 3B for shading. The details were added with a fine drawing pen.

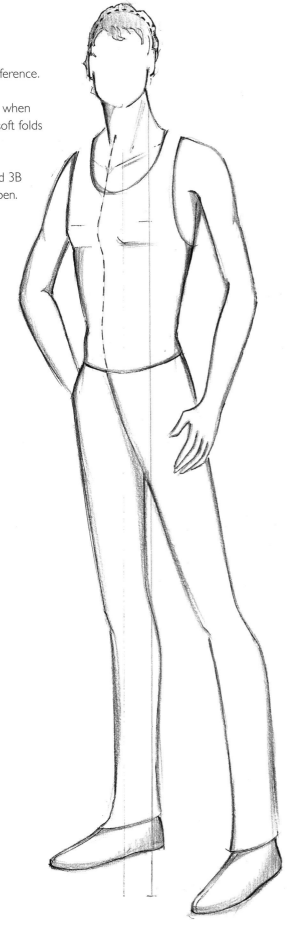

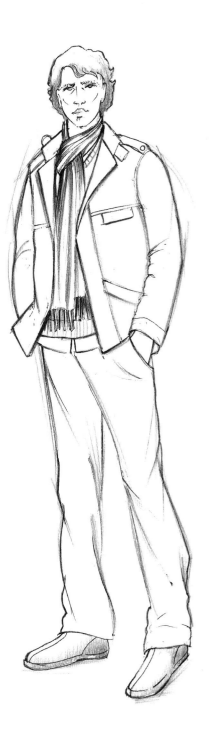

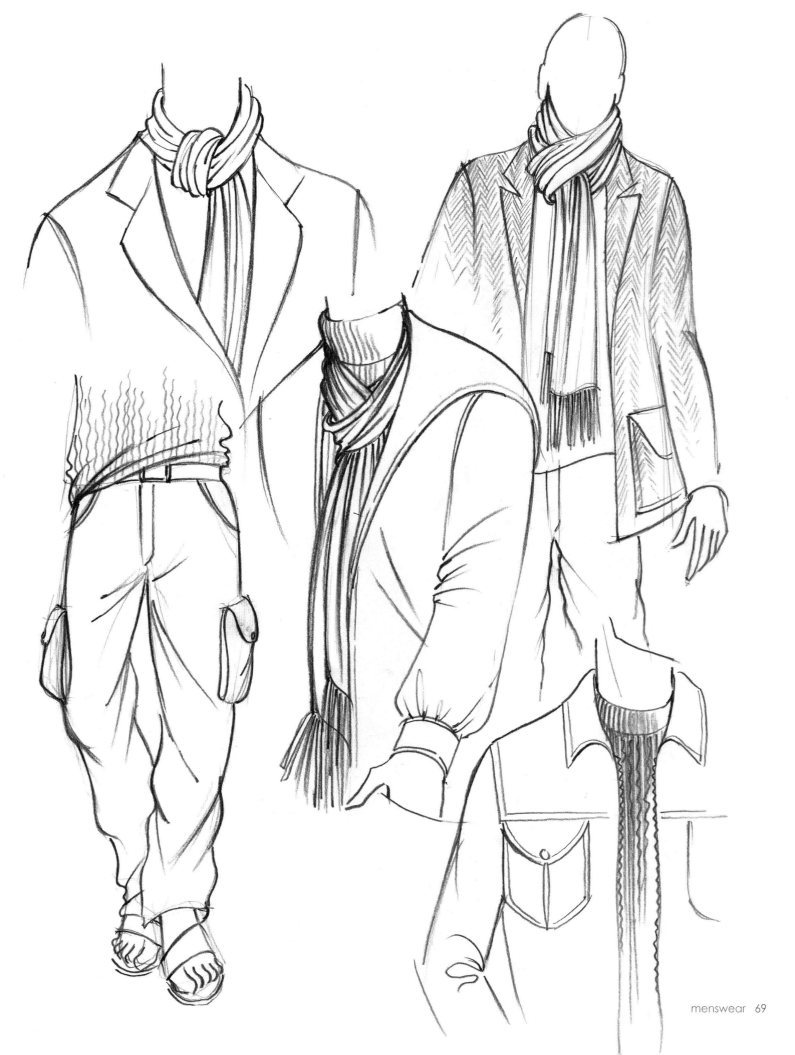

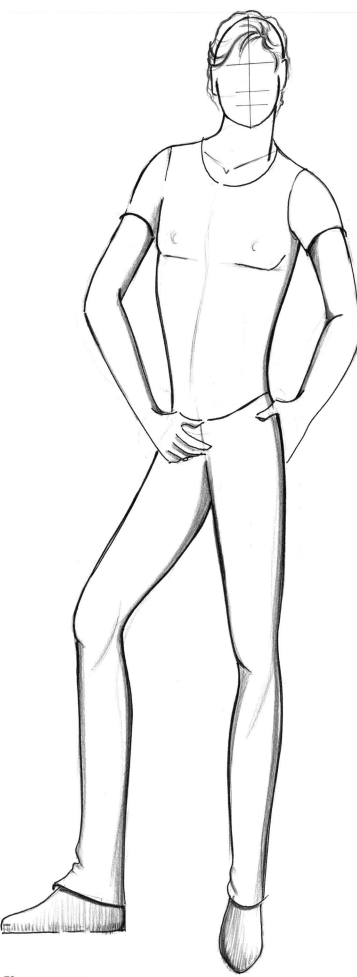

OBSERVATION DRAWING

Practise drawing details of garments by drawing from a model or working from magazine photographs. Study the details of collars, pockets or style features. Observe the behaviour of the folds and gathers of fabrics.

Note the adaptation of the figure pose on the opposite page.

- The fashion sketch should put the emphasis on the main features of the design.

- Study the cut of a garment, the placement of seams and the way in which the fabric falls when draped or gathered.

- Draw details of garments viewed from different angles: front, side, three-quarter and back views.

- Make observation sketches of belts, fastenings, pockets, pleats, collars and style features for reference.

- When presenting the design ideas in a collection, some of the designs may require a front, back and side view illustration to convey the full information of the design features.

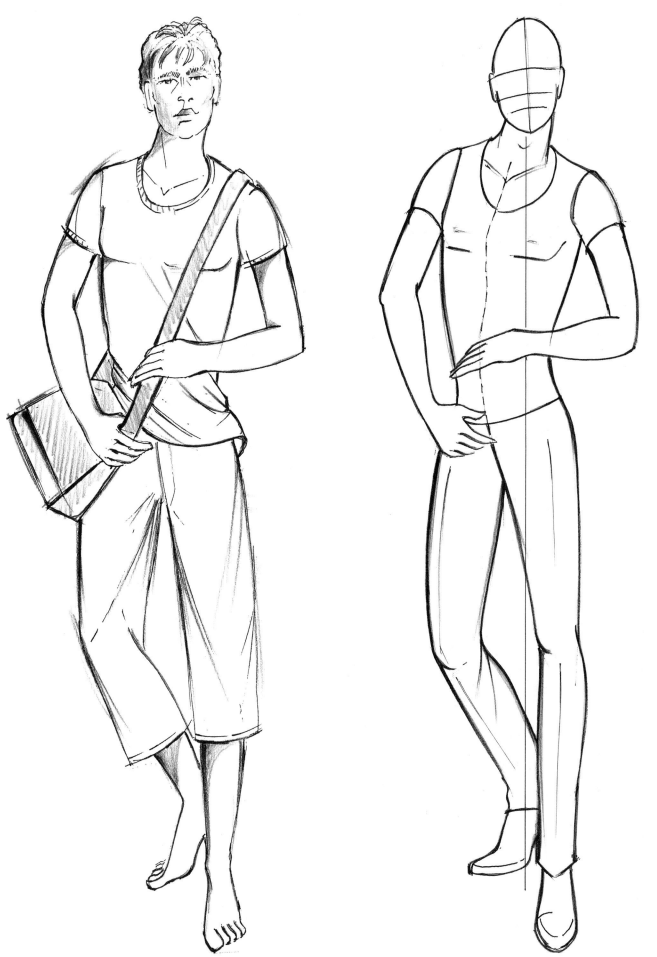

Working drawings

- Traced over on layout paper, working drawings may be used in the same way as figure templates when designing over the same basic shape.

- Clarity and accuracy is important. The drawings should convey every detail of the design.

- The working drawing may be incorporated on the presentation board or on a separate sheet of paper.

Examples of working drawings produced with a clean line presentation.

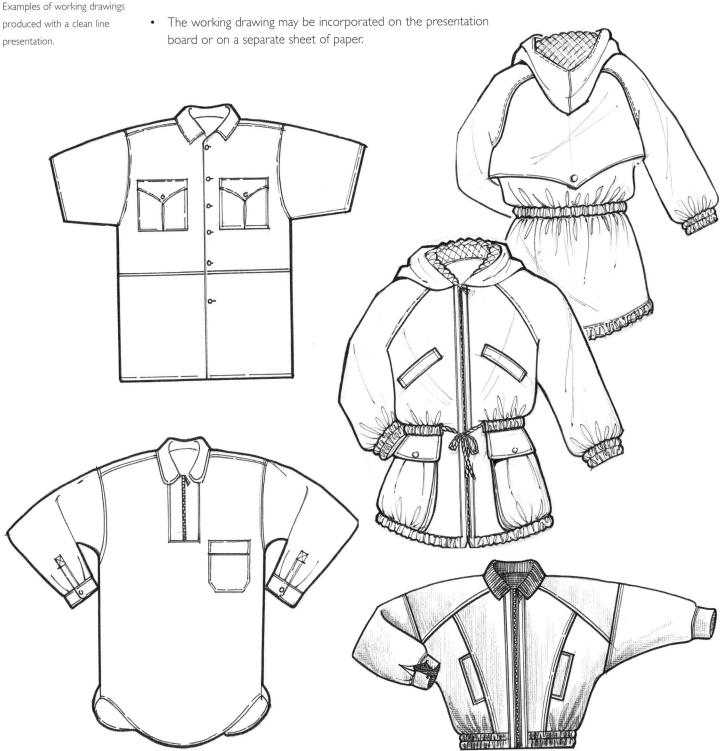

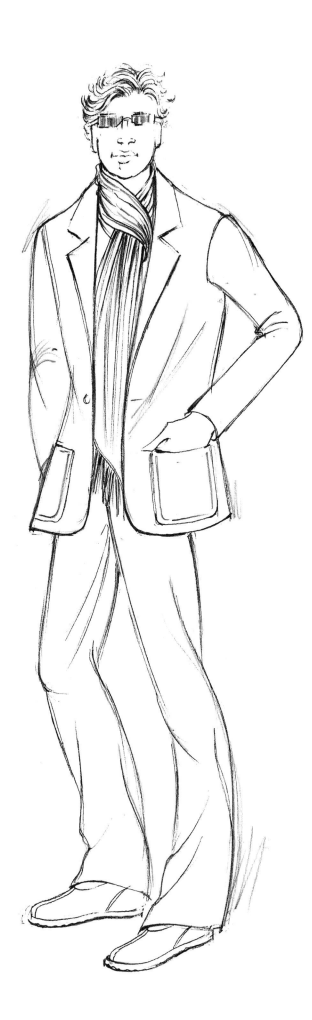

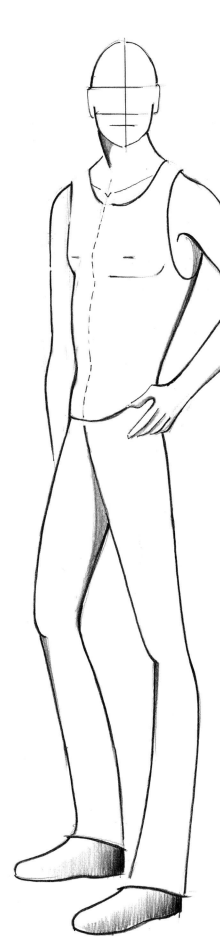

Line drawings produced with B and HB pencils, with different pressures used for details of scarf. Note the treatment of the hair using a few lines to create the style.

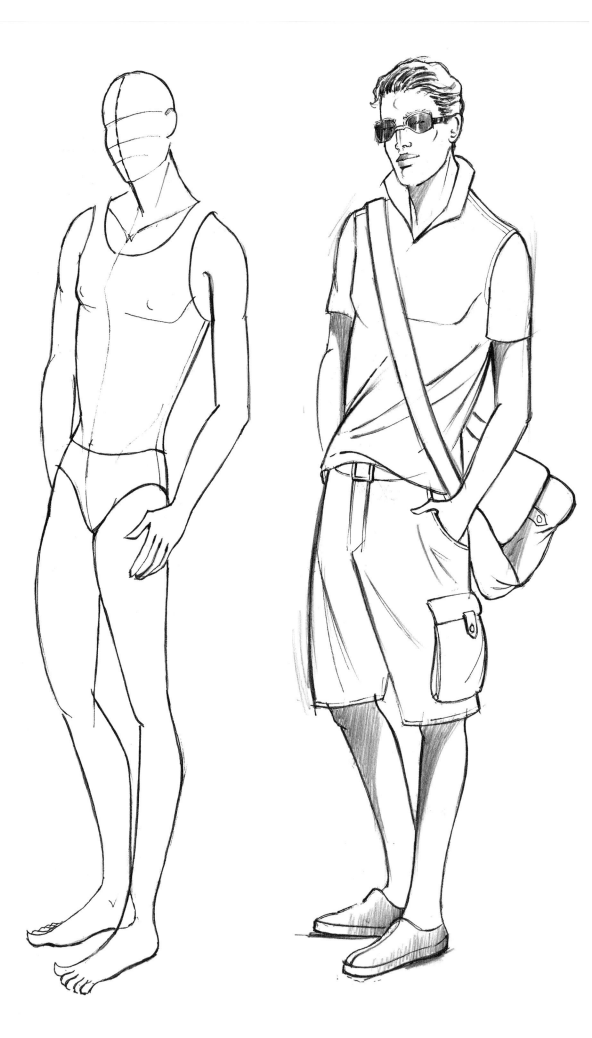

- With a few simple lines it is possible to achieve the effect of folds and loose-fitting garments without going into great detail.

- The introduction of accessories, bag, sunglasses and shoes add interest to a simple garment design for a presentation drawing.

- Keep a file of the latest fashion accessories worn.

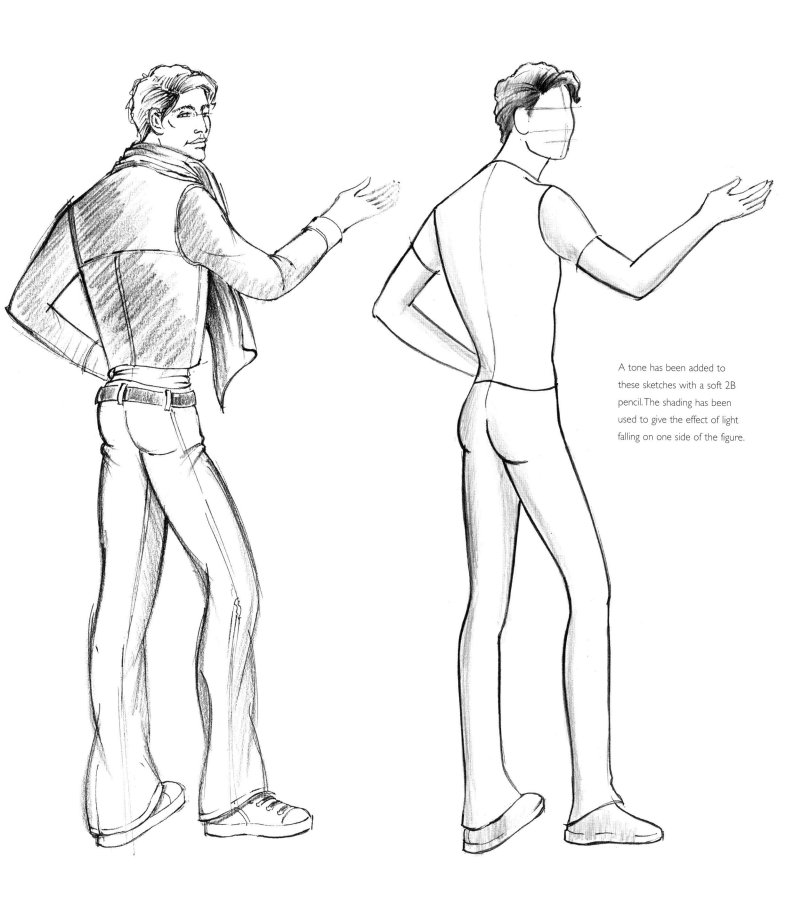

A tone has been added to these sketches with a soft 2B pencil. The shading has been used to give the effect of light falling on one side of the figure.

Sketch produced with a black
Schwan Stabilo Carbothello
pencil. Note the simple use of
line to suggest folds in the
trousers and jacket.

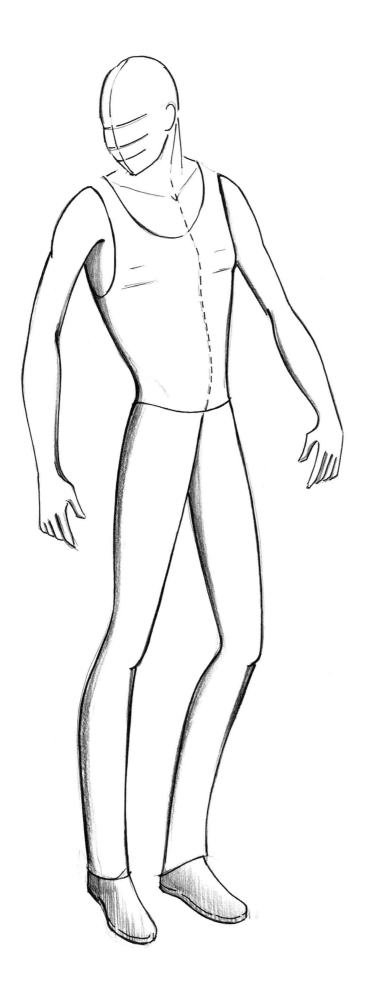

- A few selected lines will indicate a hand, foot, face or hairstyle, often more effective in a design sketch than drawing in great detail.

- Practise sketching different angles of the figure as illustrated, selecting the most suitable pose to show the main features of a design.

- Experiment with adapting the templates in this book to create your own figure images.

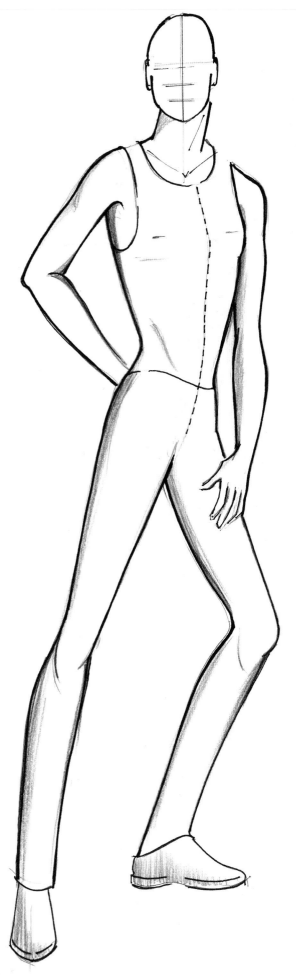

ADAPTING A POSE

Develop a number of different poses from one figure template by changing the position of the arms, angle of the head or position of the relaxed leg, leaving the other leg to take the weight of the body.

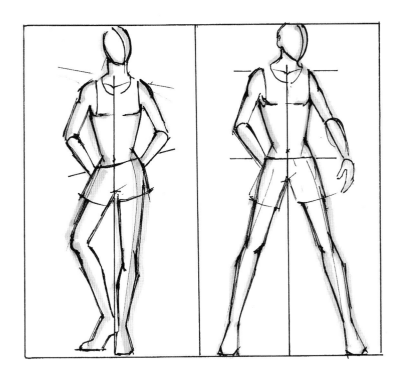

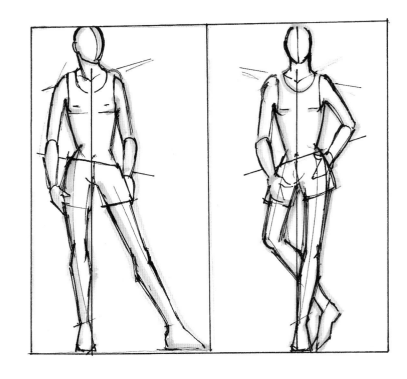

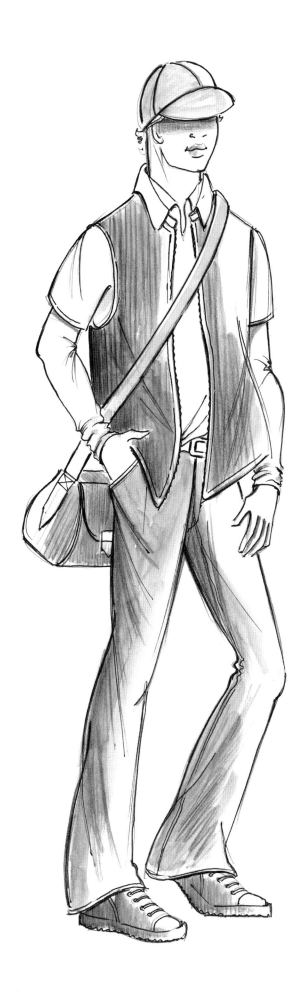
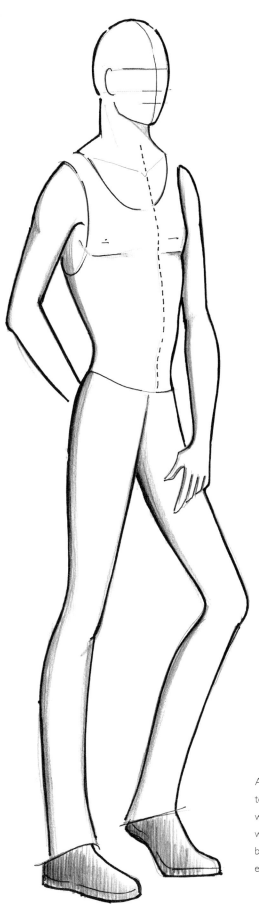

A relaxed pose has been used to illustrate a casual design. A watercolour wash combined with a black drawing pen has been used to suggest the effect of light, adding contrast.

This template has been adapted by using the same pose in a reverse position.

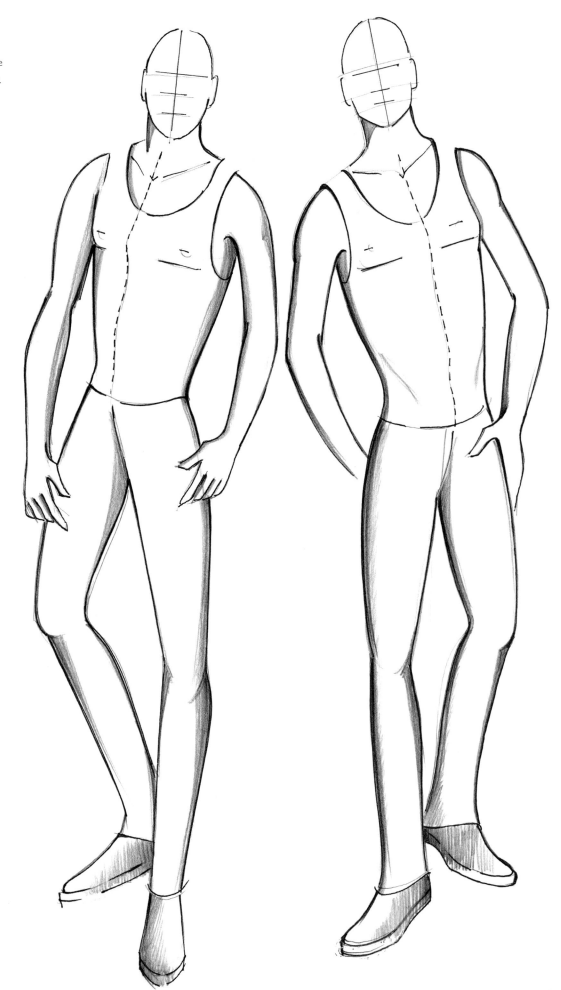

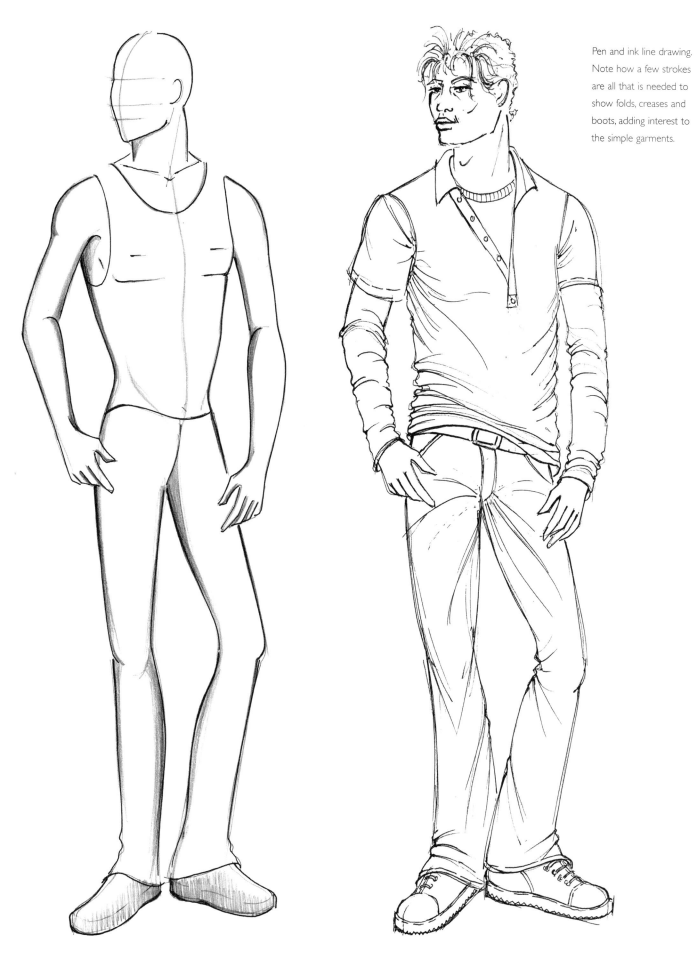

Pen and ink line drawing. Note how a few strokes are all that is needed to show folds, creases and boots, adding interest to the simple garments.

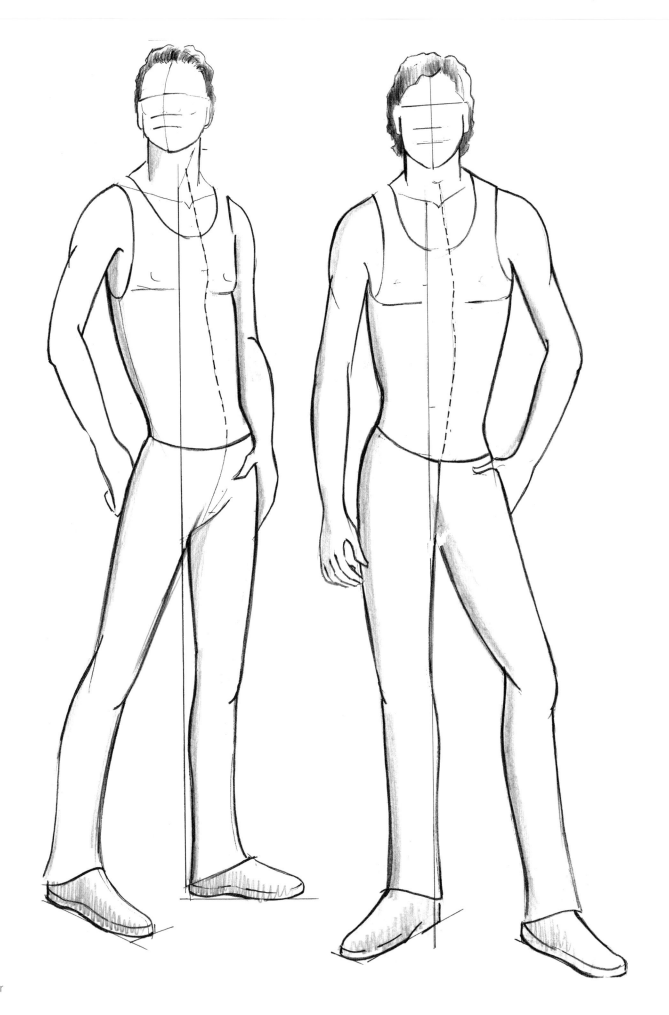

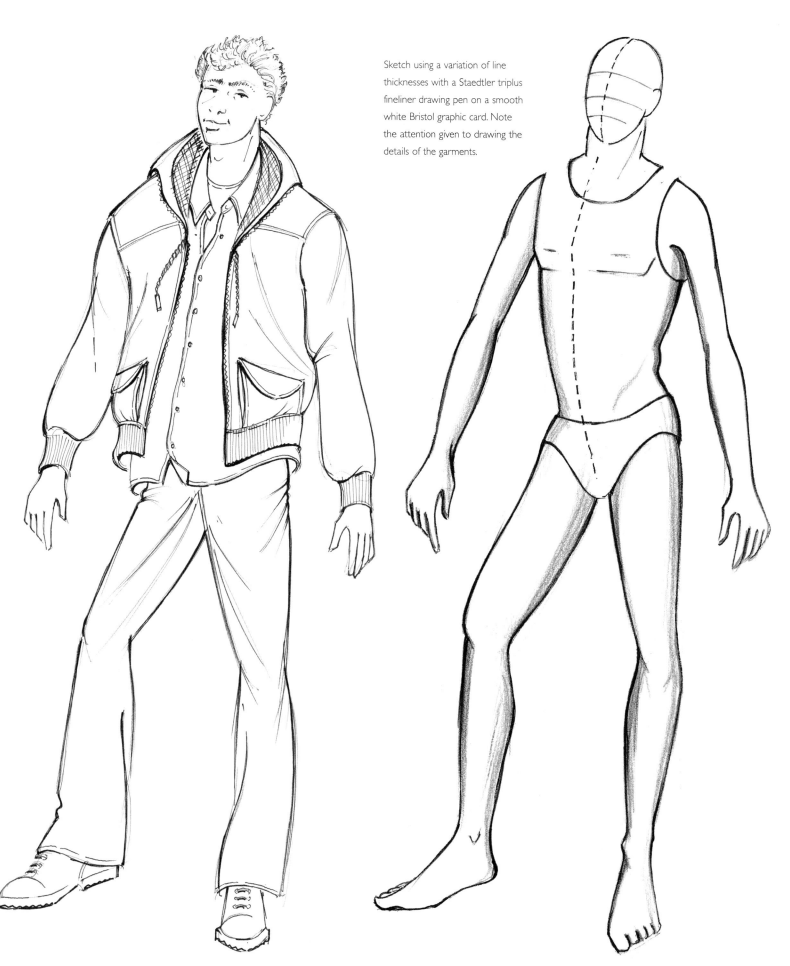

Sketch using a variation of line thicknesses with a Staedtler triplus fineliner drawing pen on a smooth white Bristol graphic card. Note the attention given to drawing the details of the garments.

Figures in movement, suitable
for sports and casualwear
designs. Pen and ink drawing
using pens of different
thickness on smooth white
drawing paper.

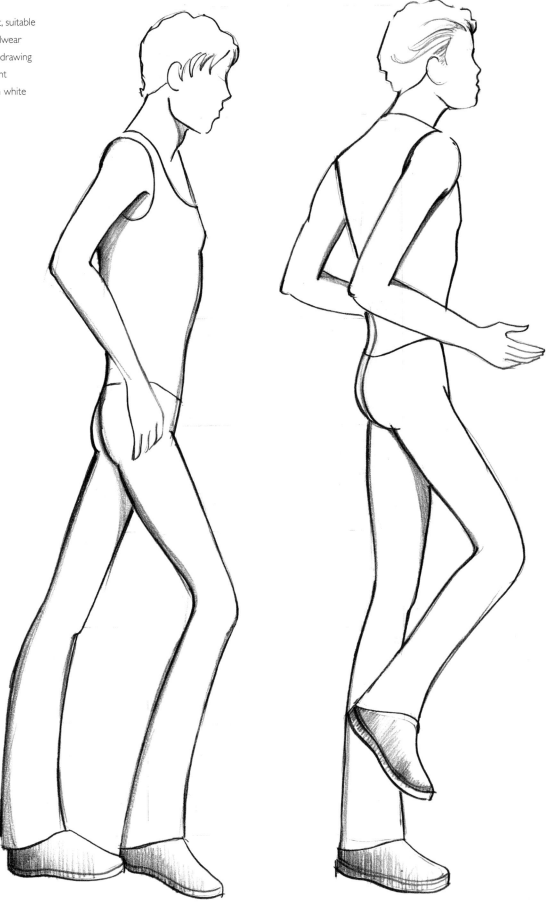

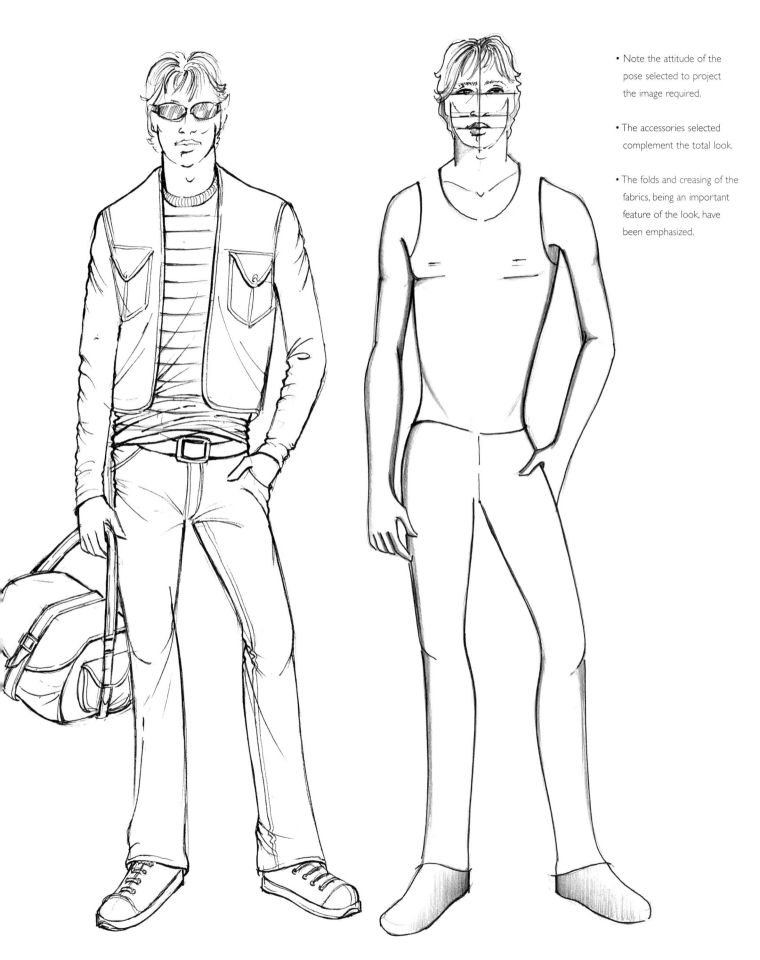

• Note the attitude of the pose selected to project the image required.

• The accessories selected complement the total look.

• The folds and creasing of the fabrics, being an important feature of the look, have been emphasized.

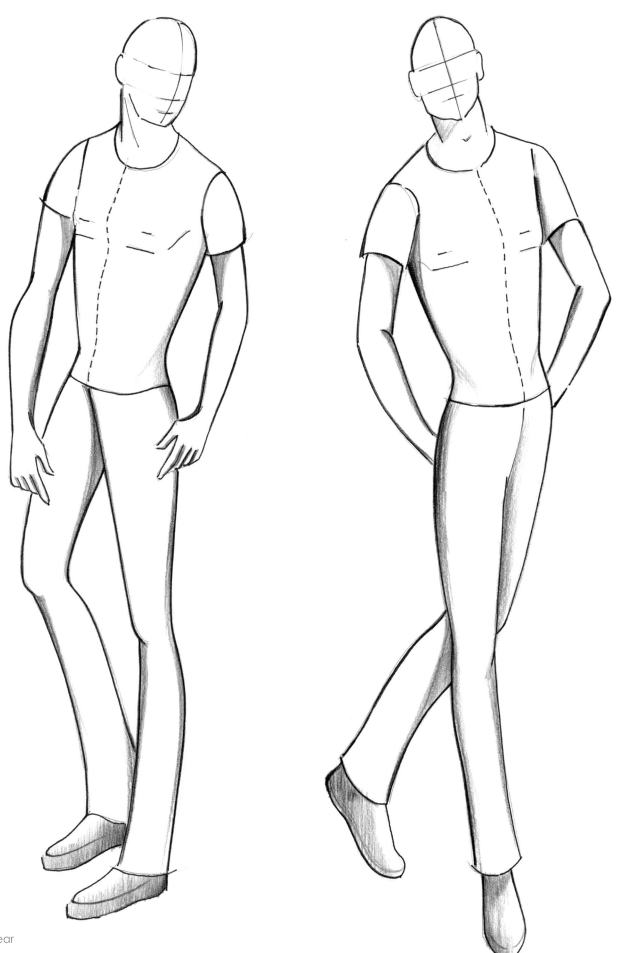

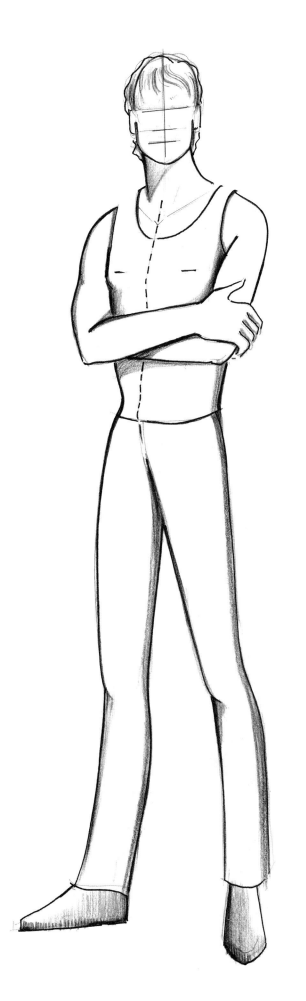
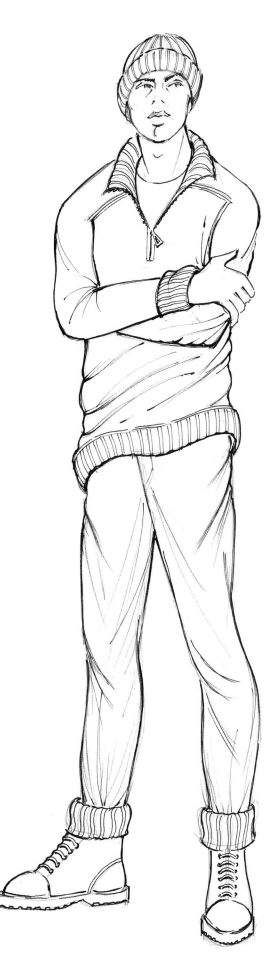

- In line work the use of pens with different line values is often made within the same drawing. This illustration is drawn with a selection of pens of different thickness on a smooth surface white drawing paper.

- Staedtler pigment liners 0.7, 0.3 and 0.05 have been used for these illustrations.

boots and shoes

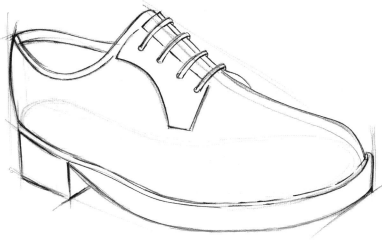

- To develop confidence in drawing shoes, make observation drawings, placing the shoes at different angles and observing their shape and general structure.

- Study new styles that will complement a fashion image.

- Keep notes in your sketchbooks, including details of shapes, stitching and decorative effects.

- Study current fashion magazines.

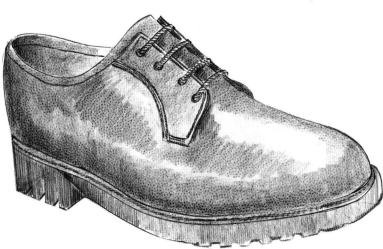

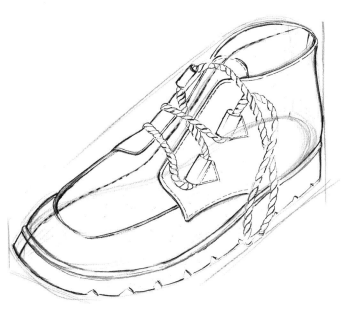

Observation drawings

The sketches were made in two stages. The basic shapes were sketched paying attention to the centre front line for balance. The sketches were then completed with style details, textures and shading.

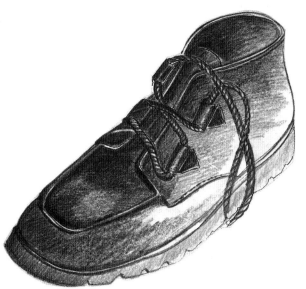

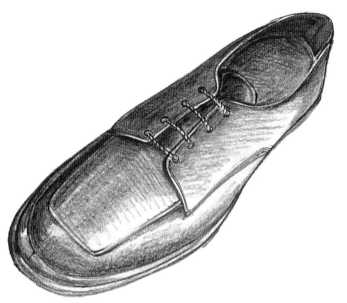

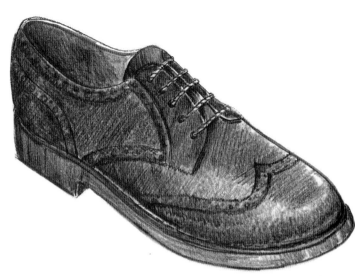

Examples of representing the shoe or boot. Usually the shoe would be simplified when producing a fashion sketch.

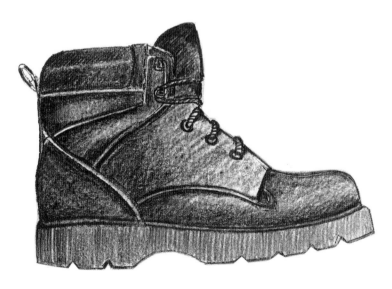

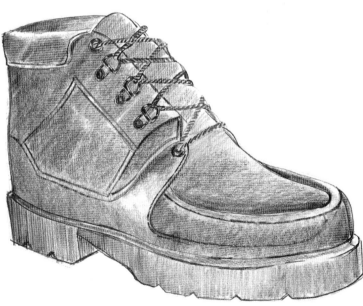

drawing the head

- Halve an oval shape vertically and horizontally. The two lower parts are again divided horizontally, providing four sections.

- The eyes are located on the centre line. The eyebrows are a quarter of the distance up from the eyes. The nose is located on the line below the centre line. The mouth is one third of the distance below the nose to the chin.

- The hairline is approximately the top quarter of the head.

- In profile, the oval is tilted and the ear is placed behind the centre line as illustrated.

- A line in front of the ear establishes the position of the jaw.

Exercise in drawing the head

Regard the head as an egg shape. Note the three lines or planes of the face, on which the eyes, nose and mouth are drawn. By changing the position of the head, the curved lines will vary in position. When the head is tilted up the lines indicating the features of the face become closer together. Correspondingly when the head is thrown back, the lines will be curved (as illustrated).

A simple interpretation of the face

Note the simple construction of the head, working with a fine lead pencil for the development of the facial features.

Note the shading on one side of the face, leaving areas of white to highlight the features.

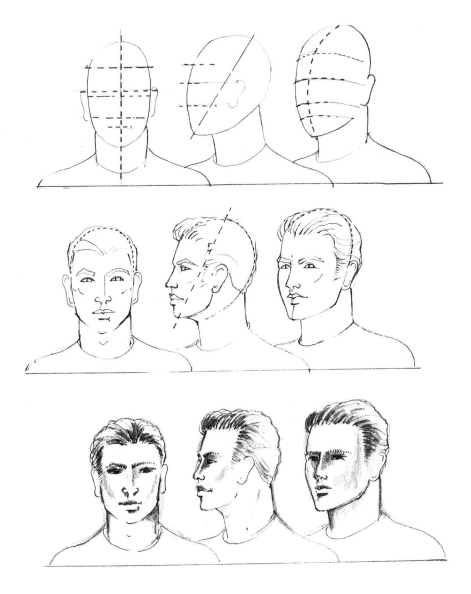

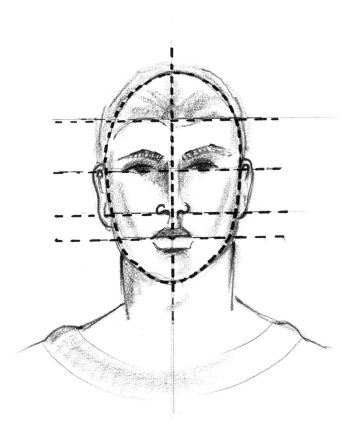

Simple interpretation of the face drawn from photographs.

• In fashion drawing facial features are often only suggested with the simplest of lines.

• Study the features from life and sketch the face from different angles.

• Practise drawing faces from life, from photographs and from the imagination.

• Note the variety in facial shapes and features.

• When illustrating design ideas, remember that the total look projected through the illustration depends on the figure's pose, face, hairstyle and accessories.

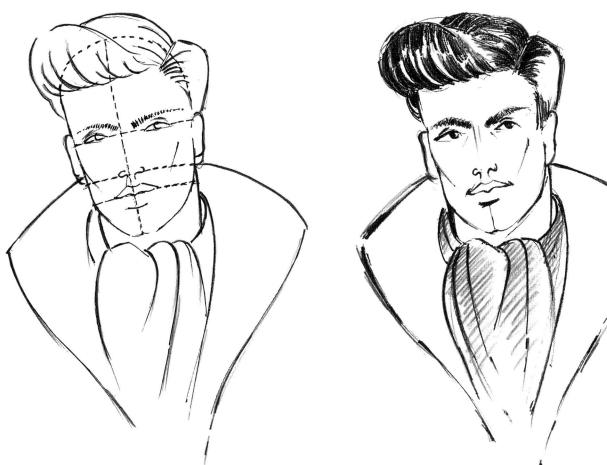

Two stages in drawing the head

HEADS AND FACES

In fashion illustration, the face, hairstyle and hat contribute to the fashion image you want to project. The face can be merely suggested using only a few lines or developed in greater detail. The style of drawing may be realistic or highly stylized depending on the image to be projected through the drawing.

Observe the latest trends and collect photograph cuttings from fashion magazines and other media and note the many variations of hairstyles and hats.

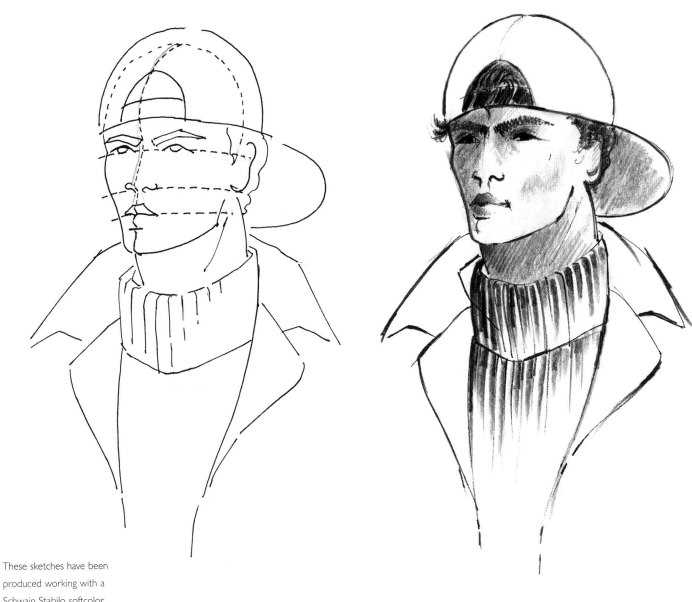

These sketches have been produced working with a Schwain Stabilo softcolor pencil on a cartridge textured paper. Note the construction of the head and the way the hats fits around the head.

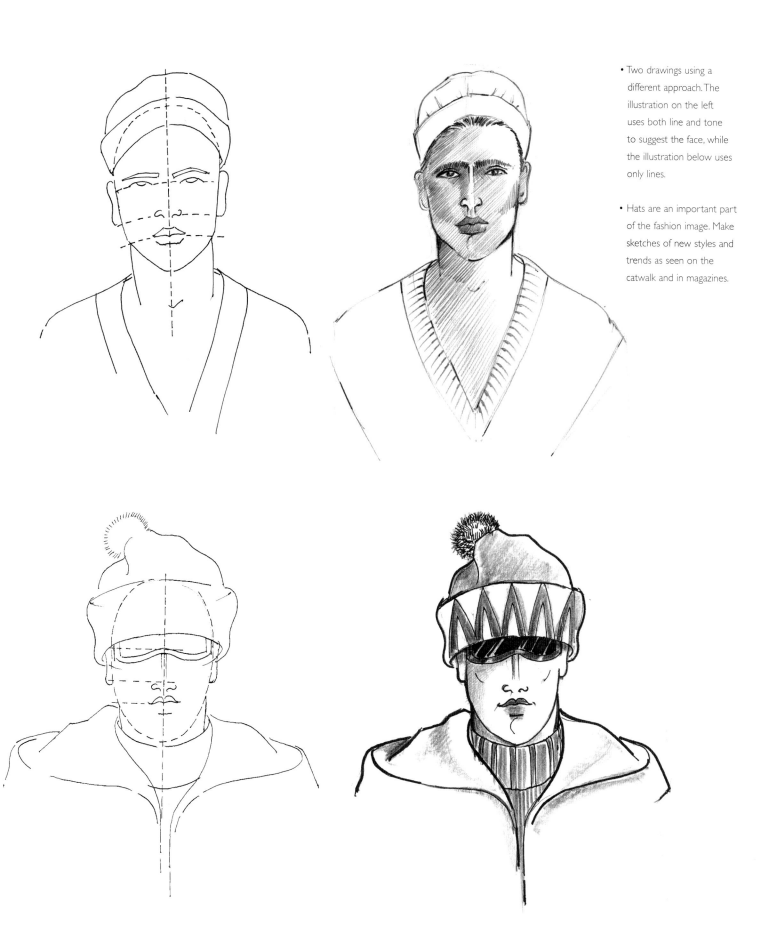

• Two drawings using a different approach. The illustration on the left uses both line and tone to suggest the face, while the illustration below uses only lines.

• Hats are an important part of the fashion image. Make sketches of new styles and trends as seen on the catwalk and in magazines.

15 years

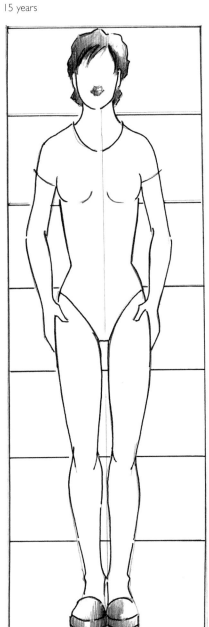

12 years

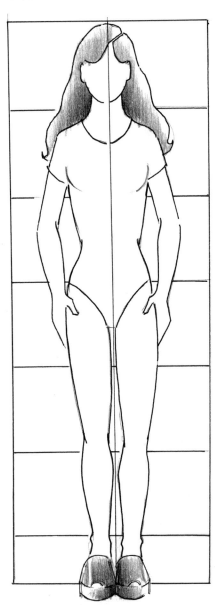

9 years

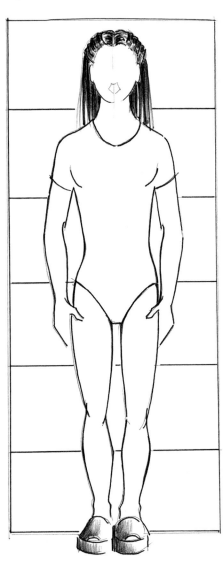

childrenswear

FIGURE PROPORTIONS FOR CHILDREN AND TEENAGERS

- A new born baby is nearly four times the height of the baby's head. The head is proportionally large with the torso being about 1½ times its size.

- During the early stages of growth the infants' limbs are proportionally short, with the upper limbs longer than the lower.

- The figure charts below illustrate the proportions of a baby to a teenager. It must be noted that these measurements are generalizations – there are many individual variations.

- When illustrating children, the proportions are often exaggerated on the length of the legs and the size of head and feet, to project a stylized image.

6 years

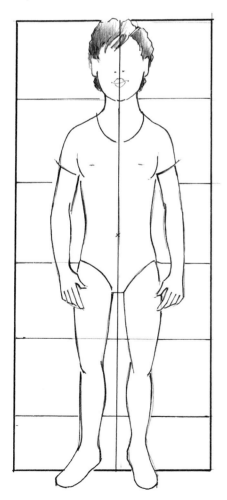

3 years

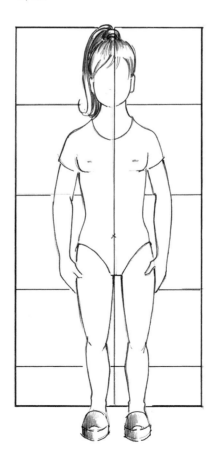

Baby

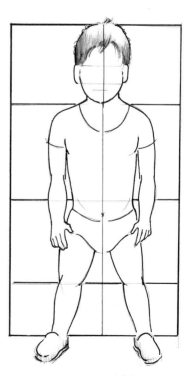

BABIES

- Practise sketching from life and keep a sketchbook for reference, observing children's and teenage attitudes. It is difficult to sketch children in a set pose as they are not patient models.

- Make use of a camera and develop new poses from the photographs you take.

- Stylized sketches of children are particularly effective when designing for the younger age groups.

- A few lines can suggest a pose reflecting the attitude of a child.

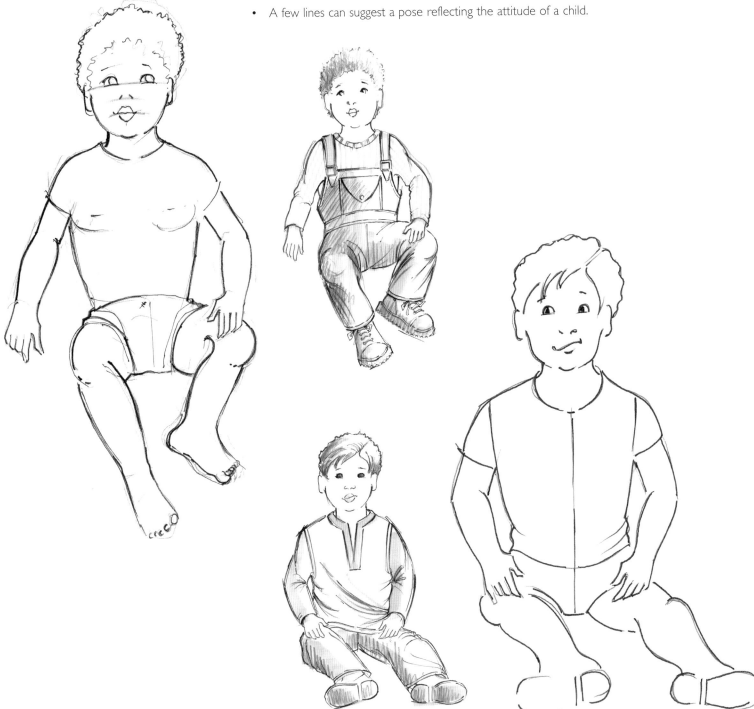

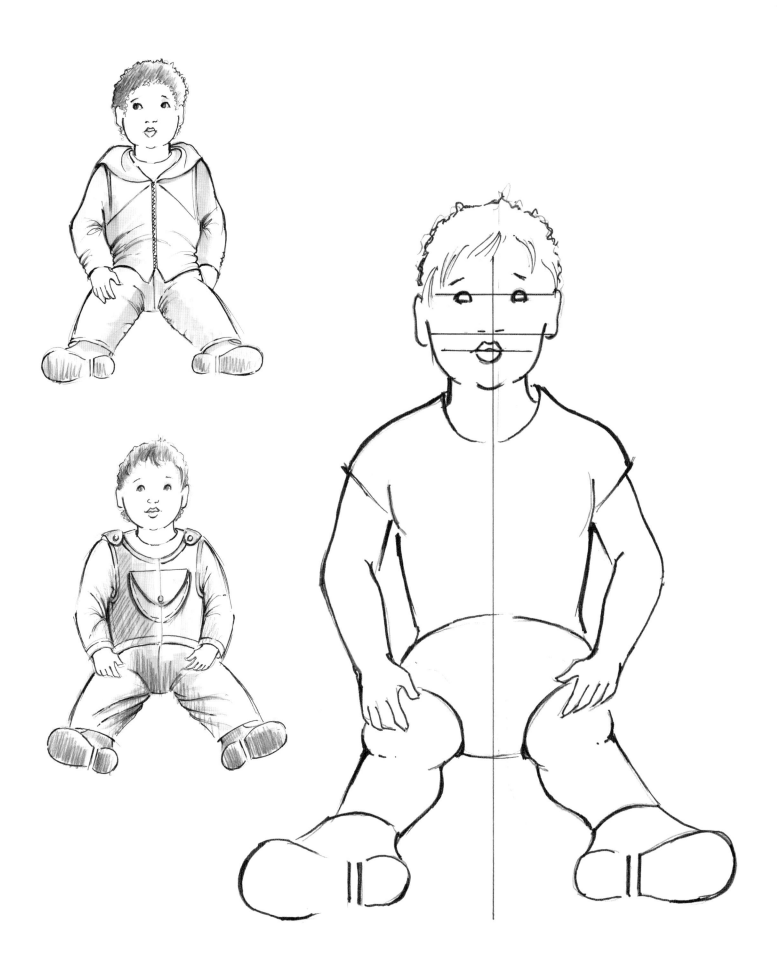

3–4 YEARS

1 Template.

2 Lightly sketched drawing.

3 Shading added using more
pressure on lthe pencil.
Fine pointed pen to add
seam details.

Sketch produced using the figure template. Note the centre front contour line of the body to balance the details in a three-quarter pose.

The figure template has been selected for the side view of the pose. It illustrates the design detail features of the hood, pockets, jacket and trousers, and also the seaming detail on the shoulder.

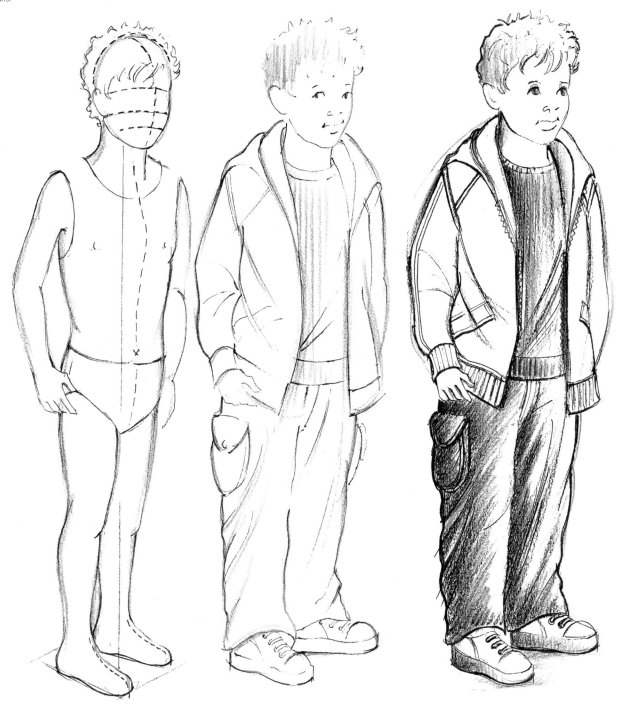

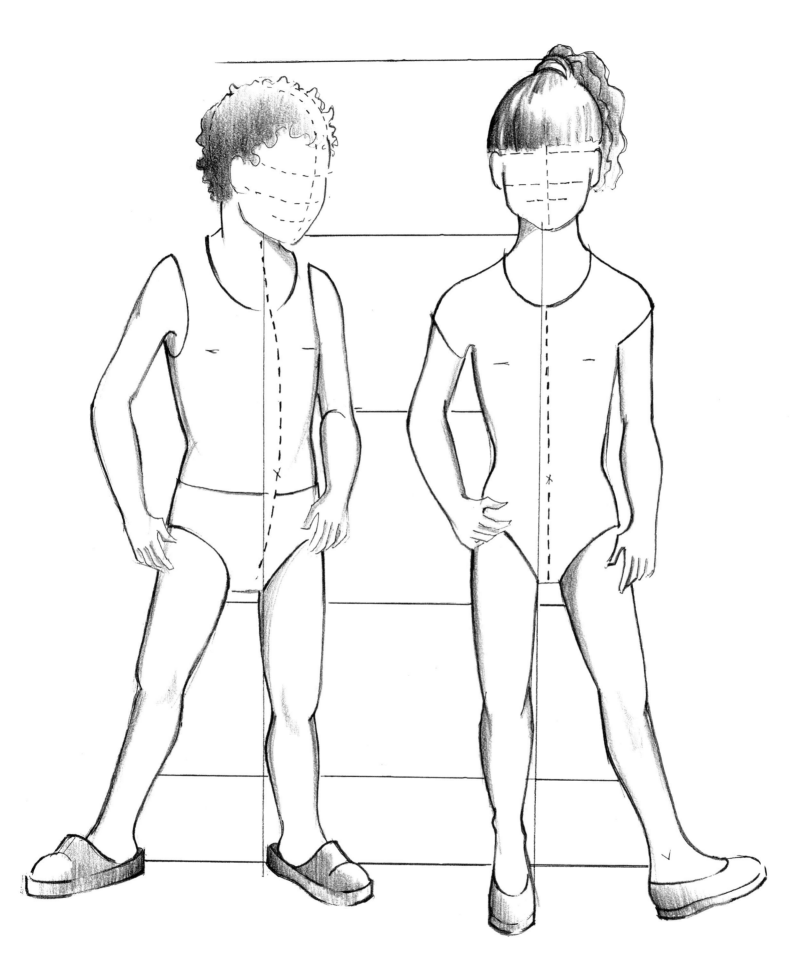

5–6 YEARS

Simple straightforward figure poses are suitable when producing roughs for a collection and developing design ideas. Work from the centre front line of the figure to balance design details.

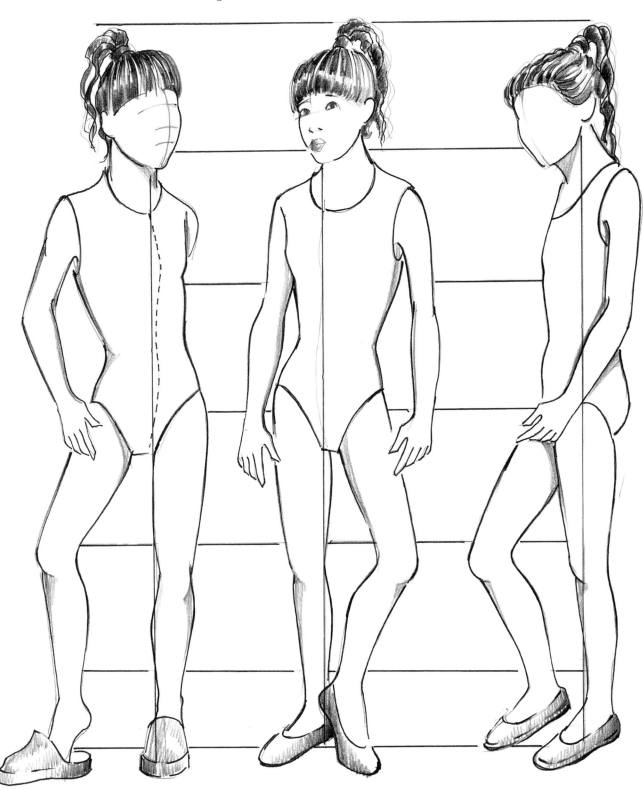

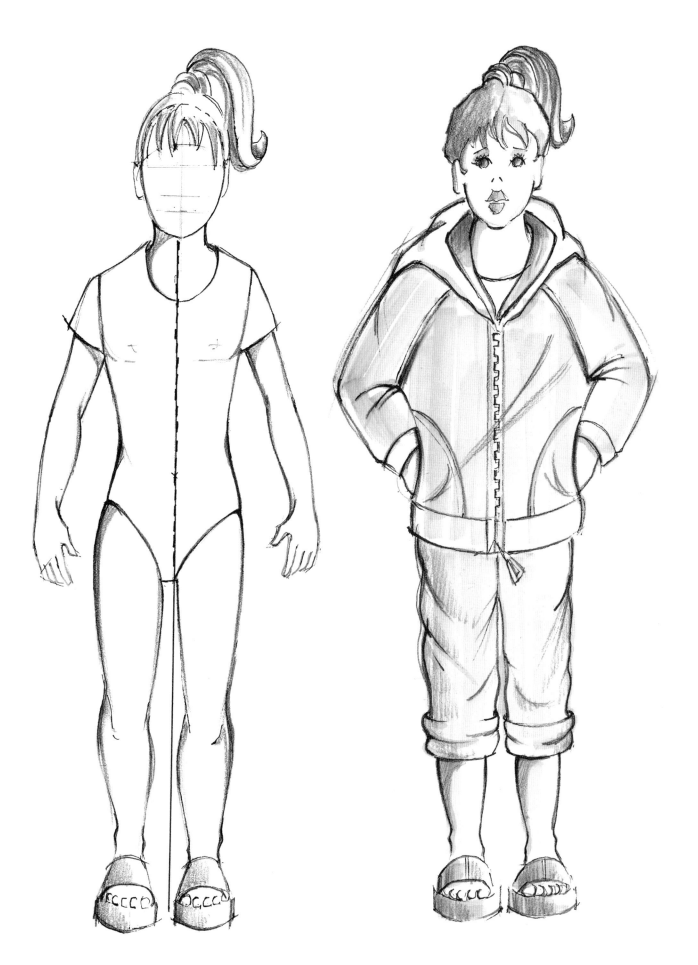

6 YEARS

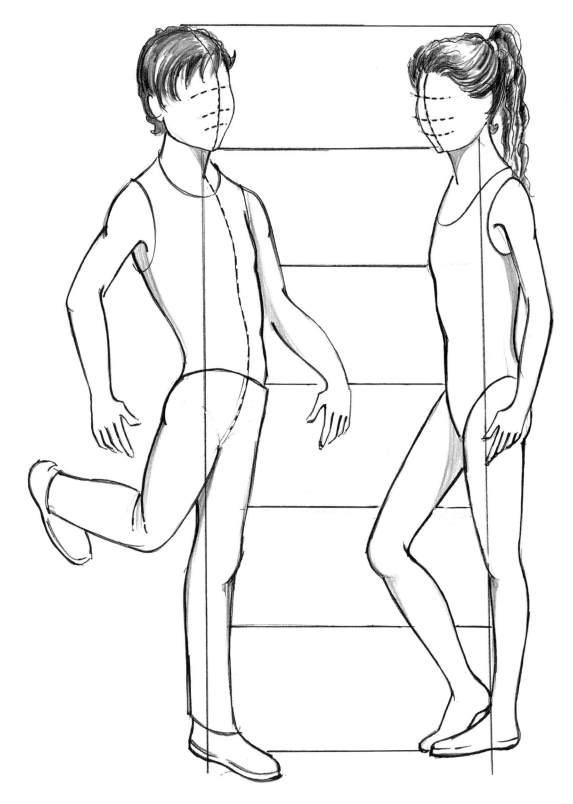

Hairstyles are an important contribution to the total image of the presentation drawing. Experiment with sketching the latest hairstyles using a few simple lines or develop them in more detail as illustrated.

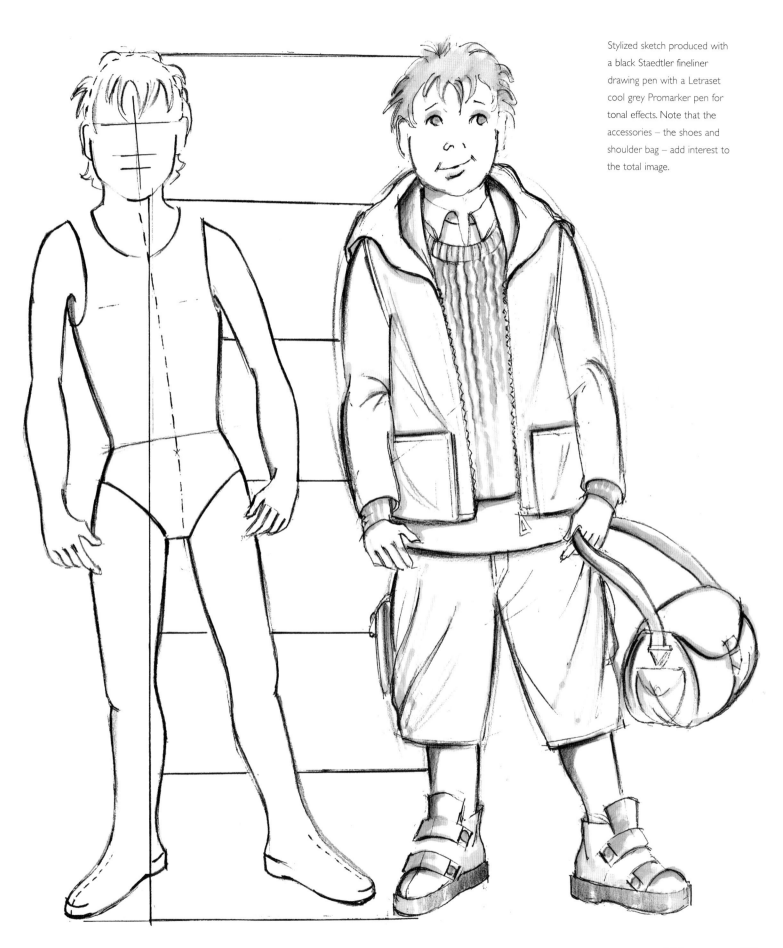

Stylized sketch produced with a black Staedtler fineliner drawing pen with a Letraset cool grey Promarker pen for tonal effects. Note that the accessories – the shoes and shoulder bag – add interest to the total image.

9 YEARS

When designing over the impression of a figure template through the paper, always sketch the garment freely round the impression to avoid a flat effect (as illustrated).

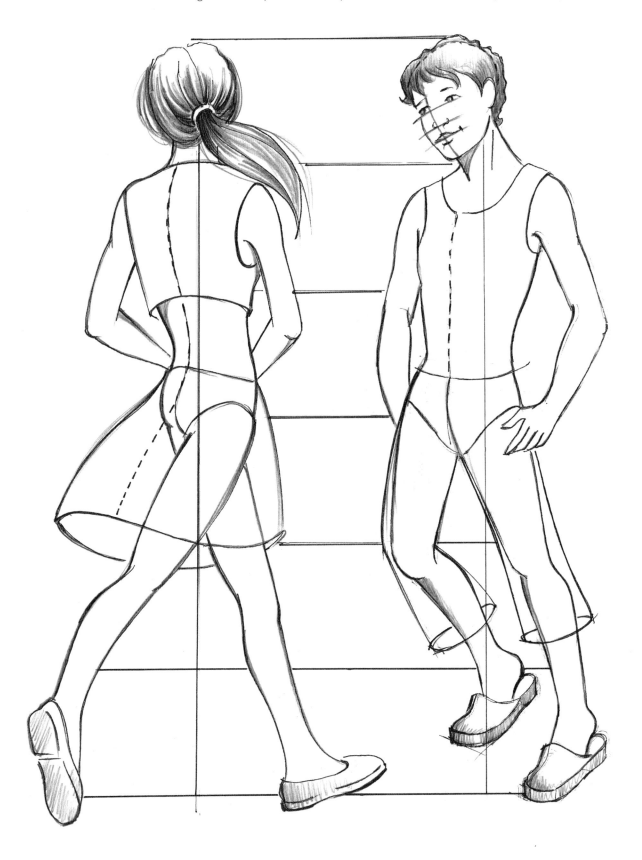

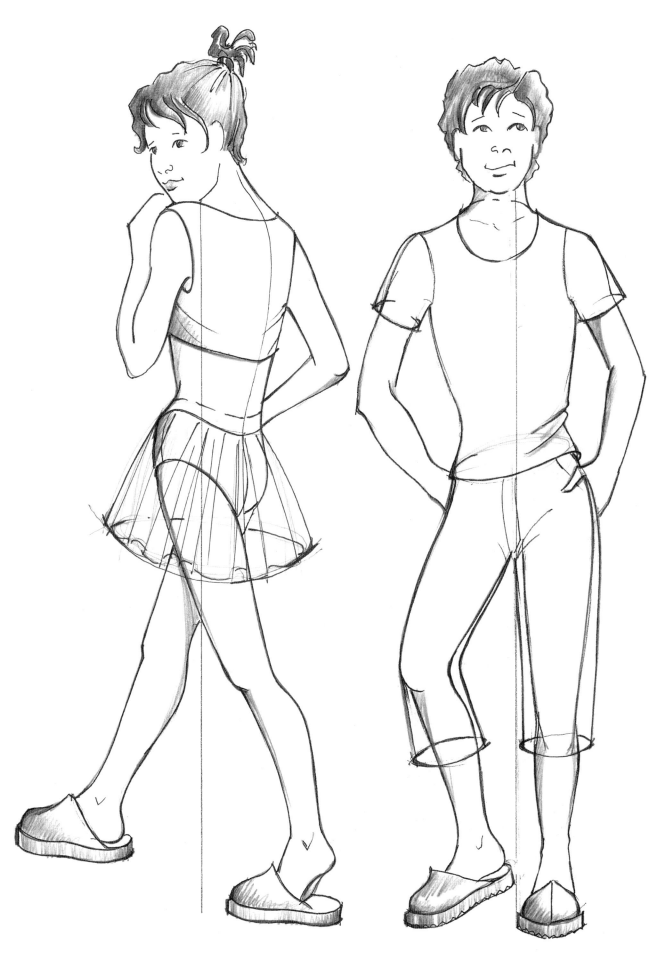

Stylized figures front and back views

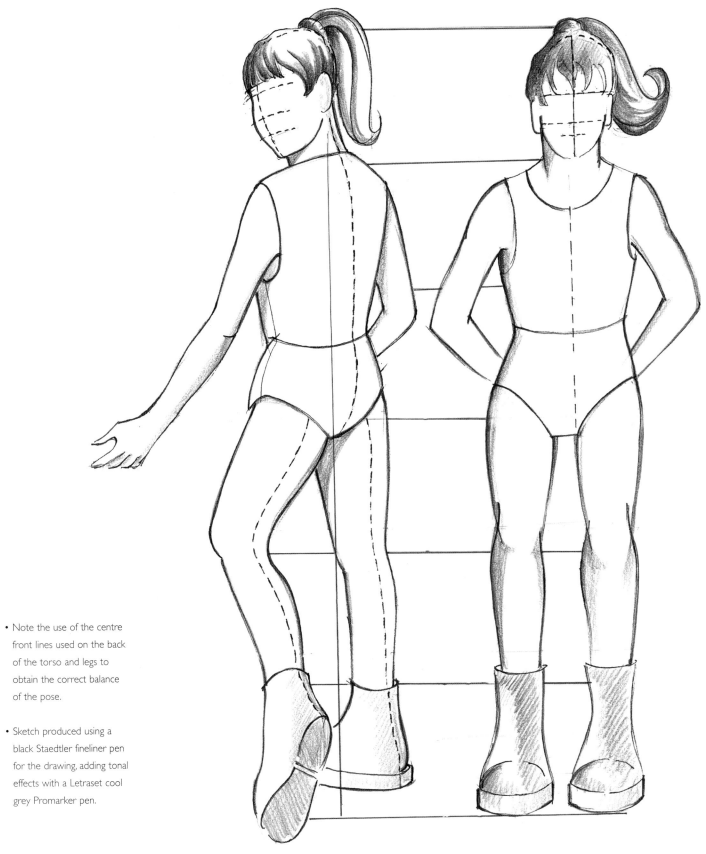

• Note the use of the centre front lines used on the back of the torso and legs to obtain the correct balance of the pose.

• Sketch produced using a black Staedtler fineliner pen for the drawing, adding tonal effects with a Letraset cool grey Promarker pen.

Note the simple indication of the hairstyle using only a few lines with tone added. The suggestion of tights and fur boots is achieved using tone.

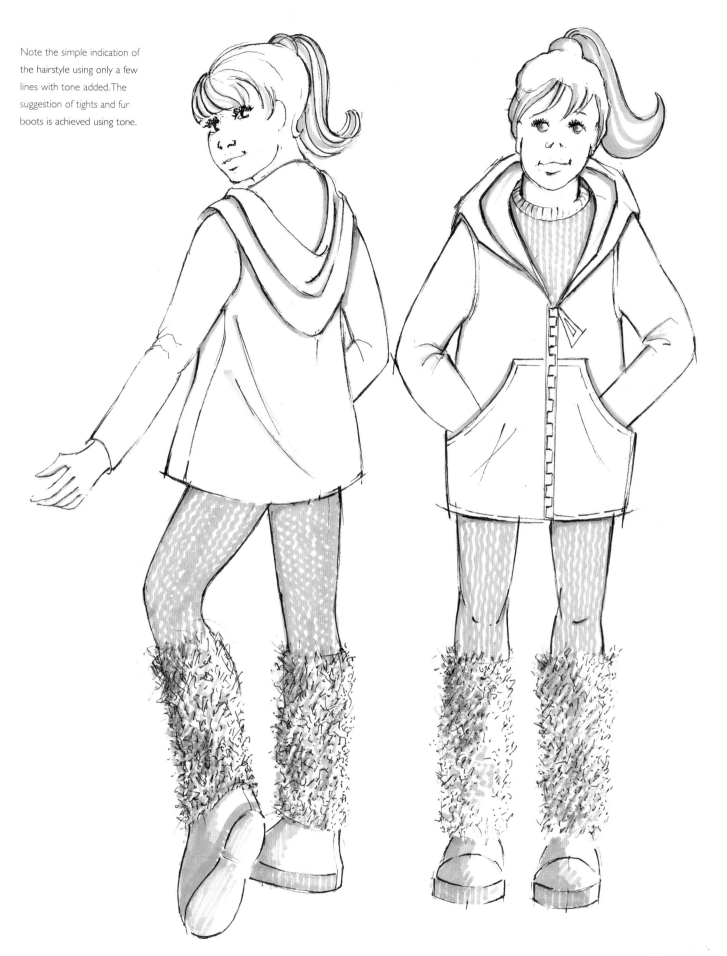

12–13 YEARS

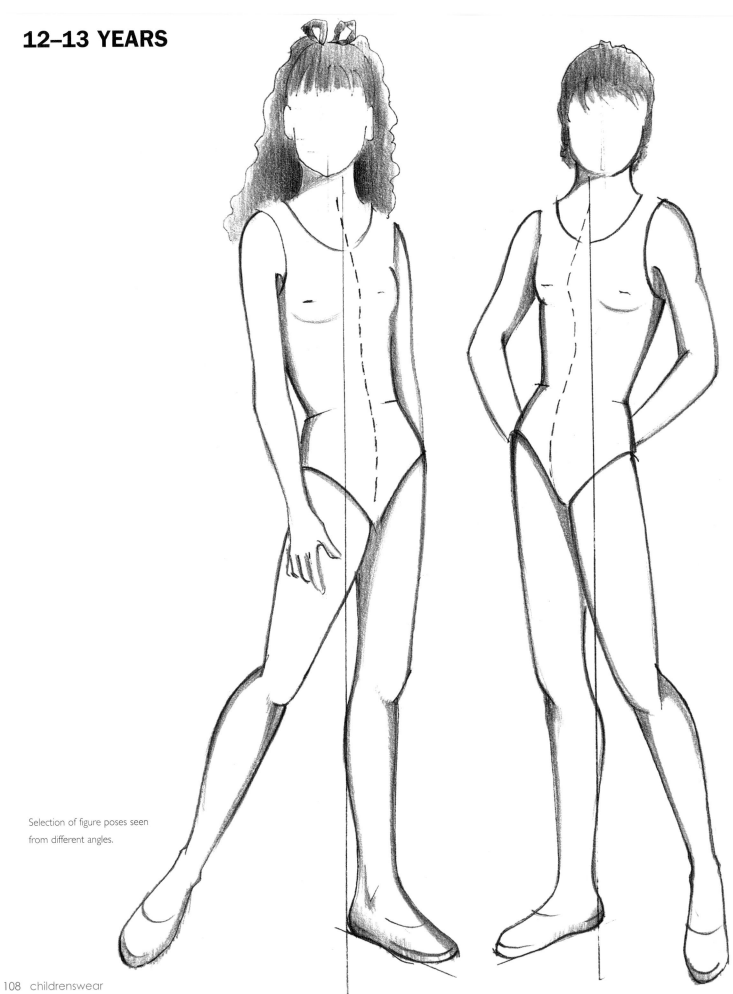

Selection of figure poses seen from different angles.

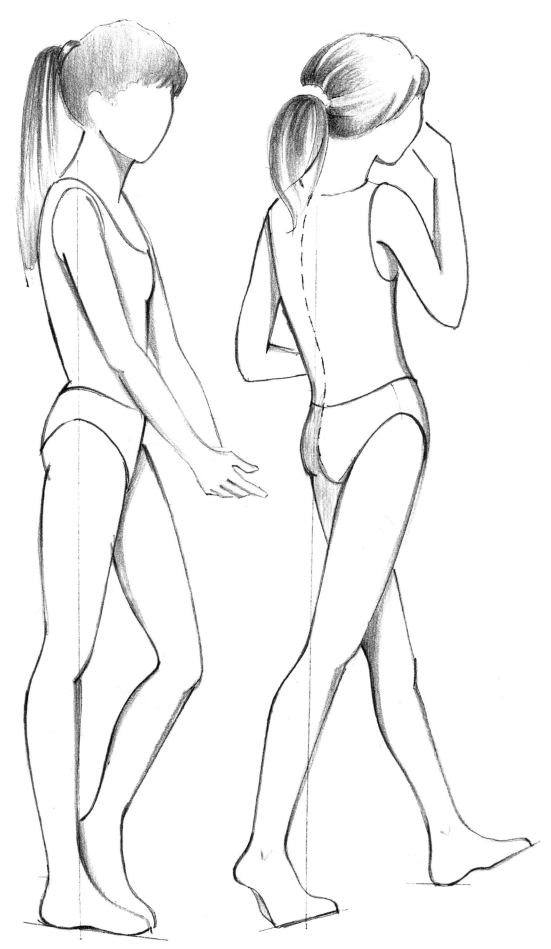

14–16 YEARS

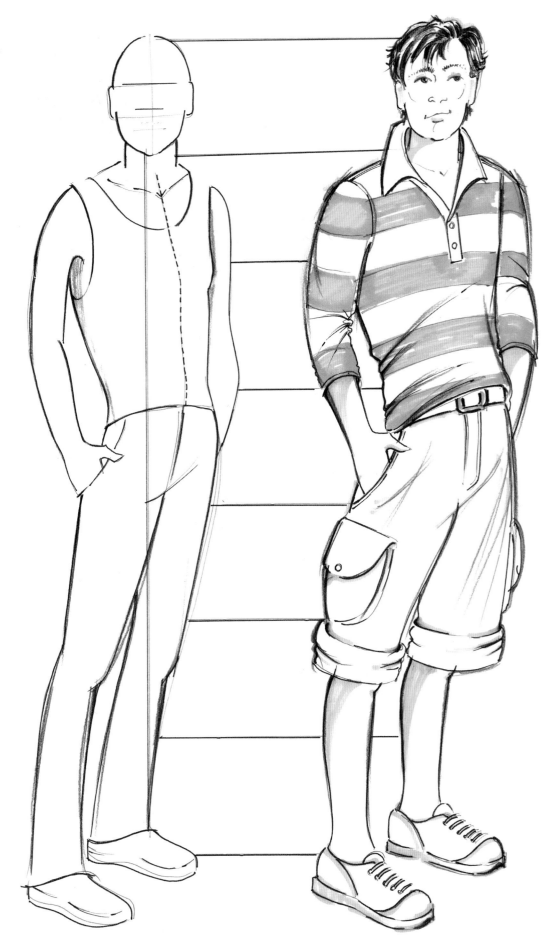

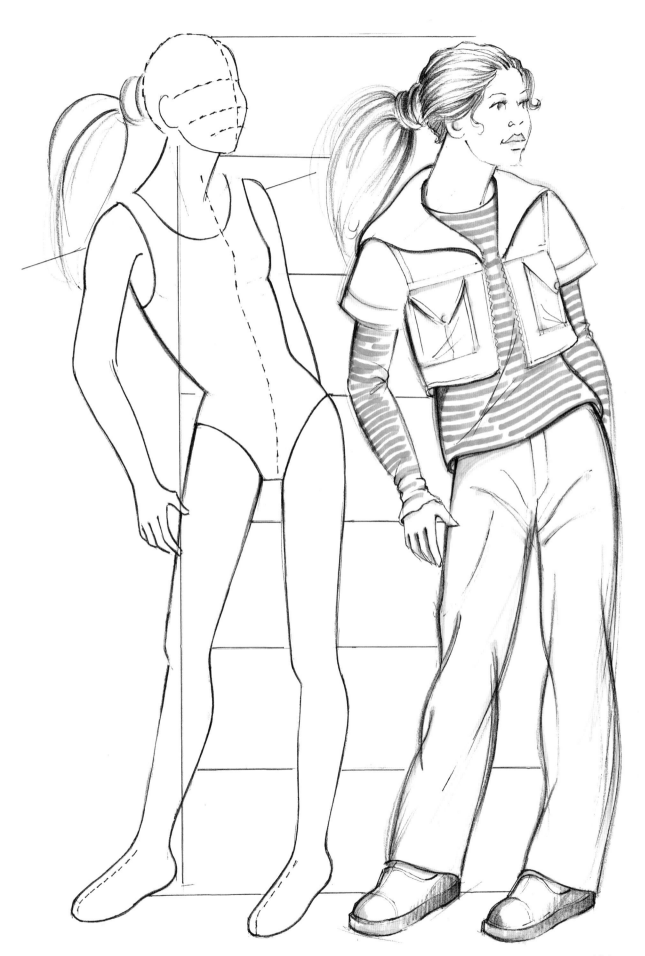

children's heads and hats

It is helpful to work from photographs when a model is not available. Select faces of different age groups from photographs you have taken or from magazines.

For fashion sketches you should stylize and simplify the drawings. Adapt the features and hairstyles to gain the effect you require. A few lines to suggest the hair and features of the face can be most effective.

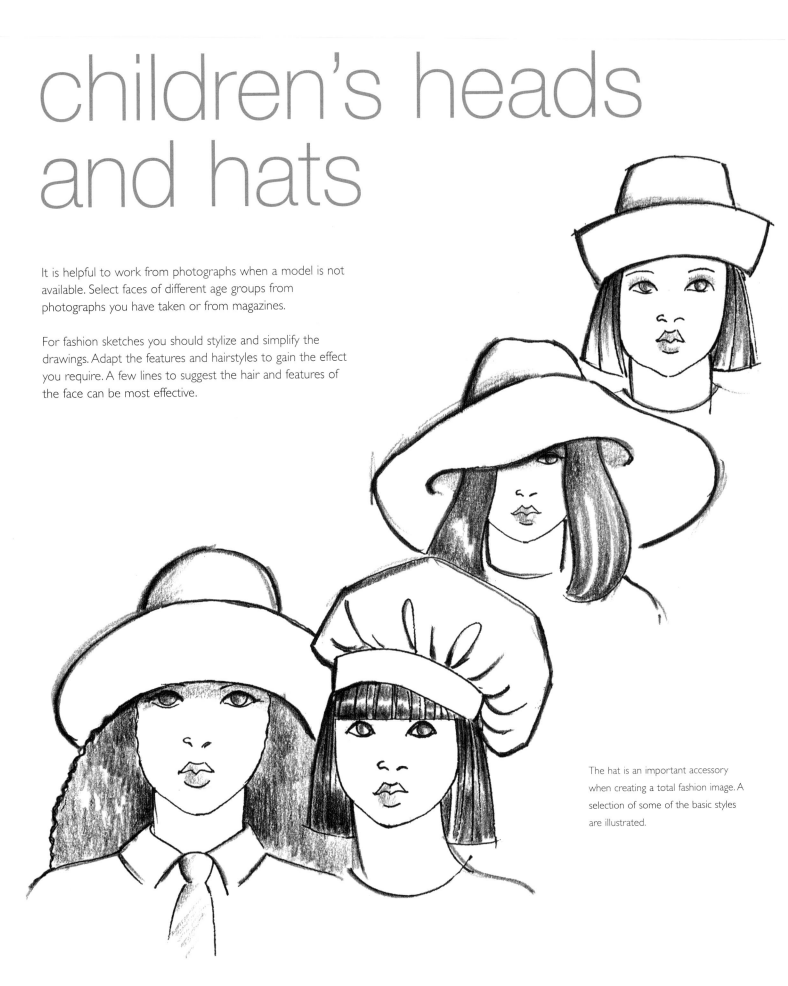

The hat is an important accessory when creating a total fashion image. A selection of some of the basic styles are illustrated.

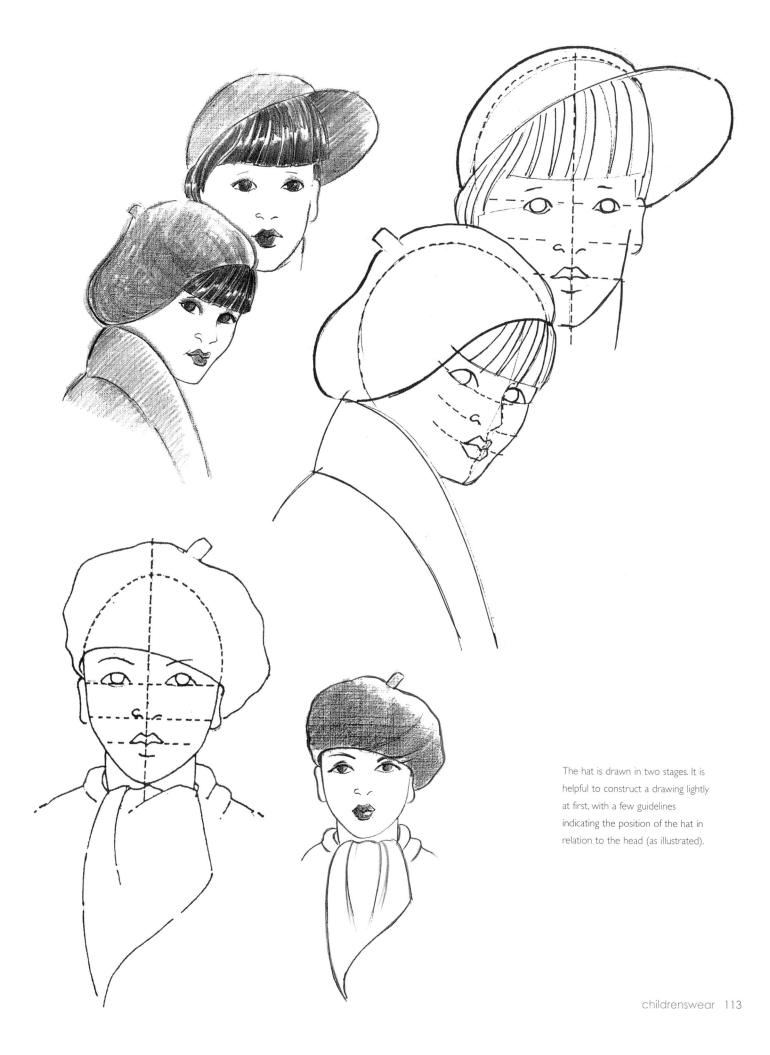

The hat is drawn in two stages. It is helpful to construct a drawing lightly at first, with a few guidelines indicating the position of the hat in relation to the head (as illustrated).

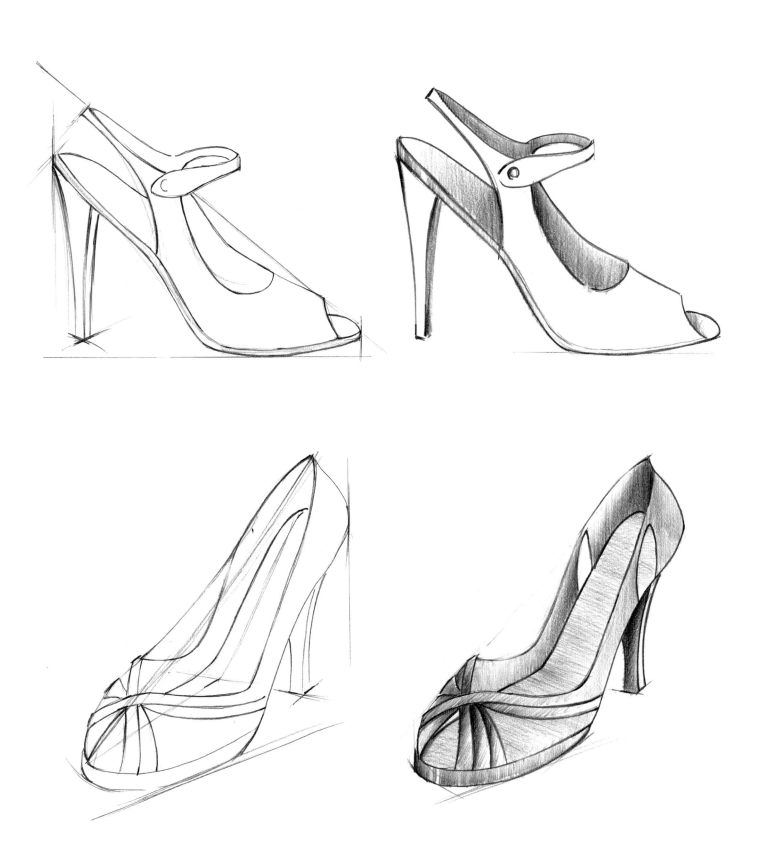

accessories

women's shoes

Drawing and designing shoes requires an understanding of the method by which they are made and the many different leathers, materials and trimmings used.

Illustrating and often merely suggesting the shoe or boot with a few simple lines on a fashion sketch requires observation of the shoes seen at different angles.

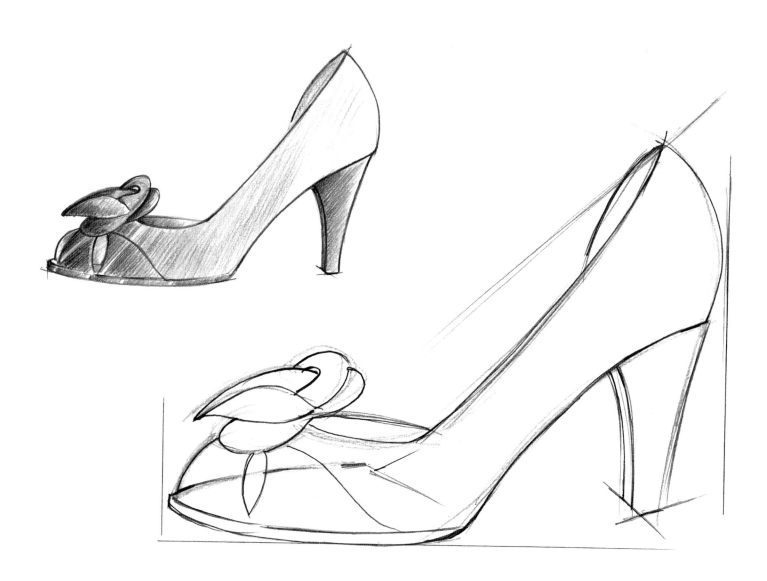

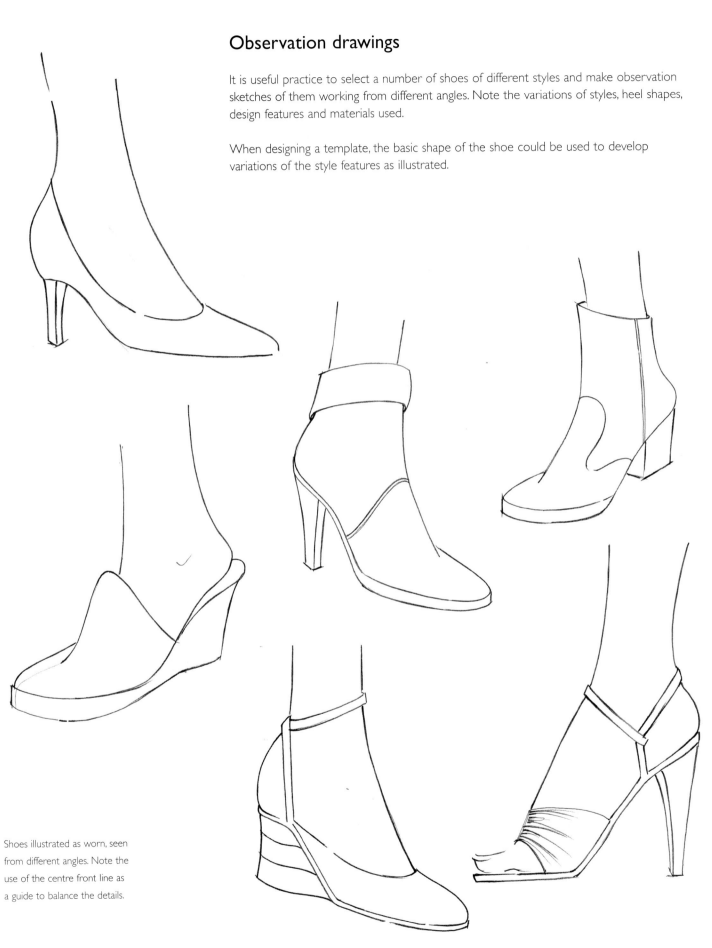

Observation drawings

It is useful practice to select a number of shoes of different styles and make observation sketches of them working from different angles. Note the variations of styles, heel shapes, design features and materials used.

When designing a template, the basic shape of the shoe could be used to develop variations of the style features as illustrated.

Shoes illustrated as worn, seen from different angles. Note the use of the centre front line as a guide to balance the details.

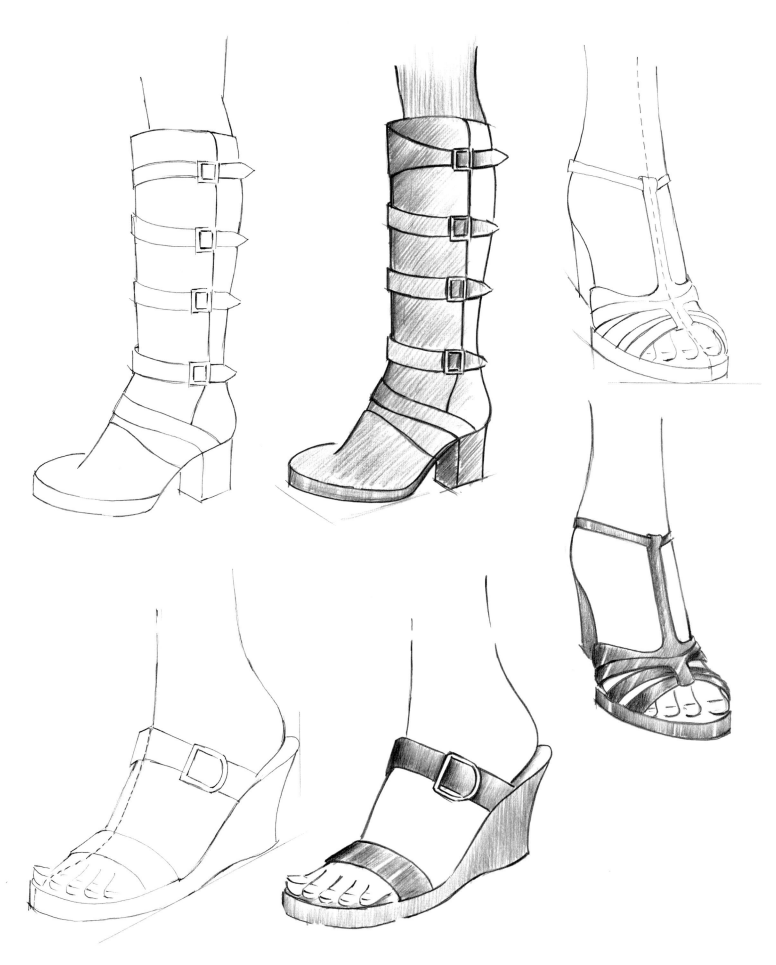

drawing hats

The hat is an important accessory to the fashion image. When illustrating hats it is useful to sketch the shape of the head and the construction lines indicating the position of the hat in relation to the shape of the head and features (see page 113).

The hats illustrated here have been developed using the construction lines.

- Sketch lightly the shape of the head and develop the shape of the crown and brim round the head.

- When developing design ideas it is helpful to use a basic template of the head shape seen from different angles. This can be a useful aid in the early stages to express design ideas.

- When presenting designs they should be drawn from different angles to show any special features.

A selection of some of the basic styles from which many variations of hats are designed.

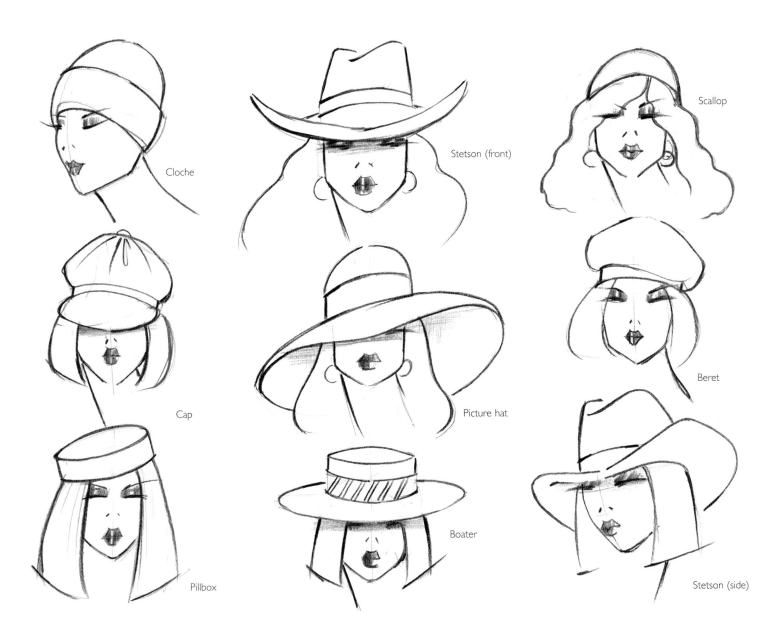

Cloche

Stetson (front)

Scallop

Cap

Picture hat

Beret

Pillbox

Boater

Stetson (side)

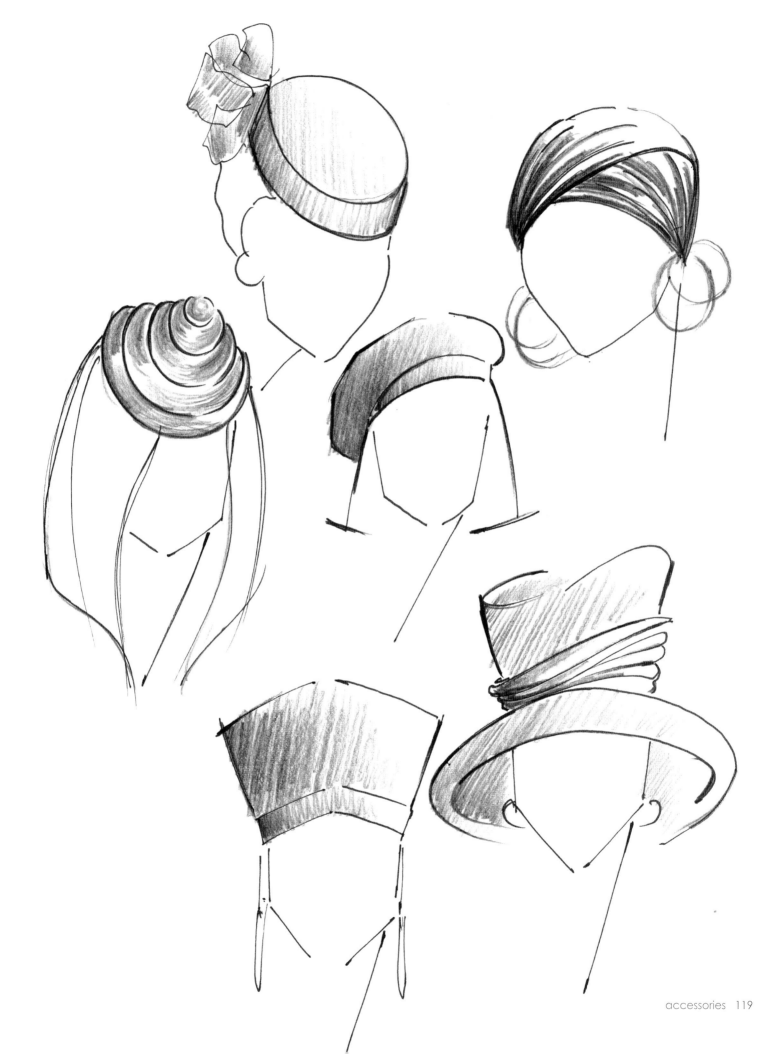

It is good practice to sketch from a model, photographs or from fashion magazines. Keep the sketches simple, observing the hat from different angles.

Design development sheet of a classic style, working on a theme. Note the variation of the crown and brim shapes seen from different angles. The face and hair have only been suggested. A Derwent Artist Ivory Black pencil on a smooth white drawing card was used for the drawing.

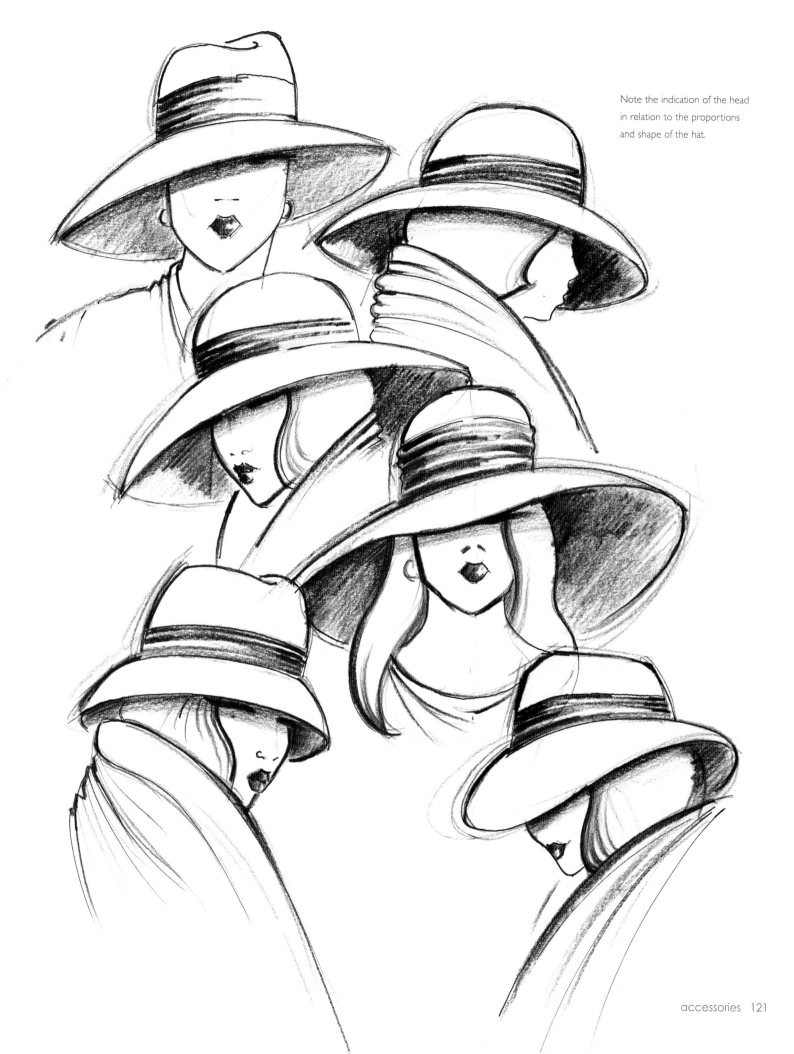

Note the indication of the head in relation to the proportions and shape of the hat.

drawing bags

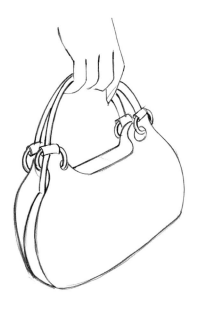

Observation drawings

Handbags are an important accessory to fashion, contributing to the overall look of a fashion illustration.

- Make detailed sketches of bags as seen from different angles.

- Observe the latest styles and the way they are worn and carried as a fashion accessory.

- Collect photographs of the most recent styles from fashion magazines for reference. Observe the use of different materials, colours, stitching and fastenings.

- When developing and drawing, carefully consider the way the bag is introduced with the overall look of the illustration. Note the style of the bag in relation to the fashion design image.

- Simple templates may be used when developing design ideas based on one shape.

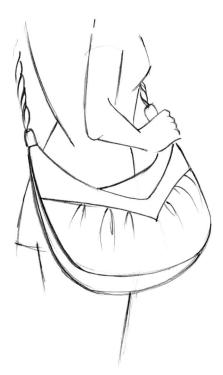

Note the basic construction lines of perspective as a guide before developing the drawing in more detail.

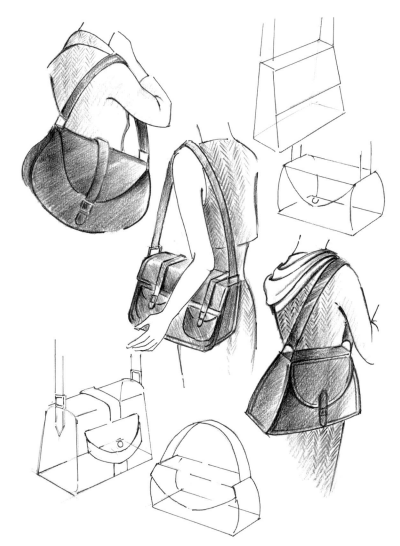

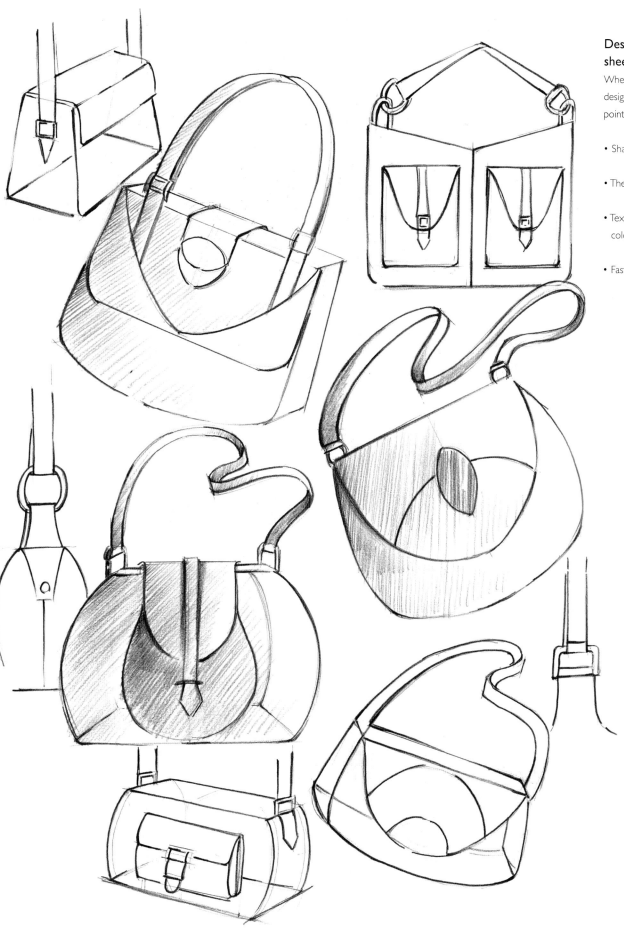

Design development sheet

When drawing and developing design ideas the following points should be considered:

• Shape and construction.

• The materials used.

• Textures, patterns and colours.

• Fastenings and trimmings.

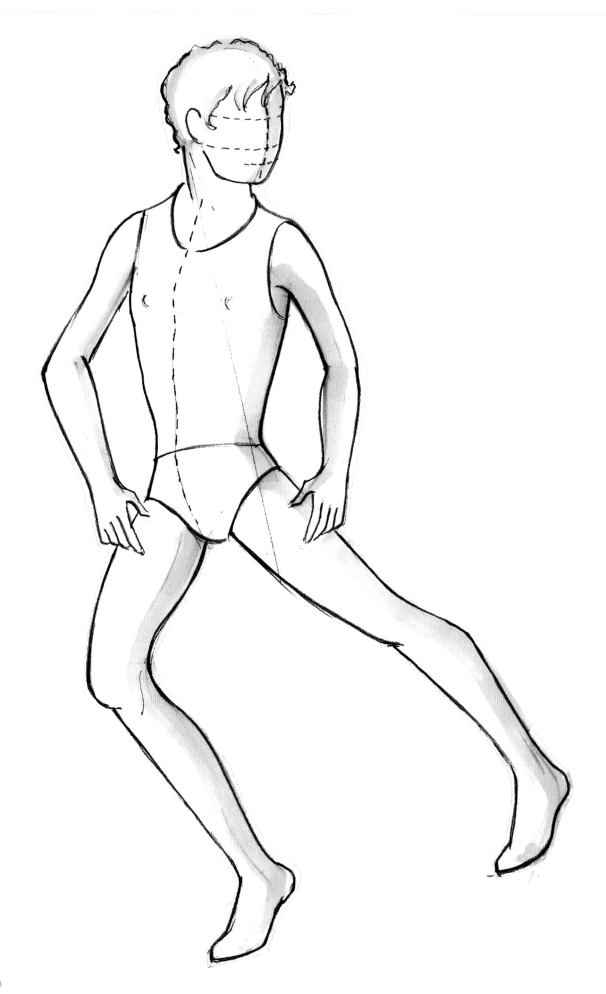

This presentation board has
been completed in three stages:

1 Template
2 Line drawing developed
 over template
3 Presentation board

Letraset Promarker pens and
Schwan Stabilo Softcolor
pencils are used for colour
effects. To complete the
presentation, the figure has
been cut out leaving a white
line. This is effective when
placed against the photograph
and coloured panel.

colour and presentation
children

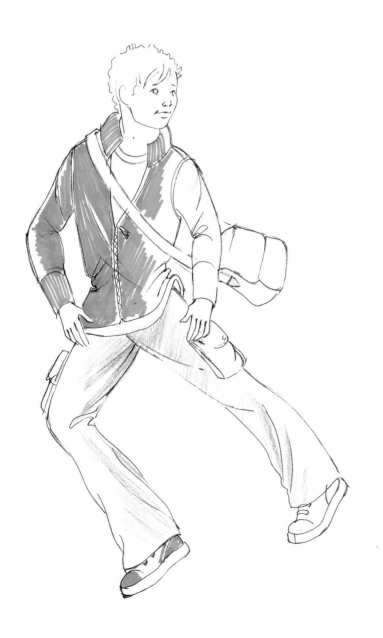

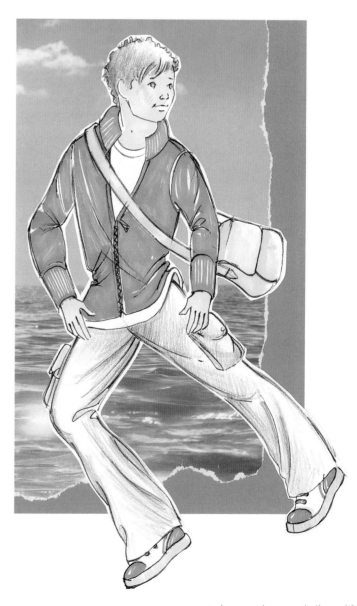

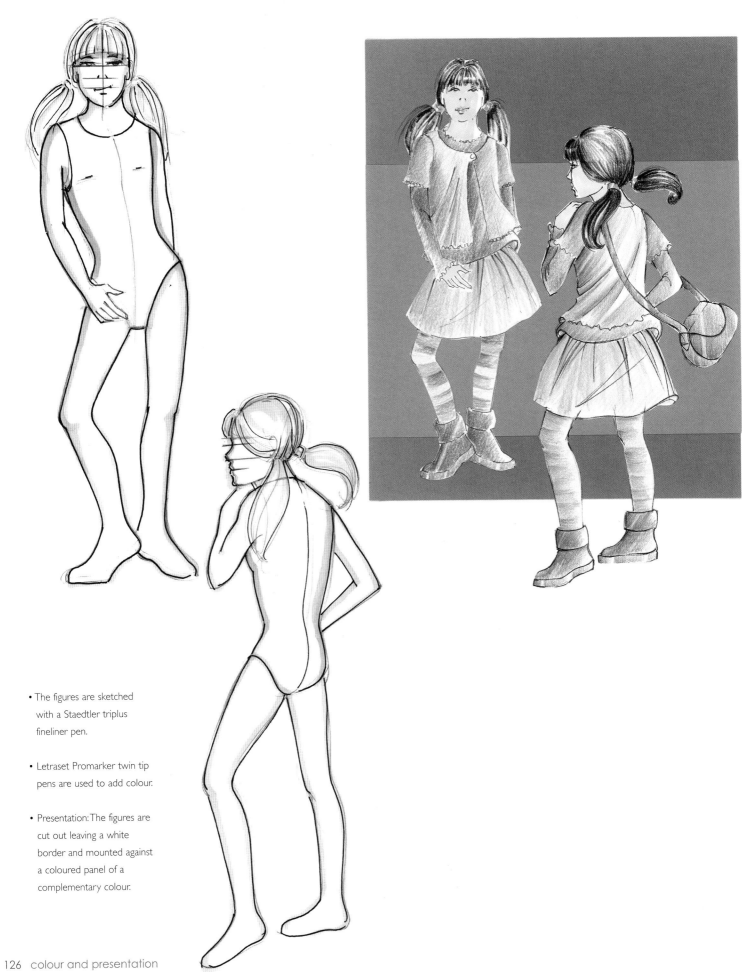

- The figures are sketched with a Staedtler triplus fineliner pen.

- Letraset Promarker twin tip pens are used to add colour.

- Presentation: The figures are cut out leaving a white border and mounted against a coloured panel of a complementary colour.

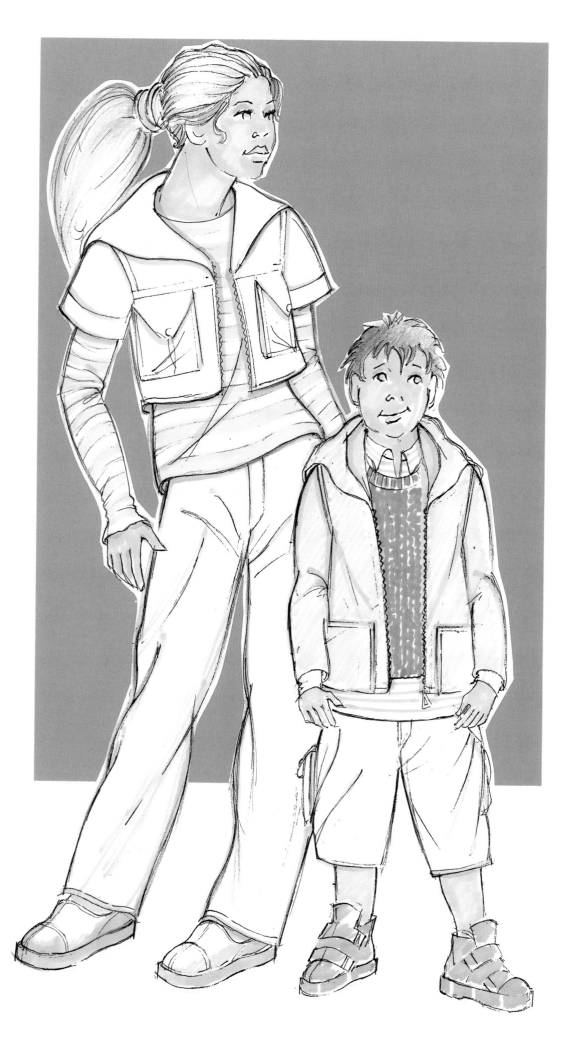

STYLIZED DRAWINGS

• The stylized figures of children are sketched in a free style over the basic templates with a black Stabilo point 88 pen.

• Letraset Promarker twin tip pens are used combined with Stabilo Softcolor pencils to add a contrast of textures.

• Note the sketch drawn over the basic shapes of the figure template using the template only as a guide.

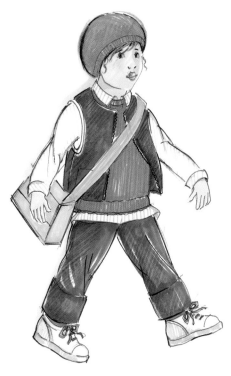

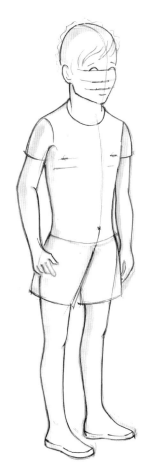

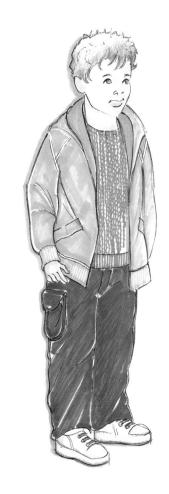

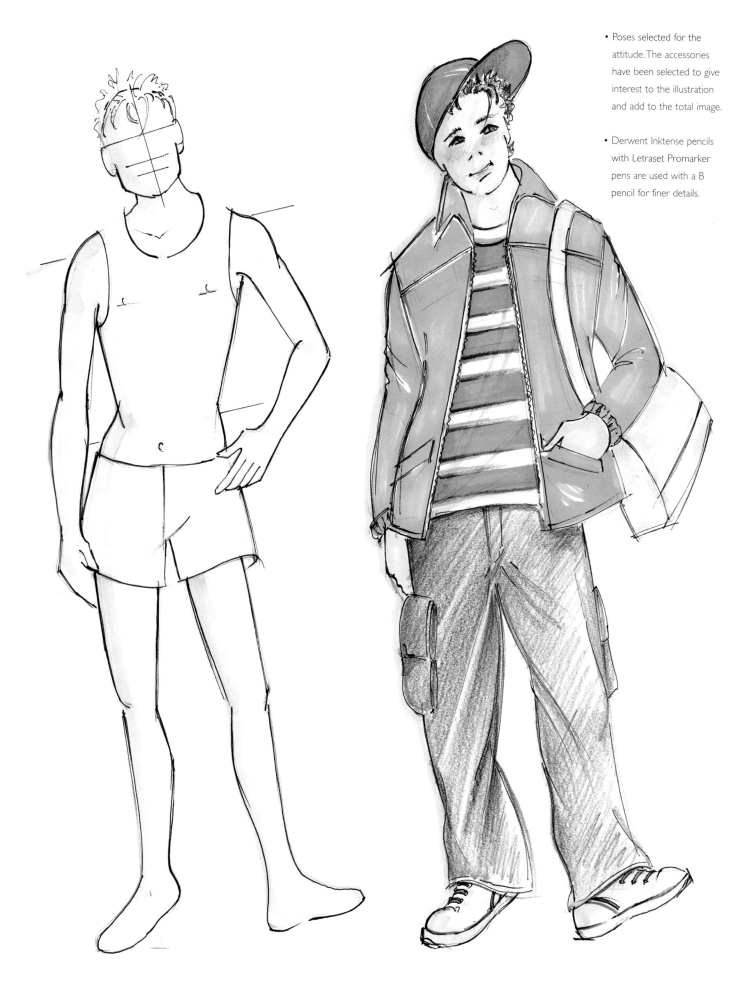

• Poses selected for the attitude. The accessories have been selected to give interest to the illustration and add to the total image.

• Derwent Inktense pencils with Letraset Promarker pens are used with a B pencil for finer details.

TEENAGERS

Note the stylized techniques, exaggerating the pose used to emphasize the casual image. A Staedtler triplus fineliner pen and Pentel Sign pen of a different line value were used in these drawings. The textured pattern was developed by placing a textured surface under the layout paper and applying a soft coloured pencil over the paper. This effect may only need to be suggested on the sketch, leaving areas of white to give the impression of light and shade.

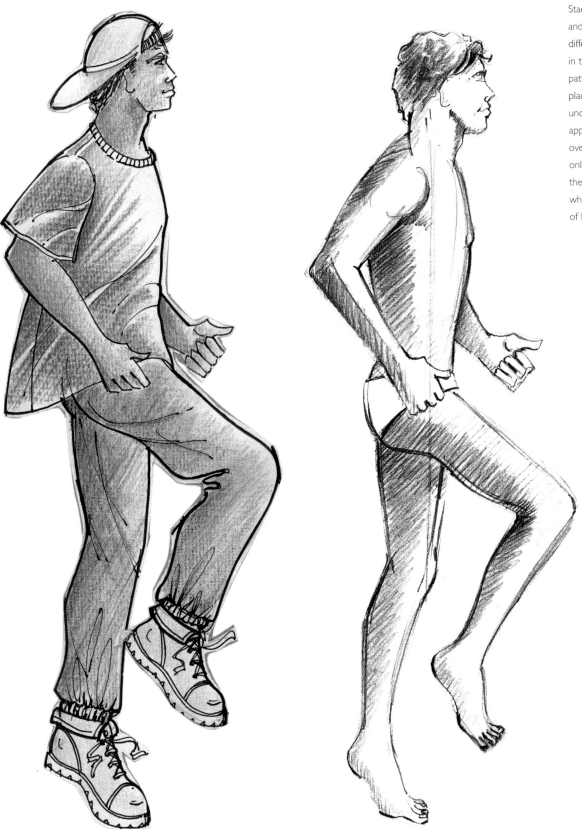

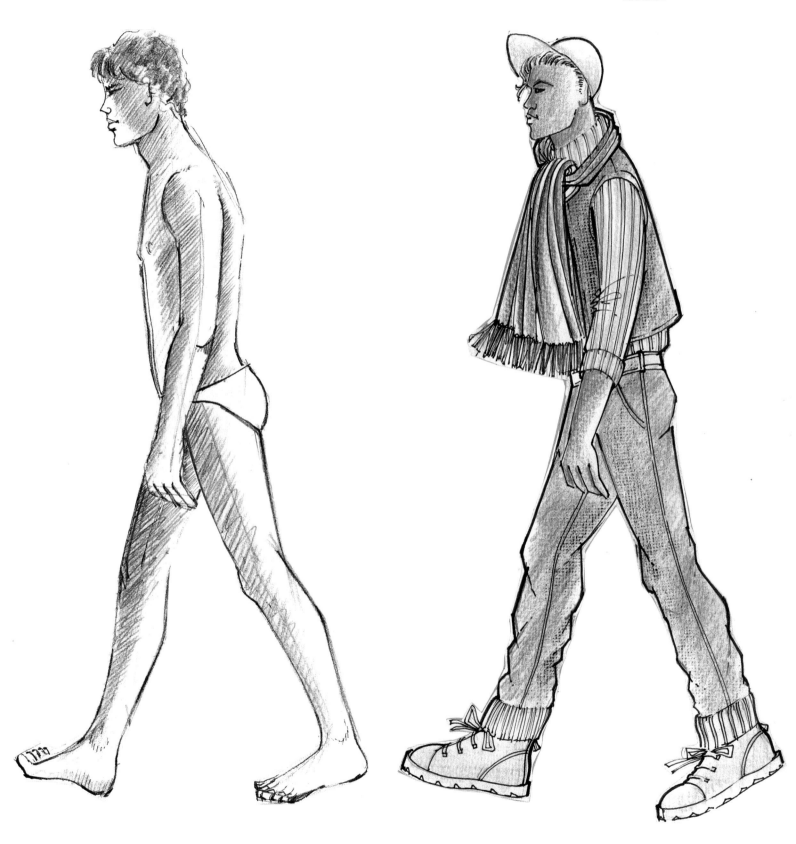

Pencil sketches produced in a
life drawing class and later
developed as templates for
illustration.

women

PRESENTATION

Presentation drawings and general display of work are required when a designer is showing a collection of designs.

The way that work is presented can vary considerably. A stylized drawing technique may be used or, alternatively, a more realistic approach.

The composition of the design sheet and the arrangement of the figures – including back views, notes if required, sample fabrics and working drawings – needs careful consideration.

It is advisable to make some rough guides in your sketchbook, or develop a number of possibilities on the computer, before deciding on the composition to be used. A background and decorative effects related to the design theme may be used to great effect, but never let the effects of decoration overpower the design content.

The use of colour and illustrative techniques should be carefully considered. Experiment with coloured pencils, pens, marker pens, watercolours and inks.

1 Figure drawn using a Staedtler fineliner pen over the template.

2 Letraset Promarker pen combined with Derwent Inktense pencils are used to add colour.

3 The finer details are added with a Staedtler pen.

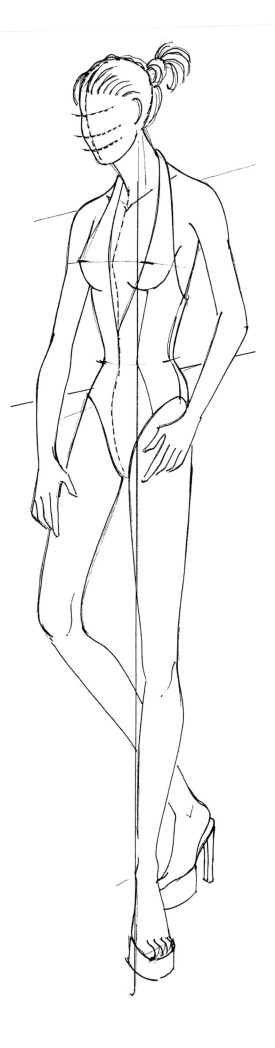

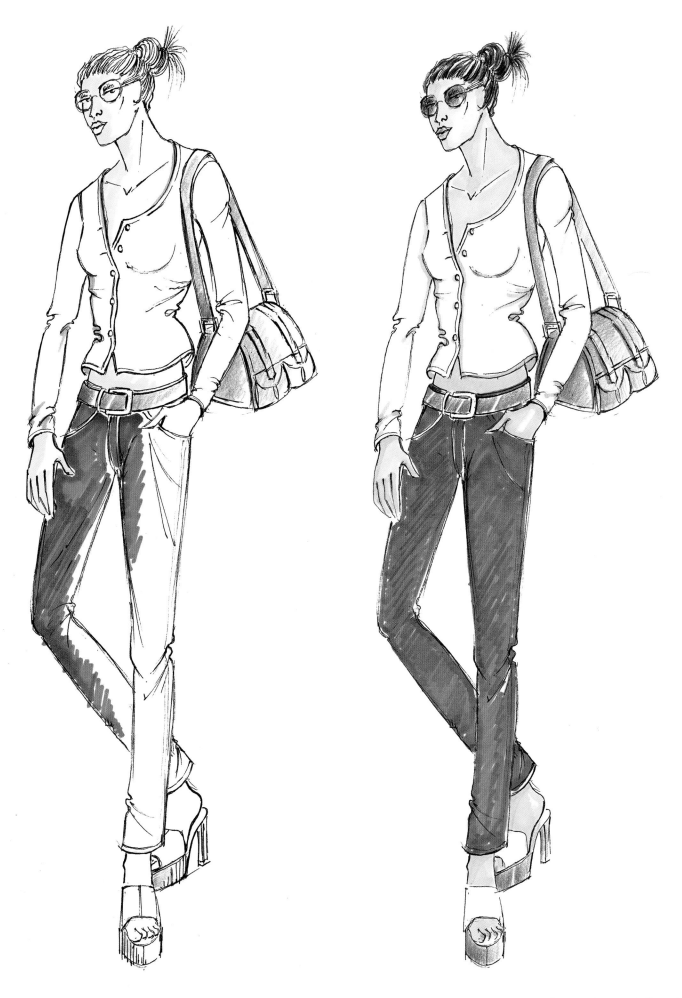

SUMMER CASUALWEAR

Designs sketched over the impression of the figure template. Note the coloured lines sketched round the figure indicating the movement of the pose and relating to the form of the body underneath the garments.

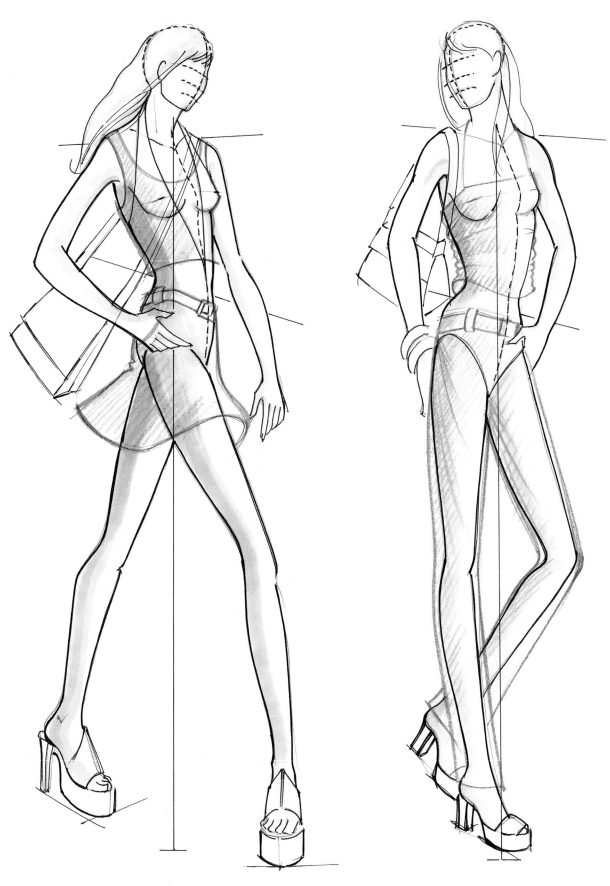

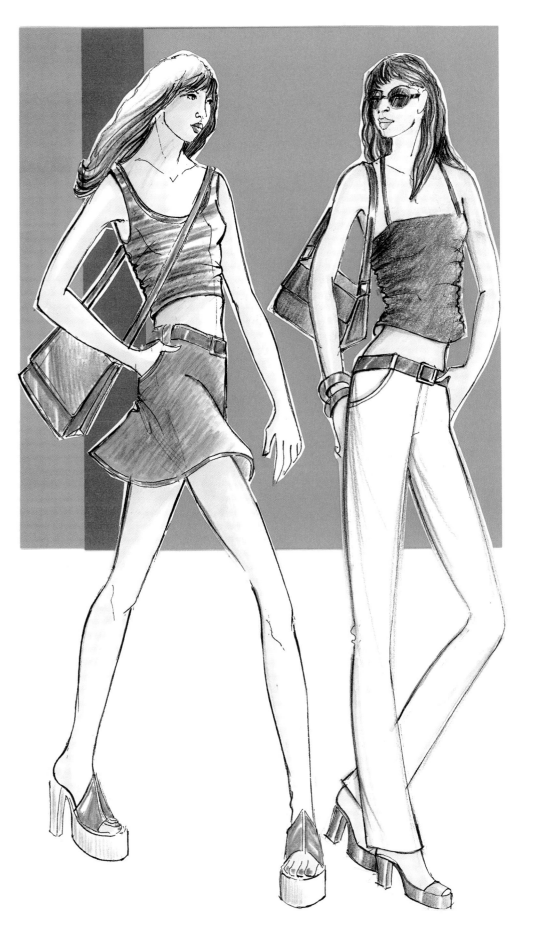

Presentation board

Figure poses selected to display the garments to their best advantage. Derwent Inktense pencils are used to add colour.

The figures were cut out and mounted against panels of colour reflecting the colour combination of the garments.

STYLIZED FASHION IMAGES

Stylized illustrations of different fashion images and a selection of figure poses.

• The illustrations are sketched using a Staedtler triplus fineliner black pen. Derwent Inktense pencils are used for colour, combined with a cool grey Letraset Promarker pen for added tone.

• Note the contrast of tone values – using different pressures with the pencils adds a contrast of light and shade.

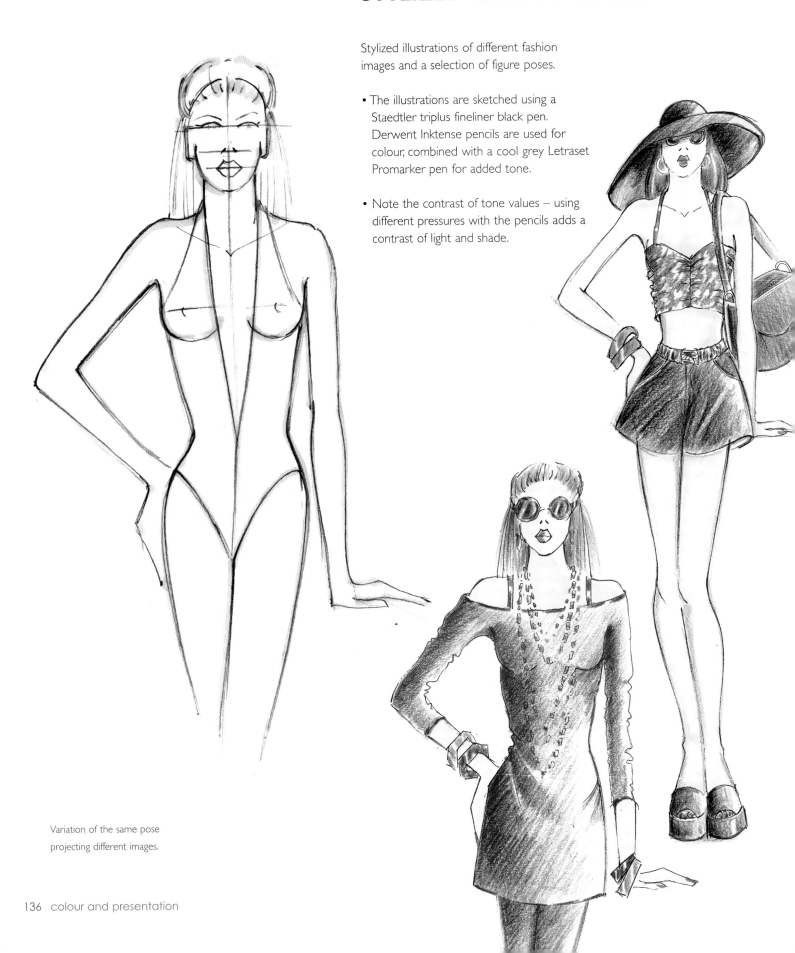

Variation of the same pose projecting different images.

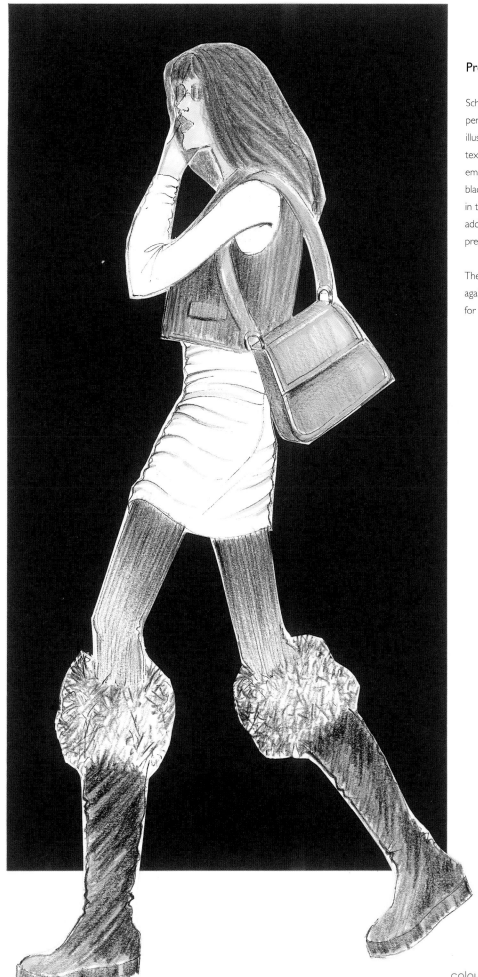

Presentation board

Schwan Stabilo Softcolor
pencils were used for the
illustrations, produced on a
textured drawing paper to
emphasize the contrasting
black and grey textures used
in the design. The red hair
adds contrast to the
presentation.

The illustration is placed
against a solid black panel
for more contrast.

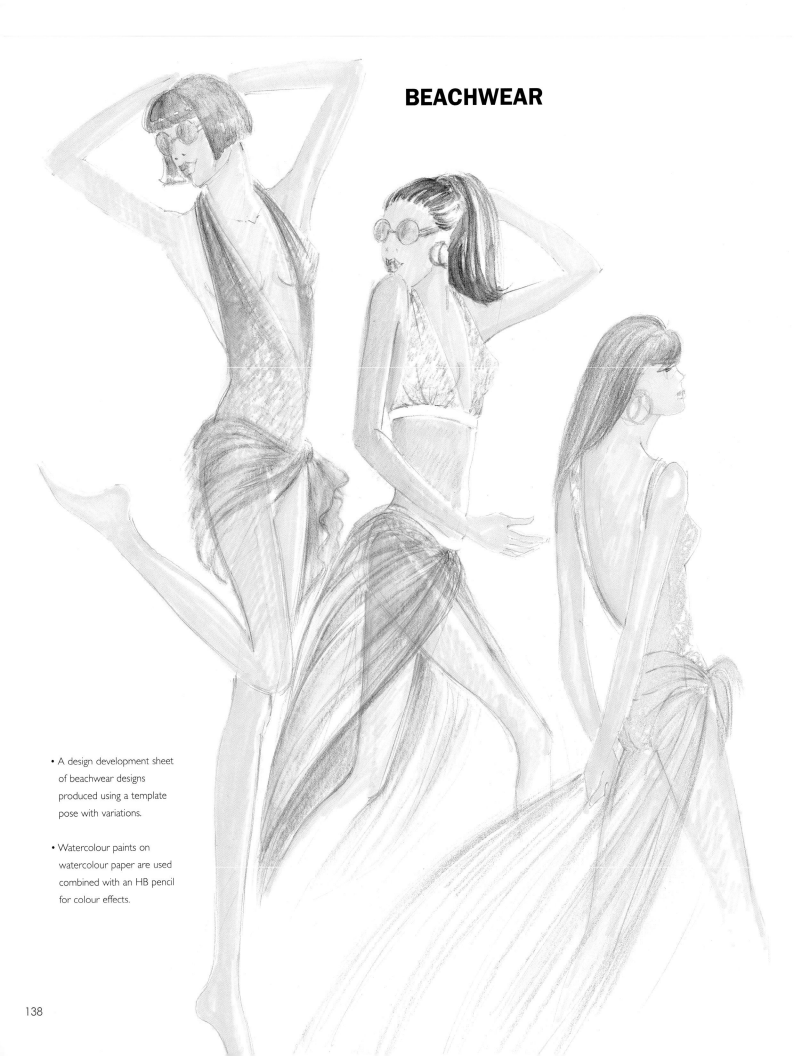

BEACHWEAR

• A design development sheet of beachwear designs produced using a template pose with variations.

• Watercolour paints on watercolour paper are used combined with an HB pencil for colour effects.

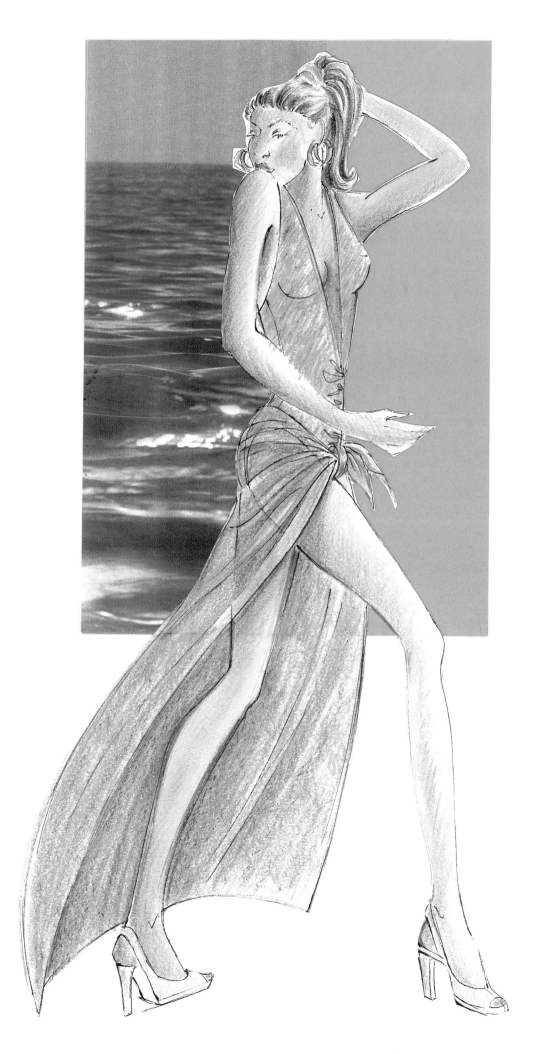

Presentation board

Beachwear illustration. The figure is cut out and mounted onto a photograph.

Derwent Inktense coloured pencils are used with water applied to achieve the effect of pattern and colour.

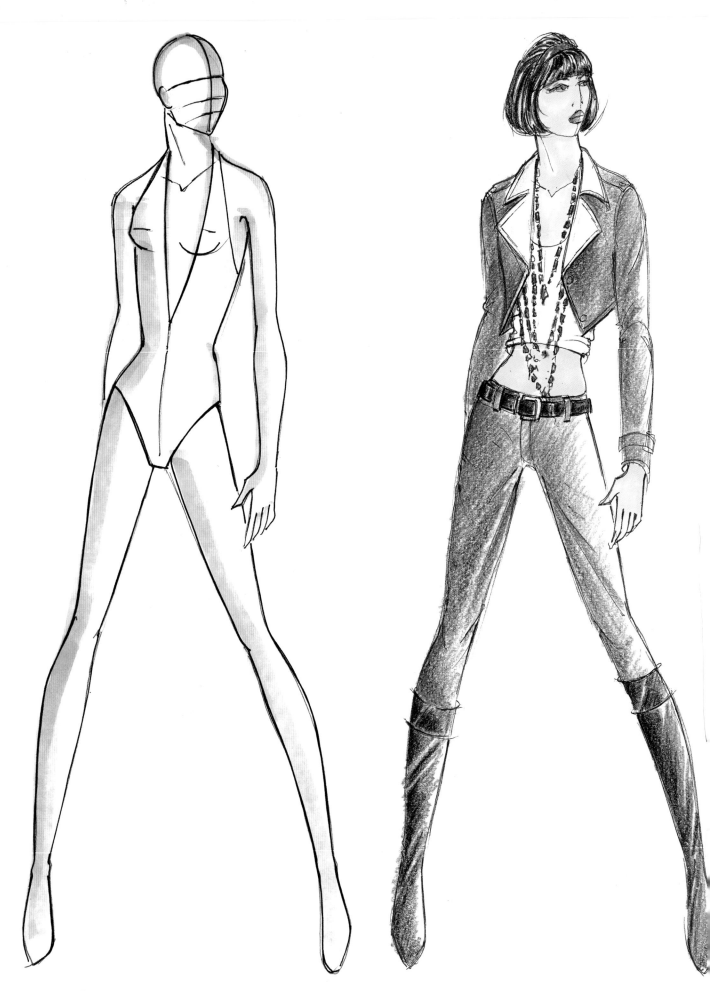

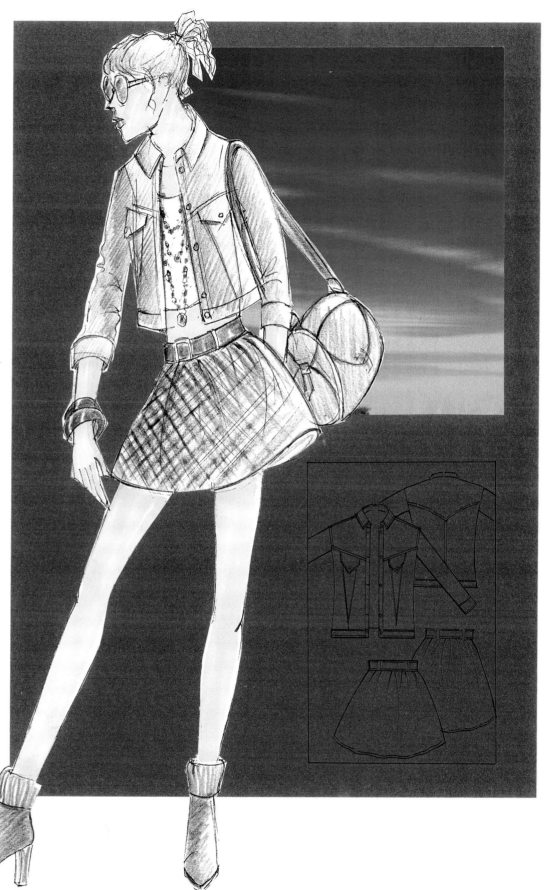

Presentation board

The figure is cut out and mounted against a coloured panel and photograph to suggest the mood and atmosphere appropriate to the garment.

Derwent Inktense water-soluble ink pencils are used on a textured drawing paper. Water has been applied on parts of the drawing with a fine brush to add depth to the folds.

The working drawing of the garments is added to give a clear indication of the detail of cut, seam placement, collar, pockets and style features.

FIGURES IN MOVEMENT

These illustrations have been developed over templates designed to suggest movement.

Coloured marker pens can be applied to build up depth of colour. Shading and texture are suggested by drawing in different directions and leaving areas of white. A fine pointed HB pencil or fineliner pen is useful for adding the details.

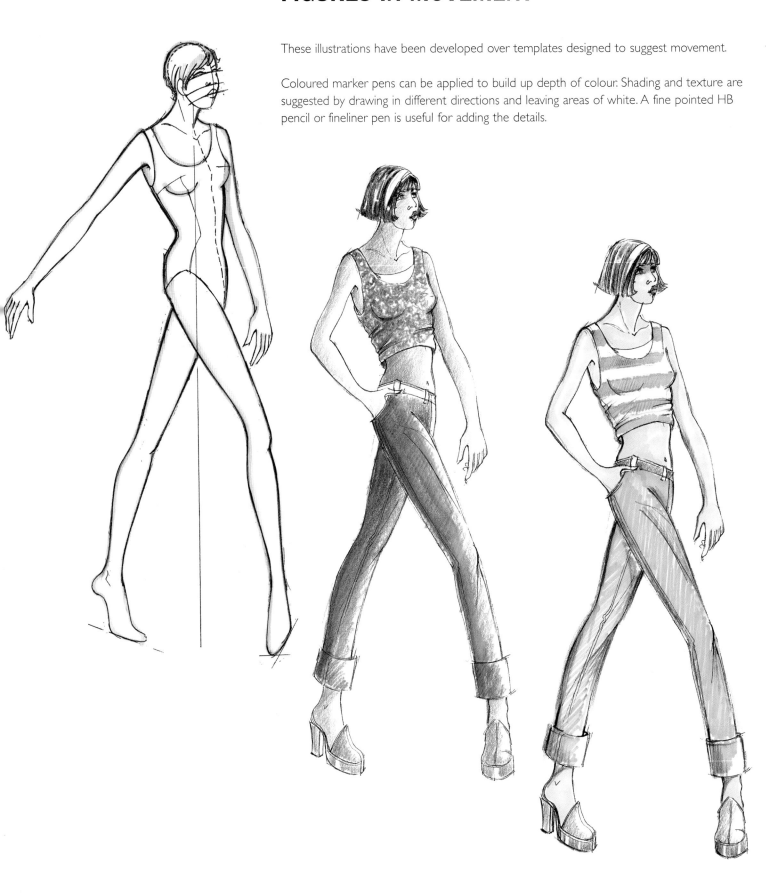

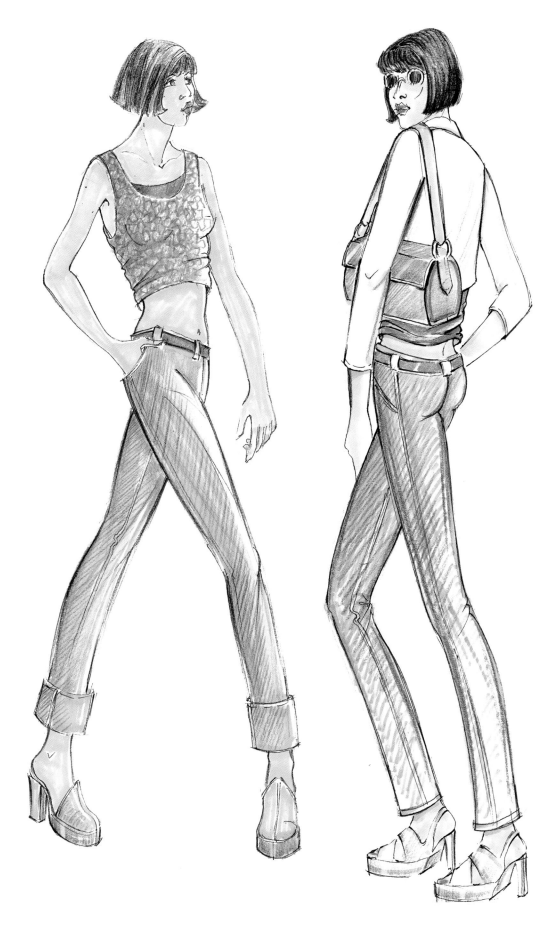

- The figures are sketched and then Schwan Stabilo Softcolor pencils used to add colour.

- The fashion sketch developed using the figure template.

- Experiment with different techniques for applying colour and pattern, using a selection of mixed media

- Photocopy a number of fashion sketches produced in line. Experiment with colouring techniques using marker pens, coloured pencils, inks and watercolours.

- Adapt figures from the book and create your own variations of the pose.

Presentation board

Note the attitude of the figures stepping out with the weight of the figures distributed on both legs.

The use of the shoulder bag and scarf add movement to the figure poses.

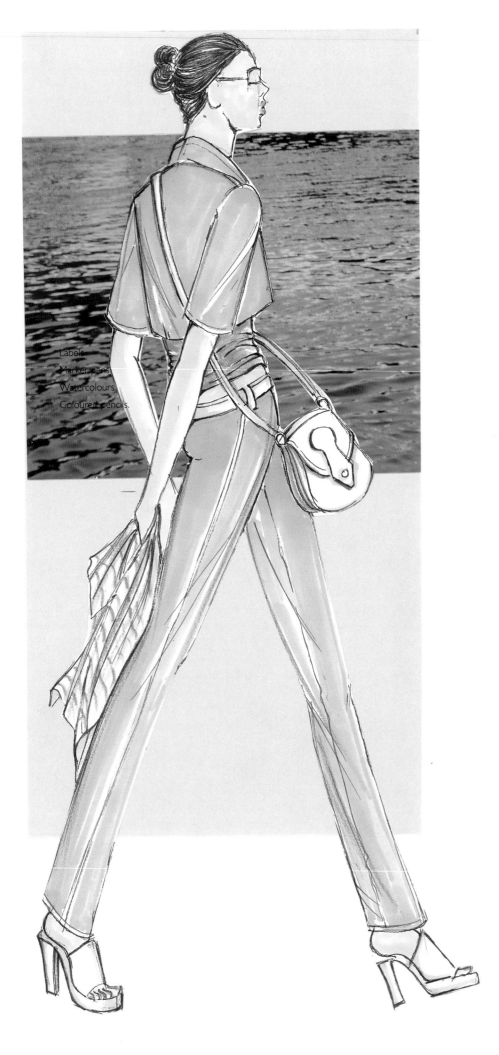

Label:
Marker pens.
Watercolours.
Coloured pencils.

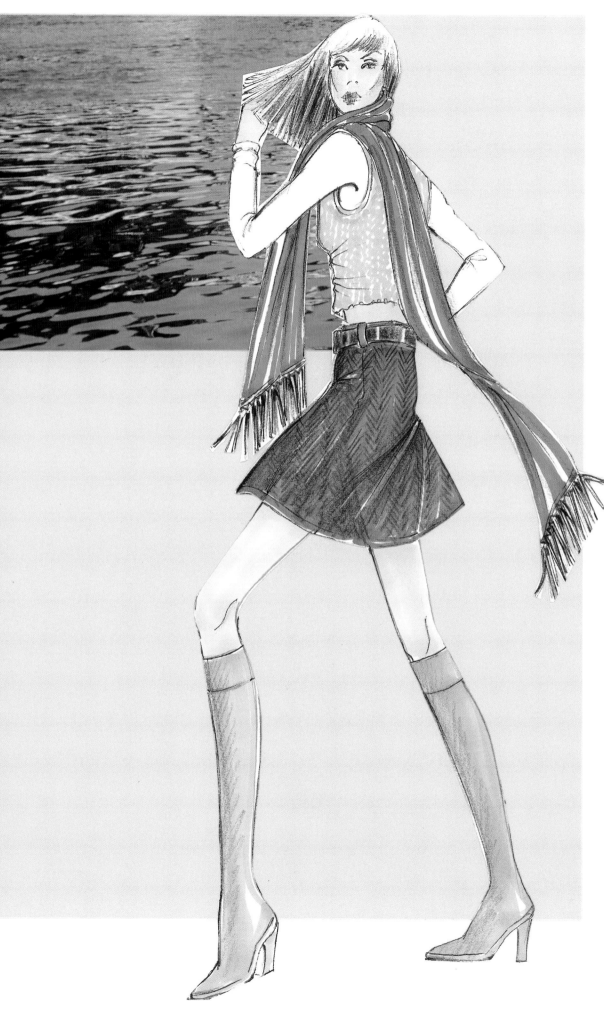

Presentation board

These presentation boards illustrate the use of marker pens combined with coloured pencils and a soft 3B pencil line to suggest texture of the fabric. The details are indicated with a fineliner pen.

To complete the presentation the figures have been cut out and pasted onto boards. A section of a photograph suggests the environment in which the garment could be worn, adding colour and interest to complement the design.

EVENINGWEAR

Design sketches illustrating the effects of folds, gathers and drapes.

• These sketches are produced with a 2B pencil on a smooth surface white drawing paper.

• Letraset Promarker pens and Derwent Inktense pencils are used to colour the sketches.

• Fine-pointed HB pencils are used to emphasize the folds and gathers, using extra pressure to provide a darker line.

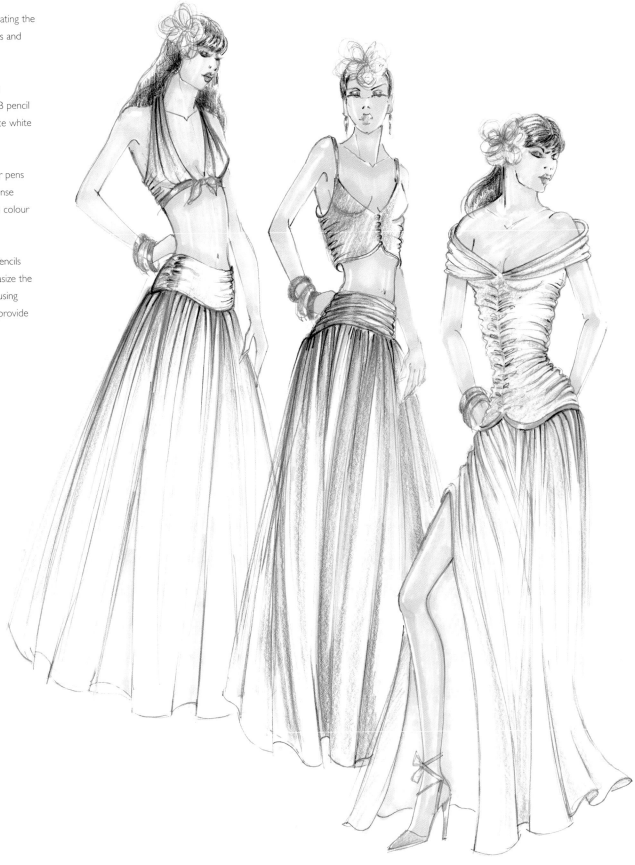

Folds, gathers and drapes

When representing folds, gathers and drapes, it is important to understand the character of the fabric to be illustrated. The way in which it falls into folds depends on its weight and thickness. To have a real understanding of the fabric it is helpful to drape a selection of fabrics on a dress stand and study the way in which folds and gathers behave.

Note the way in which lightweight fabrics fall into small soft folds in contrast to those of heavy and rich materials.

Fabric characteristics

When sketching, consider the solid form of the body beneath the clothing. Simply suggesting surface effects will not necessarily produce the required effect for a fashion sketch.

The areas where the body supports the clothing can suggest the characteristics and behaviour of the fabric, which may be the essential part of the look required.

Certain fabrics and their characteristics influence the way in which the figure is revealed. Soft fabrics, such as jersey silk or fine cotton, hang and drape in soft folds and show the form of the figure more clearly. Heavy and stiff fabrics such as tweeds and linen tend to drape and fold in an angular way, producing hard folds that resist movement.

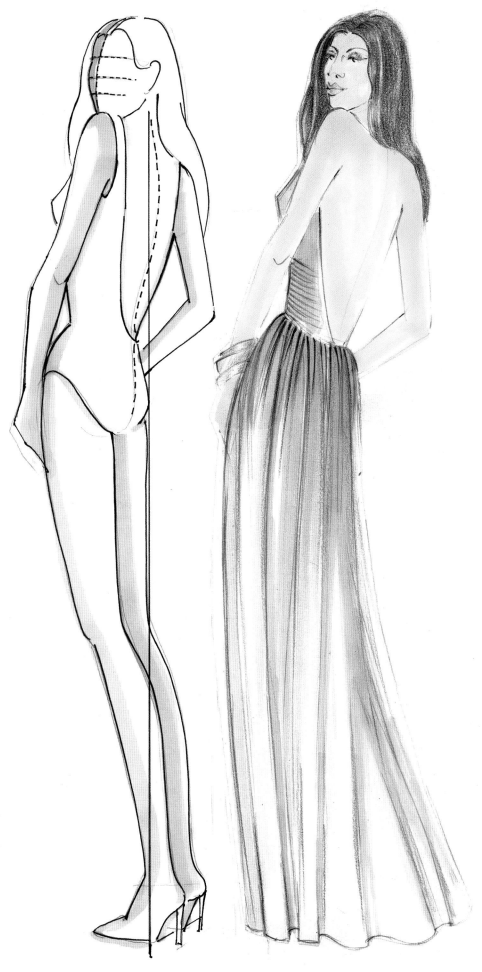

Presentation

- Figures illustrating how to use the template to develop the sketch, relating the garment to the figure pose by drawing round the figure, and avoiding a flat impression.

- Derwent Inktense pencils are used on a smooth white drawing paper.

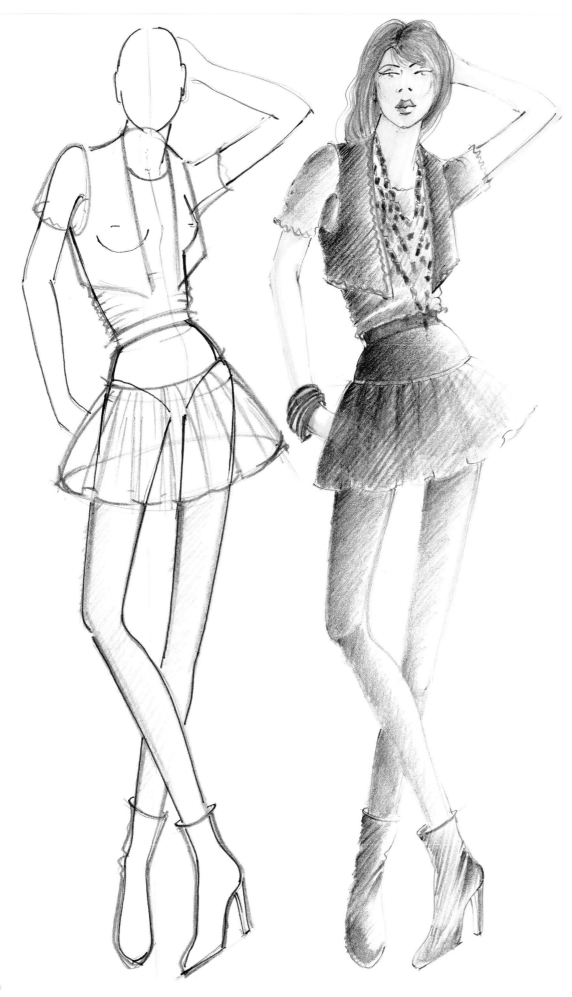

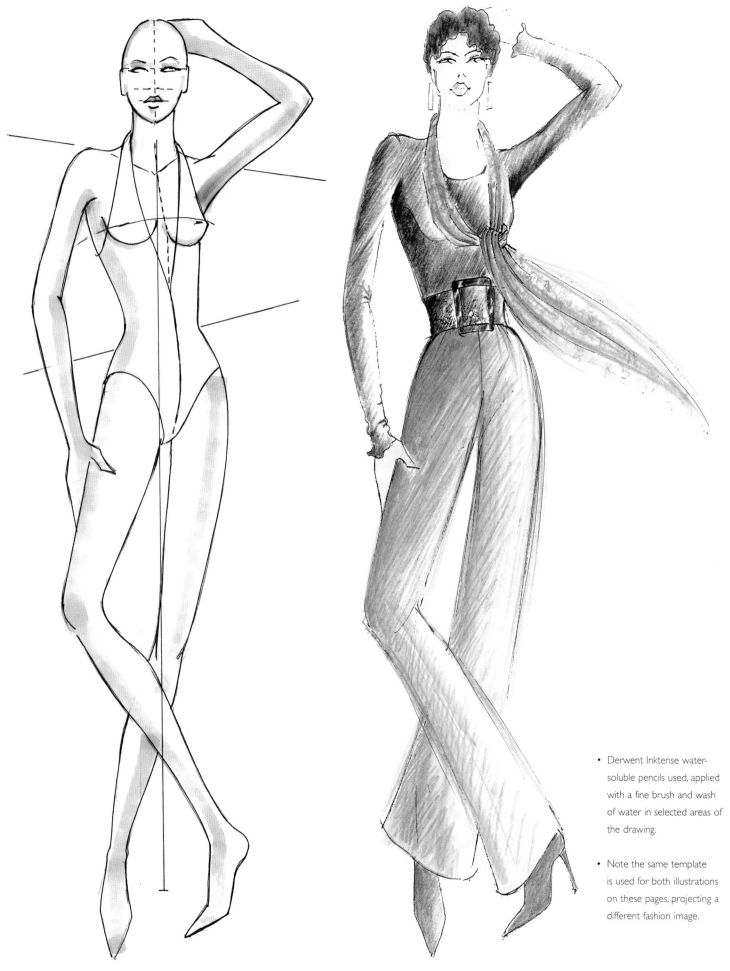

- Derwent Inktense water-
 soluble pencils used, applied
 with a fine brush and wash
 of water in selected areas of
 the drawing.

- Note the same template
 is used for both illustrations
 on these pages, projecting a
 different fashion image.

men

CASUALWEAR

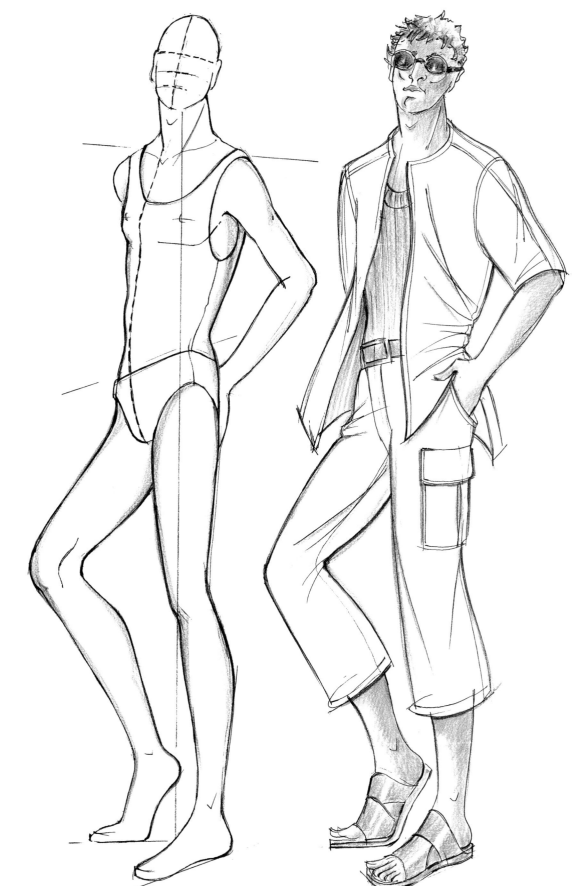

- Figures sketched over a template with a soft 3B Derwent Artist pencil.

- Schwan Stabilo coloured pencils, combined with a cool grey Letraset Promarker pen for tonal effects, are used for colour.

- A fine black Stabilo pen is used to draw into the sketch to emphasize folds, pockets and seam placement.

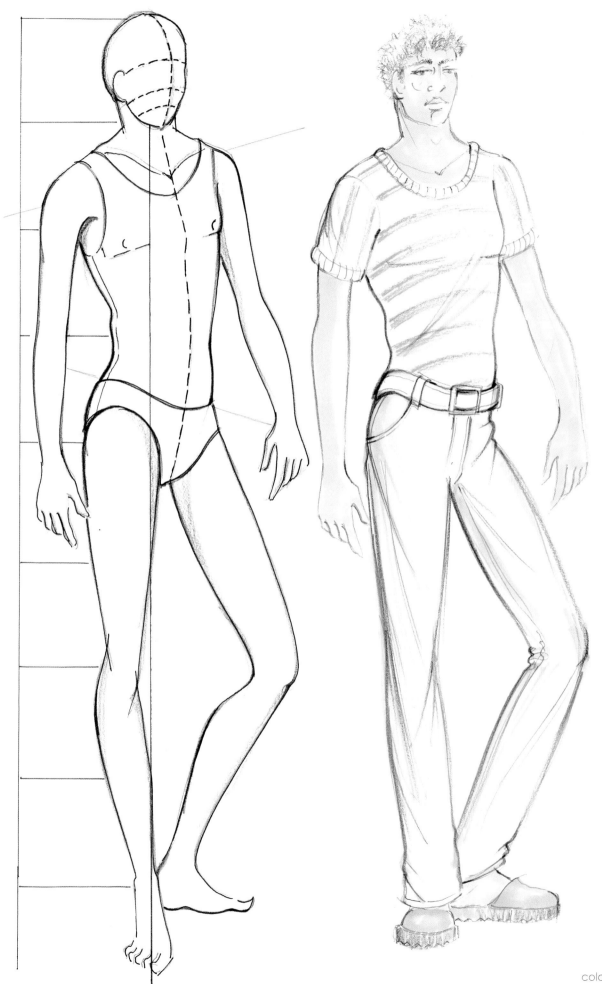

SUMMER CASUALWEAR

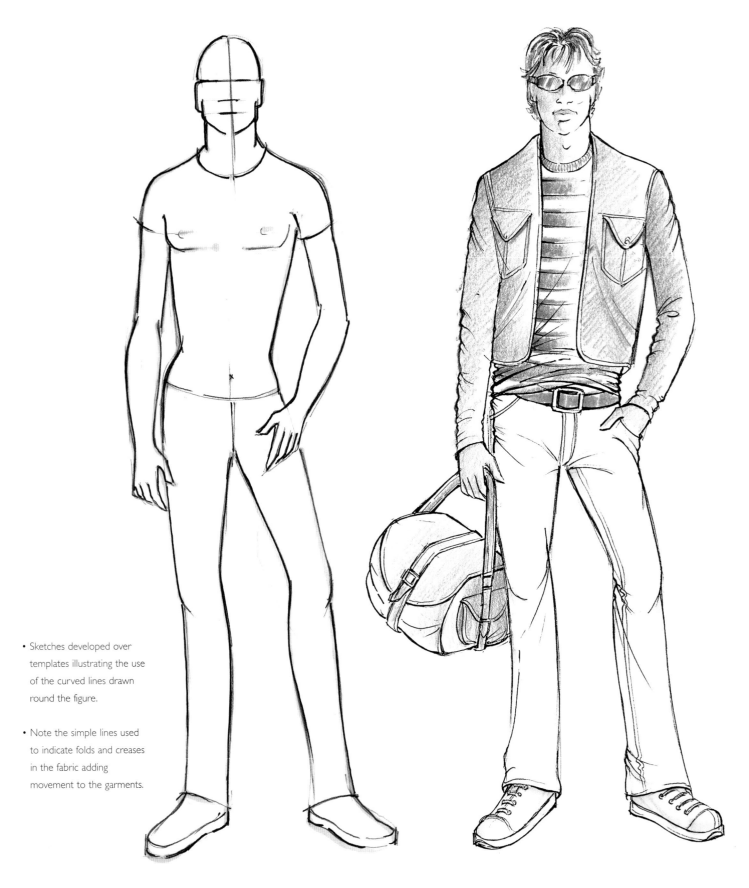

- Sketches developed over templates illustrating the use of the curved lines drawn round the figure.

- Note the simple lines used to indicate folds and creases in the fabric adding movement to the garments.

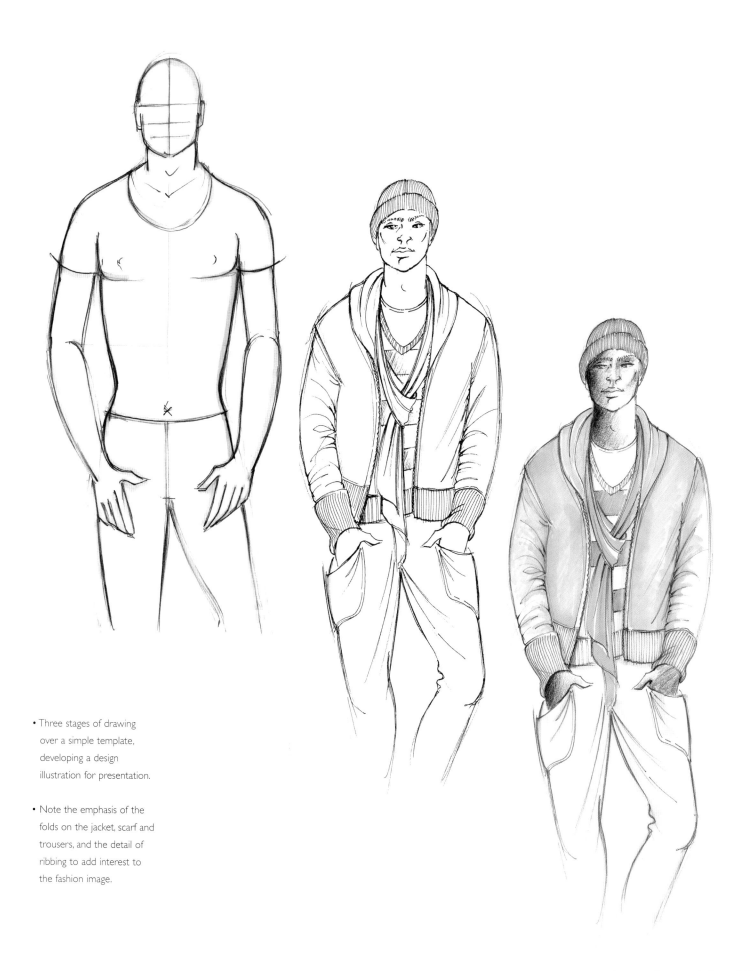

• Three stages of drawing over a simple template, developing a design illustration for presentation.

• Note the emphasis of the folds on the jacket, scarf and trousers, and the detail of ribbing to add interest to the fashion image.

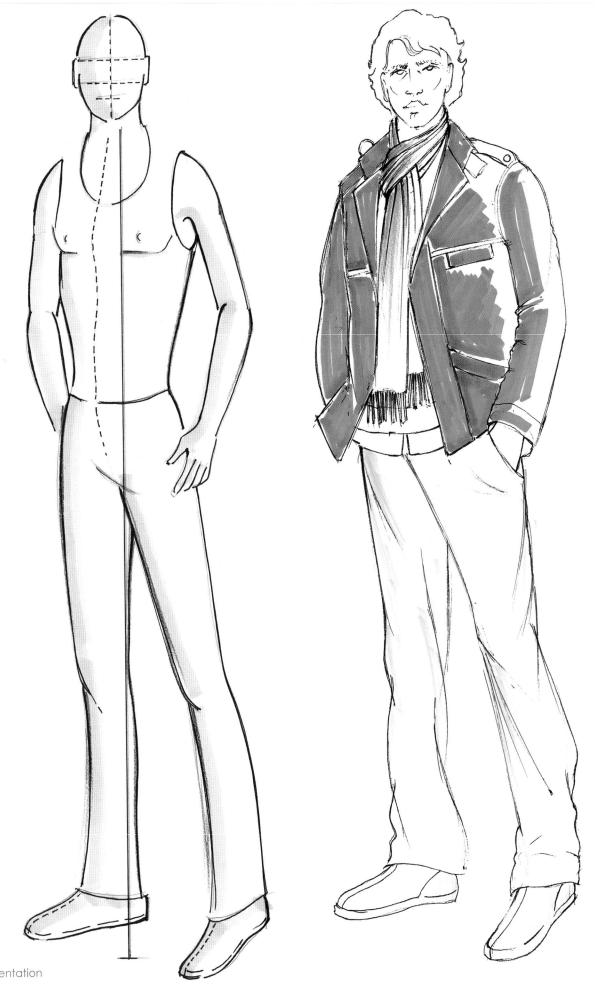

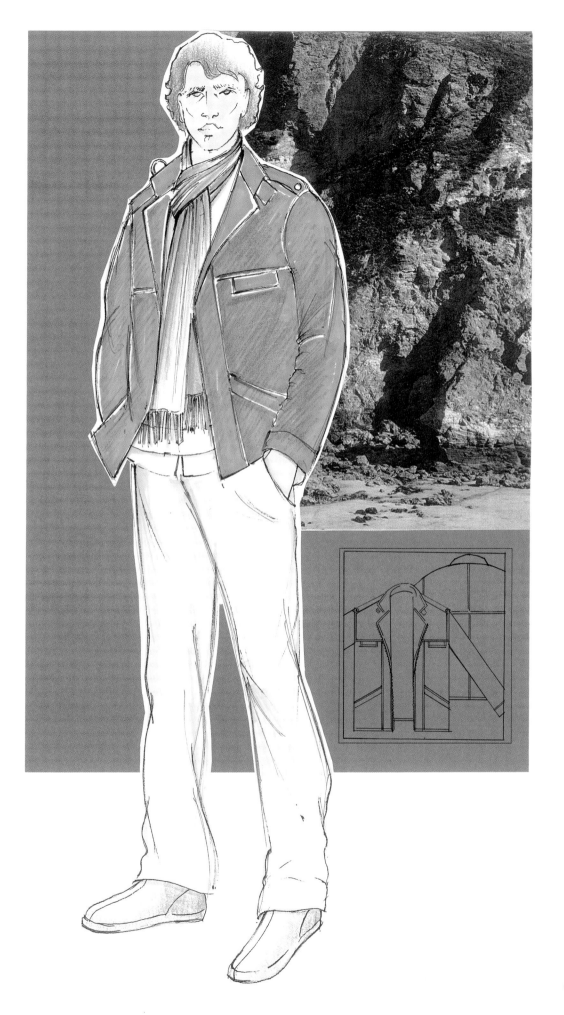

Presentation board

A pen and ink line drawing, using Letraset Promarker pens combined with Derwent coloured pencils.

The figure is cut out, leaving a white line around the edge of the figure. This is effective when pasted onto a coloured mount board. The photograph suggests the environment in which the garment could be worn.

Working diagrams are shown, giving clear information on the cut and style features of the jacket.

index

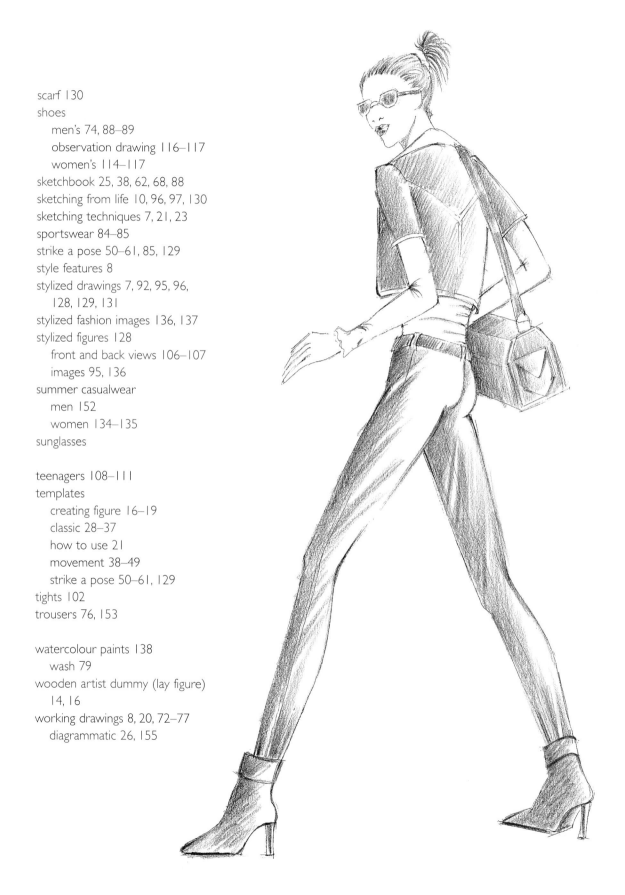

ACKNOWLEDGEMENTS

The author would like to thank all the students and lecturers of the many colleges visited for their support in producing this book. I would also like to extend my thanks to Thelma Nye for her advice and support, and Daphne Teague for her encouragement. Finally, thanks to my editors at Batsford, Tina Persaud and Kristy Richardson.